Studies in the History of Art
Published by the National Gallery of Art,
Washington

This series includes: Studies in the History of
Art, collected papers on objects in the Gallery's
collections and other art historical studies
(formerly *Report and Studies in the History of
Art*); Monograph Series I, a catalogue of stained
glass in the United States; Monograph Series II,
on conservation topics; and Symposium Papers
(formerly Symposium Series), the proceedings
of symposia sponsored by the Center for
Advanced Study in the Visual Arts at the
National Gallery of Art.

*Forthcoming

American Art around 1900

STUDIES IN THE HISTORY OF ART · 37 ·

Center for Advanced Study in the Visual Arts
Symposium Papers XXI

American Art around 1900

Lectures in Memory of Daniel Fraad

Edited by Doreen Bolger and Nicolai Cikovsky, Jr.

National Gallery of Art, Washington

Distributed by the University Press of New England

Hanover and London 1990

Editorial Board
DAVID A. BROWN, *Chairman*
DAVID BULL
NICOLAI CIKOVSKY, JR.
HENRY A. MILLON
CHARLES S. MOFFETT

Editor
CAROL ERON

Designer
CYNTHIA HOTVEDT

Editorial Assistant
ABIGAIL WALKER

Abstracted by RILA (International Repertory of the Literature of Art), Williamstown, Massachusetts 01267

Proceedings of the symposium, "American Art around 1900," sponsored by the Center for Advanced Study in the Visual Arts, National Gallery of Art, and the Metropolitan Museum of Art, 4 and 18 March 1989

ISSN 0091-7338
ISBN 089468-143-5

This publication was produced by the Editors Office, National Gallery of Art, Washington
Editor-in-chief, Frances P. Smyth
Printed by Garamond Pridemark Press, Inc., Baltimore, Maryland

The text paper is 80 pound LOE Dull text with matching cover
The type is Trump Medieval, set by BG Composition, Baltimore, Maryland

Distributed by the University Press of New England, 17¹/₂ Lebanon Street, Hanover, New Hampshire 03755

Cover: Detail, George Bellows, *Shore House*, 1911. Collection of Rita and Daniel Fraad

Dimensions are given in centimeters followed by inches, with height before width and depth

Contents

Preface

This volume of *Studies in the History of Art* documents a twin program of lectures jointly sponsored by the Center for Advanced Study in the Visual Arts, National Gallery of Art, and the Metropolitan Museum of Art, and held in Washington on 4 March 1989 and in New York on 18 March 1989. The purpose of this linked series was twofold: to present current research in the history of art of the United States around the year 1900, and to honor the memory of Daniel Fraad, admired, along with his wife Rita Fraad, as an early collector of American paintings and drawings created during the late nineteenth and early twentieth centuries.

The impetus for this program came from Mr. and Mrs. Raymond J. Horowitz of New York, who are also collectors of American art and close friends of the Fraads. The Center for Advanced Study and the Metropolitan Museum are grateful to Mr. and Mrs. Horowitz for their support of the program, and for their additional contribution toward the publication of the papers. The program was formulated by Doreen Bolger, former curator of American paintings and sculpture and manager of the Henry R. Luce Center for the Study of American Art at the Metropolitan Museum of Art and now curator of paintings and sculpture at the Amon Carter Museum, and by Nicolai Cikovsky, Jr., curator of American art at the National Gallery of Art, who together also generously agreed to edit the papers for publication and to write the introduction. The Center for Advanced Study would like to express appreciation to John K. Howat, chairman of the department of American art at the Metropolitan, and John Wilmerding, former deputy director of the National Gallery and now professor of art history at Princeton University, for their interest in and support of this lecture program.

This publication forms part of a separate series of *Studies in the History of Art* designed to document scholarly meetings held under the auspices of the Center for Advanced Study in the Visual Arts and to stimulate further research. A complete listing of published and forthcoming titles may be found on the opening leaf of this volume. Many of these publications are the result of collaboration between the Center for Advanced Study and sister institutions, including universities, museums, and research institutes. *American Art around 1900* is the first such collaborative endeavor with the Metropolitan Museum.

HENRY A. MILLON
Dean, Center for Advanced Study in the Visual Arts

Introduction

Rita Fraad and the late Daniel Fraad began to collect American art during the late 1950s, when there were only a few other collectors, Arthur G. Altschul, the Meyer Potamkins, and the Raymond Horowitzes among them, who were drawn to this material. The Fraads collected American art of the late nineteenth and early twentieth centuries, generally works by the realists and impressionists who challenged the conventions of the academic establishment. The Fraad collection grew quickly during the early 1960s, and by 1964, when it was catalogued and exhibited at the Brooklyn Museum and the Addison Gallery of American Art, its distinctive character was already determined. Several significant paintings were added later, notably John Singer Sargent's *Venetian Street* and George Bellows' *Shore House*, both focal points of essays in this volume, but these and other more recent acquisitions reflected the interests and tastes displayed by the Fraads from the start.

Many of the pictures in this collection are familiar to us, for the Fraads, always great supporters of scholarly work in American art and, in particular, of the role played in the field by museums and their curators, have lent generously to many exhibitions over the years. In 1985, twenty-one years after its first exhibition, their collection was shown at the Amon Carter Museum, accompanied by a catalogue that is the most complete record of the American paintings, drawings, and watercolors the Fraads chose to bring together for their, and our, enjoyment.

This volume of *Studies in the History of Art* celebrates the Fraads' achievement as collectors with the publication of six lectures presented jointly by the National Gallery of Art and the Metropolitan Museum of Art on 4 and 18 March 1989. The inspired idea for such a collaborative effort as a memorial to Daniel Fraad came from Mr. and Mrs. Horowitz, close friends of the Fraads. We are most grateful to the Horowitzes, not only for their generous support of the event, but also for their constant encouragement at every phase of the undertaking.

By design the speakers chosen for the program were all museum curators, largely from the institutions closest to the Fraads as they built and shared their collection. The subjects for the lectures were developed around major artists and important examples in the collection. The speakers were encouraged to see these painters and paintings with a fresh eye and to apply the findings of recent scholarship to their interpretations. Prepared independently and with no attempt at comprehensiveness or even consistency, the lectures cover much of the tumultuous period represented by the Fraads' collection—from Winslow Homer and Thomas Eakins to Everett

Shinn and George Bellows. More important, they address many of the central concerns—artistic, philosophical, and thematic—embodied in the collection.

From the late nineteenth to the early twentieth century, American painters were conscious, even self-conscious, of their relationship to convention and tradition and struggled to redefine that relationship. All except Winslow Homer spent their formative years in art academies, whether in Paris at a school such as the Ecole des Beaux-Arts or in one of its American counterparts. Even Homer, largely self-trained and inured to foreign influences, sought accommodation with academic convention in different ways throughout his career. In the 1860s, while he concentrated on highly original works innovative in their organization and treatment, his drawings suggest that he developed ideas for ambitious but rarely executed paintings. By the 1880s, however, his completed paintings reveal his fascination with convention and artistic tradition in their large scale, studied compositions and narrative structures, and careful surface finish. By the same token, Theodore Robinson admitted in 1893 that he had "too much ignored old art" and praised a painting by his friend J. Alden Weir as "modern yet curiously mediaeval in feeling. . . . one feels Durer would have painted it that way." Thomas Eakins, in so many ways committed to the academic practices he had learned at the Ecole, consistently used oil sketches, photographs, and studio accoutrements such as rag figures to assemble compositions synthetically in the studio. Yet he too flirted with painting out-of-doors, and his work, like that of so many of his contemporaries, cannot be easily labeled.

Once the continuity of tradition is recognized in the work of these artists, another very different factor must also be acknowledged—their modernity. As Bellows put it in 1920, "There is no new thing proposed, relating to my art as a painter of easel painting, that I will not consider." These were artists who sought inspiration in other progressive painters (Robinson in Monet, Everett Shinn in Edgar Degas, Bellows himself in Robert Henri); in the use of modern means (for example, Eakins in photography and Bellows in compositional dynamics that emphasized the flatness of the picture surface); and all, most noticeably, in the depiction of modern life, often life as it unfolded in a highly personal world. Thomas Eakins' landscapes, like his figure paintings, are filled with his family and friends. American impressionists—Weir, Twachtman, and Robinson—painted mostly places of personal, not topographical, significance: their own farms and the surrounding countryside, coastal villages, and shore resorts where they taught *plein air* painting or simply vacationed.

The artist's presence, the physicality of his touch and the expression of his mind and emotions, is also felt strongly in works in the Fraads' collection. Some of the lectures explore the autobiographical implications of these works, often with challenging results. John Singer Sargent's figure paintings, whether they show nameless Italian peasants or family members and friends, reveal the artist's sexuality in highly charged works that belie his image as a facile painter of society portraits. George Bellows, often characterized as a "pure" painter with a rather objective eye, displayed a broad and deep range of emotions in *Shore House*, painted on his honeymoon at desolate Montauk. These painters and the works they created prove Bellows correct in his assertion that "a picture is a human document of the artist."

DOREEN BOLGER
Amon Carter Museum

NICOLAI CIKOVSKY, JR.
National Gallery of Art

American Art around 1900

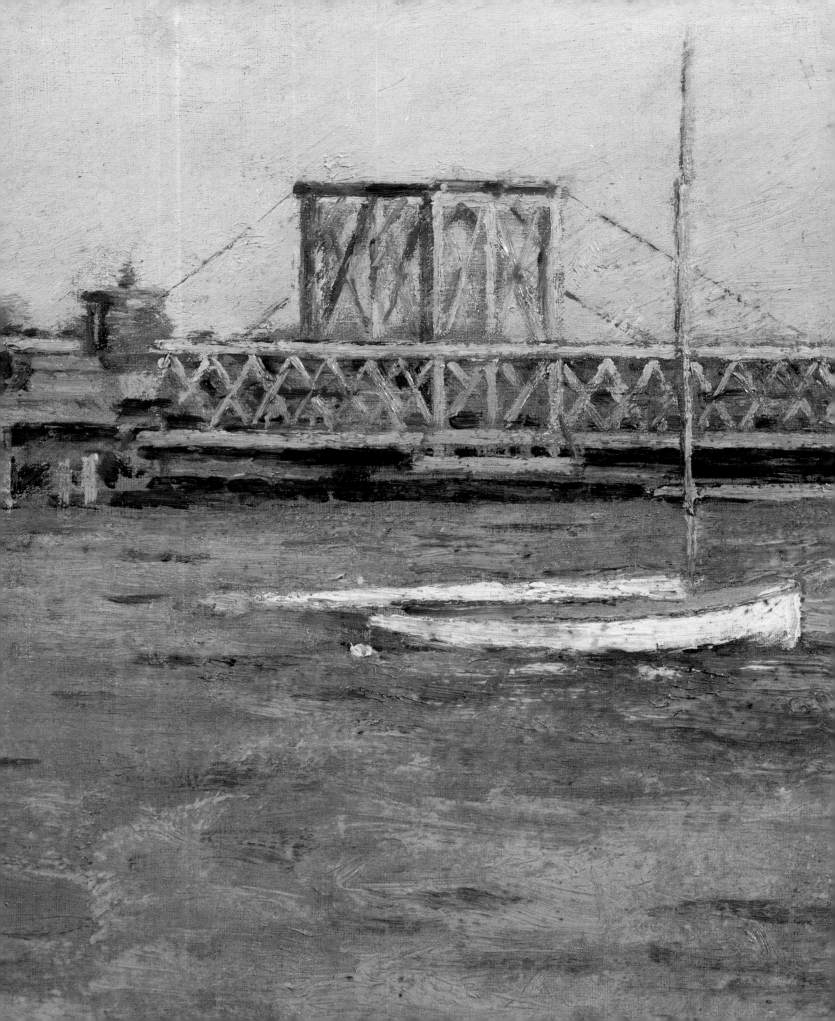

DOREEN BOLGER
Amon Carter Museum

American Artists and the Japanese Print:

J. Alden Weir, Theodore Robinson, and John H. Twachtman

Japanese art, particularly the woodblock print, has long been assumed to be an important influence on the American impressionists.[1] This is hardly surprising, since the French painters who inspired the American movement had already discovered Oriental art and absorbed its influence. In 1854 Commodore Matthew Perry had reopened commerce with Japan, and by the 1860s Japanese art was exported to the West. In Paris, there was a display of Japanese art at the Universal Exposition of 1867, and in the ensuing decades French painters expressed their enthusiasm for things Japanese, first by including Japanese costumes and accessories in their paintings and then by incorporating the unconventional colors and compositions of Japanese prints into their art.[2] In fact, when French impressionist paintings were first shown in New York in large numbers at the American Art Association and the National Academy of Design in 1886, the connection between these paintings and the Japanese print was acknowledged. In the catalogue that accompanied this important exhibition, the French writer Theodore Duret noted that the impressionists had borrowed their "bold and novel methods of coloring" from the Japanese.[3] American writers saw Japanese influence not only in the impressionists' palette, but in compositions that, as Theodore Child put it in 1887, reflected the Japanese interest in "novel aspects of nature."[4] Child saw a similar approach in the work of the impressionists, who "helped to broaden our view of reality, and to call attention to aspects of nature which had hitherto escaped the Western artist."[5] The American enthusiasm for Japanese art actually had preceded the introduction of impressionism, and some conservative art writers, such as the Bostonian William Howe Downes, objected to what they deemed a pejorative comparison between the two. Downes asserted: "There is as much resemblance between the Impressionists' pictures and any respectable Japanese work of art as there is between the music of a street band and that of the Boston Symphony Orchestra."[6]

The influence of Japanese art on Americans who took up impressionism during the late 1880s and early 1890s was soon recognized. In 1891 it was reported that no less an authority than Ernest Fenellosa "exult[ed] in numberless discourses on the increasing Japanese influence evident in the use of simple pure tints and unconventional composition."[7] The response to Japanese woodblock prints in particular can be seen in the work of three painters—J. Alden Weir, Theodore Robinson, and John H. Twachtman—all of whom became leading American exponents of the French style. Japanism is most evident in their work from 1893 to 1896, for among these artists only Twachtman seems to have

made an enduring commitment to the style. Ironically, Japanese woodblock prints appear to have had the greatest influence not on these artists' graphic works, but on their oil paintings. This made the impact of Japanese prints more apparent: the decisive contours and flat areas of color that were a natural outgrowth of the medium and techniques of Japanese woodblock prints seem more exaggerated when translated into the medium of oil painting.

In light of the pervasive influence of Japanism on American decorative artists and the presence of so many Japanese objects in American domestic interiors, including artist's studios, during the 1870s and 1880s, the influence of Japanese woodblock prints on the American impressionist painters was belated.[8] Certainly, these three American impressionists, Weir, Twachtman, and Robinson, must have known about Japanese prints during this period. During the early 1880s Robinson did decorative work with John La Farge, whose early familiarity with things Japanese is now thoroughly documented;[9] Weir knew the Japanese importer Heromichi Shugio during the early 1880s, when they were both members of the Tile Club, and he even visited James McNeill Whistler, that consummate enthusiast of things Japanese, in London; Twachtman, who was in Paris from 1883 to 1885, could hardly have avoided familiarity with Japanese prints.

Why did Japanism emerge as a force at just at the moment it did, during the early 1890s? In general, it seems that the response of these painters to Japanese woodblock prints was strongly conditioned both by their academic training and by their knowledge of French impressionism, particularly by the late date of their introduction to that style. By the 1880s, when French impressionism was imported to America, the original members of the impressionist group were moving away from the style that had been identified with their group. Many of the qualities of their later work—its flatness, its bold contours, and its emphasis on decorative pattern— were seen correctly by Americans as Japanese in inspiration. Moreover, American painters came to impressionism from an academic training, usually in the independent ateliers of Paris or the Ecole des Beaux-Arts, and, as a result, they continued to see their work as a part of the larger academic tradition. They especially valued draftsmanship, and the draftsmanly qualities of the old masters that American impressionists saw, somewhat curiously, in Japanese prints made them even more receptive to Japanism.

Weir, Twachtman, and Robinson were close friends and artistic comrades. They socialized together, painted together, and exhibited together, joining forces to gain adequate exhibition space for impressionist paintings at the Society of American Artists during the early 1890s.[10] The period of their greatest apparent interest in the Japanese print, 1893 to 1896, is bracketed by important events in the lives and careers of all three artists. Robinson returned permanently to New York from France at the end of 1892 and became increasingly entranced with the landscape of his native land. His role in the spread of impressionism in the United States had been a unique one. Between 1888 and 1892 Robinson had spent part of each year in France, at Giverny, where he worked closely with Claude

1. Theodore Robinson, *A Bird's-Eye View*, 1889, oil on canvas, 65.4 x 81.3 (25¾ x 32) Metropolitan Museum of Art, Gift of George A. Hearn, 1910 (10.64.9)

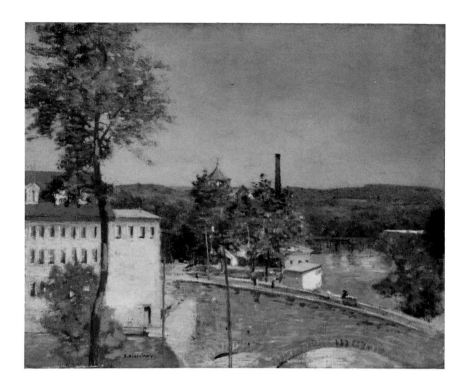

Monet—widely regarded by Americans as the leading French impressionist landscape painter—and painting in an impressionist style inspired by his mentor (fig. 1). As a result, Robinson became the messenger of new ideas, including Japanism, for he was a direct conduit between Monet and his less cosmopolitan friends back in New York. Not surprisingly, hints of Robinson's delicate pastel palette and the structured arrangement of the architectural forms he favored in his landscape compositions soon appeared in such paintings as Weir's *U.S. Thread Company Mills, Willimantic, Connecticut* (fig. 2) and *Waterfront Scene—Gloucester* by Twachtman (fig. 3).

J. Alden Weir had just passed through a difficult personal crisis in the early 1890s. Following the death of his wife Anna in 1892, he had traveled to Chicago to paint decorations at the World's Columbian Exposition, so that when he returned to New York and his easel paintings after a lengthy

2. J. Alden Weir, *U.S. Thread Company Mills, Willimantic, Connecticut*, c. 1893–1897, oil on canvas, 50.8 x 61 (20 x 24)
Mr. and Mrs. Raymond J. Horowitz

3. John H. Twachtman, *Waterfront Scene—Gloucester*, c. 1901, oil on canvas, 40.6 x 55.9 (16 x 22)
Mr. and Mrs. Raymond J. Horowitz

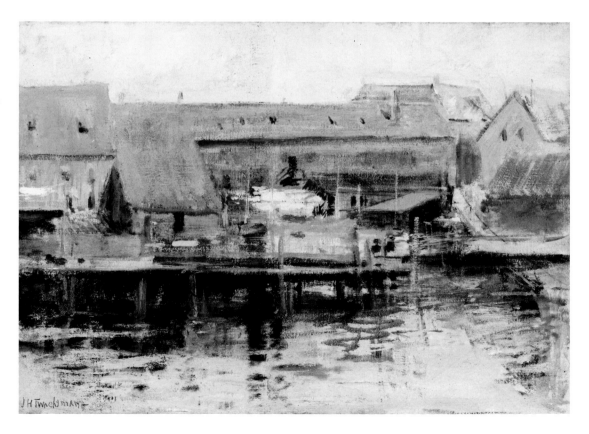

hiatus, he was ready for a fresh start and a new direction. That this new direction was impressionism soon became evident. In 1893, when he and Twachtman displayed their paintings at the American Art Association in a comparative exhibition with the work of Claude Monet and Paul Besnard, the French inspiration of their work was clear. Weir, already the most successful painter in his circle, served as the mainstay of his friends Twachtman and Robinson, offering the others stability and support. After remarrying in 1893, he made his home in the city and his Connecticut farm havens for his artist friends, among them Robinson, who was unmarried, in poor health, and still struggling financially, and Twachtman, whose fortunes had improved but who still faced difficulty in gaining critical and commercial support for his work.

The enthusiasm for Japanese woodblock prints that all three artists shared is recorded in the diary Theodore Robinson kept from 1892 to 1896. Robinson called Weir "Japanese-mad" and described him and Twachtman as "rabid" about Japanese prints.[11] Weir is known to have purchased prints from the international connoisseurs Siegfried Bing and Tadamasa Hayashi, as well as from the New York–based importer Heromichi Shugio. All three painters knew other artists who collected Japanese prints—Samuel Colman, Francis Lathrop, and Robert Blum, to name a few. Blum had worked in Japan from 1890 to 1892. Weir, Robinson, and Twachtman often visited him in his studio, where they saw paintings of Japanese subjects such as *The Ameya* (fig. 4), and it seems likely that their familiarity with examples from his print collection heightened their interest in Japanism.[12] Robinson and Twachtman spent long hours looking through Weir's collection of Japanese prints.[13] Robinson described Hiroshige's *Trout Fishing in the Tama River in Moonlight* (fig. 5), one of several prints that Weir acquired in trade for a drawing by Jean-François Millet, rather specifically as "a charming landscape—moon rising—a lake with fisherman—willows."[14] Robinson also reported on sales and exhibitions of Japanese prints at the American Art Association and Bous-

sod-Valadon Gallery in New York and at the Museum of Fine Arts in Boston, among other locations, and he mentioned fellow artists in attendance, often Weir and Twachtman.[15]

While little documentary information survives about Twachtman's introduction to Japanism, he may have been the first artist in this group to incorporate the aesthetic principles of Japanese art into his work. Certainly, *Arques-la-Bataille* (fig. 6), which he painted in Paris between 1883 and 1885, suggests his familiarity with Japanese prints such as Hiroshige's *Sumida River, Hashiba Ferry, and Tile Kilns*, (fig. 7) in its calculated arrangement of forms, including some reeds placed close to the picture plane; in its strong, often sinuous, contours; and in the areas of color broadly, almost flatly, applied in distinct bands. When Twachtman began to work in an impressionist style, probably during the winter of 1888–1889, the Japanese inspiration remained strong. His *Icebound*, c. 1889 (fig. 8), and Hiroshige's print *Ochanomizu Snow Scene* (fig. 9), once in Weir's collection, both depict frozen water or water

4. Robert Blum, *The Ameya*, c. 1893, oil on canvas, 63.7 x 78.9 (25¹/₁₆ x 31¹/₁₆)
Metropolitan Museum of Art, Gift of the Estate of Alfred Corning Clark, 1904 (04.31)

5. Hiroshige, *Trout Fishing in the Tama River in Moonlight, Famous Views of Snow, Moon, and Flowers*, woodblock print
Brigham Young University Museum of Fine Arts, Provo, Utah

6. John H. Twachtman, *Arques-la-Bataille*, 1883–1885, oil on canvas, 152.4 x 200.3 (60 x 78)
Metropolitan Museum of Art, Morris K. Jesup Fund, 1968 (68.52)

7. Hiroshige, *Sumida River, Hashiba Ferry, and Tile Kilns*, woodblock print, detail
Brigham Young University Museum of Fine Arts, Provo, Utah

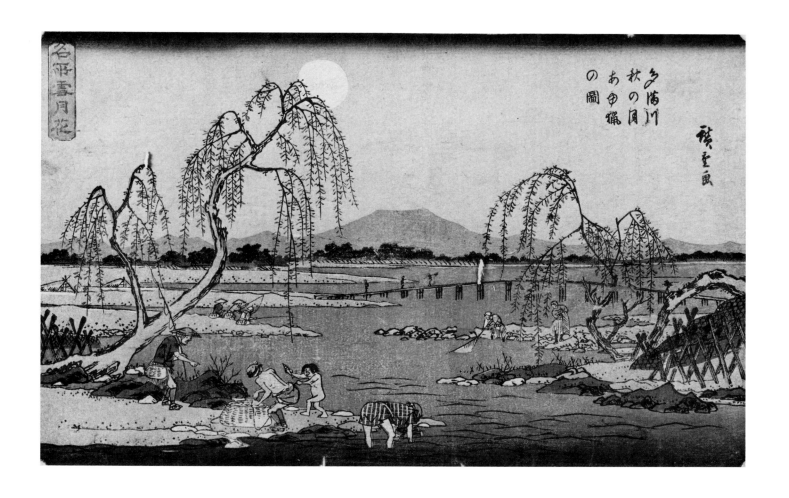

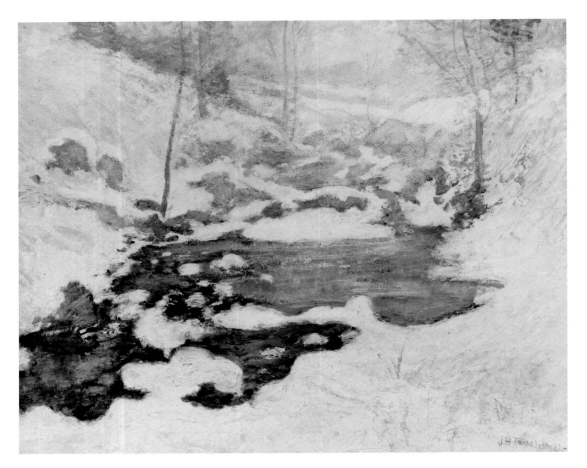

about to freeze, surrounded by snow receding diagonally to a raised horizon line. The strength of design and pattern in *Icebound* may well have been Oriental in inspiration. The scene is simplified and unified by the snow that has fallen, yet the artist has achieved a subtle pattern of rocks and shadows, ice and water, light and dark, all in a fairly restrained palette. During the 1890s Twachtman undertook two series of commissioned works representing Niagara Falls and the Yellowstone Falls. The powerful design evident in the Yellowstone painting, *Emerald Pool, Yellowstone*, painted around 1895 (fig. 10), may have been inspired by such woodblock prints as Hiroshige's *Fireworks over the Ryōgoku Bridge* (fig. 11). Actual landscape elements are virtually unrecognizable, viewed so closely and painted so broadly that they are reduced to flat shapes bounded by sinuous lines. Japanism had a sustained impact on Twachtman and, even after the

turn of the century, was perhaps one of the more crucial components in the development of his personal style. In a view from the porch of the Bush-Holley House in Cos Cob, painted around 1901 (fig. 12), Twachtman employs a number of devices evident in such woodblock prints as Hiroshige's *Lumberyard, Fukagawa* (fig. 13). The foreground elements are enlarged, placed close to the picture plane, and cropped along the bottom edge of the canvas. The distant view, which drops off precipitously from the foreground stage, is seen in part through a railing and a vine-covered trellis.

J. Alden Weir collected mainly nineteenth-century Japanese woodblock prints, often examples by Hiroshige and Hokusai, and by 1894, when he purchased a copy of Bing's *Le Japon Artistique* (1889), Japanism affected nearly every aspect of his work.[16] The Japanese influence seems to have first appeared in his graphic work.[17] His *Grape Leaves* of the early 1890s (private collec-

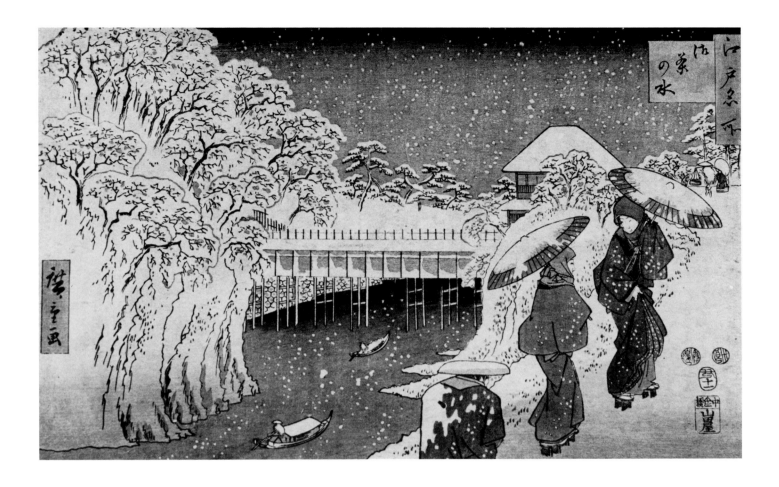

9. Hiroshige, *Ochanomizu Snow Scene, Famous Sites in Edo*, 1853, woodblock print
Brigham Young University Museum of Fine Arts, Provo, Utah

tion) recalls illustrations from Bing's book, such as *Squirrels on a Vine*.[18] Even more original drawings by Weir, such as *In the Hammock*, c. 1894 (fig. 14), executed in ink wash, recall the technique used in illustrations in Bing; the varied brushstrokes, often resembling dots and dashes, create a strong sense of pattern that nearly obscures the two girls at rest. Japanesque qualities are enhanced by cropping and asymmetry, as well as by pressing the elements close to the picture plane. Weir used similar compositional devices in such figure paintings as *In the Days of Pinafores*, c. 1893–1894 (private collection), and *Face Reflected in a Mirror*, 1896 (Museum of Art, Rhode Island School of Design).

Study of Japanese prints also made Weir more concerned about the design and structure of his landscape compositions, so that he was more inclined to choose scenes with strong focal points, such as buildings or bridges, and their geometric shapes to impart order and structure to his depictions of nature. *U.S. Thread Company Mills, Willimantic, Connecticut* (fig. 2), like Hokusai's print *Kintai Bridge, Suo Province* from the series *Wondrous Views of Famous Bridges in All Provinces*, c. 1831–1832, depicts a bridge beyond buildings and foliage which are pressed close to the picture plane. The delicate colors of Weir's palette, particularly soft pinks and lavender-tinted grays, the decisive contours, and even some areas of flat color that are modeled relatively little suggest additional ways in which Japanese woodblock prints affected his painting style in this period. Weir's most Japanesque landscape, *The Red Bridge*, c. 1895 (fig. 15), could easily owe its daring composition to another print from his collection, Kuniyoshi's *Twelfth Act, from the Japanese Kana copybook version of the "Chūshingura"* (fig. 16). As in the

Japanese print, the geometric bridge in Weir's oil is viewed from below through a screen of tree branches and foliage. The horizon is raised and the scene is reduced to a flat pattern of solid elements and carefully balanced reflections. *The Red Bridge* depicts an actual scene on the Shetucket River in Connecticut, but its painted appearance seems to result from Weir's study of Japanese woodblock prints.

Robinson must have seen Japanese prints while abroad, and back in New York he collected them, apparently with enthusiasm. At the end of January 1895, for example, he attended a sale at the American Art Association and at its conclusion reported his print purchases victoriously: "a total for the two nights of 31 for $126.50, pretty good for a poor man."[19] His painting, *Low Tide, Riverside Yacht Club*, 1894 (fig. 17), exemplifies the Japanesque style Robinson developed around 1894. Turning to Japanese woodblock print artists like Hiroshige for inspiration, Robinson reduced the contents of his pictures to their essentials: there are a few boats moored in shallow water at low tide, a few rocks scattered in the foreground, all carefully arranged to recede vertically to a high horizon line. The broken

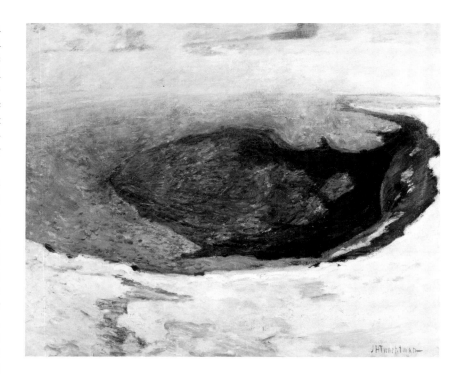

brushwork of his earlier paintings has been replaced by a broad, flat application of pigment. *Boats at a Landing*, 1894 (fig. 18), best exemplifies the simplification Robinson achieved through his experiments in Japan-

10. John H. Twachtman, *Emerald Pool, Yellowstone*, c. 1895, oil on canvas, 64.1 x 76.8 (25¼ x 30¼)
Wadsworth Atheneum, Hartford, Ella Gallup Sumner and Mary Catlin Sumner Collection

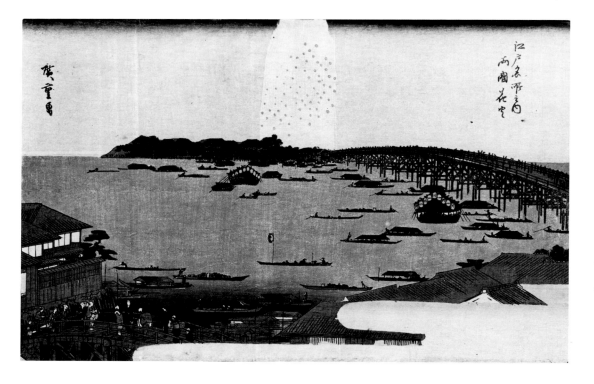

11. Hiroshige, *Fireworks over the Ryōgoku Bridge, Famous Views of Edo*, c. 1849–1850, woodblock print
Brigham Young University Museum of Fine Arts, Provo, Utah

12. John H. Twachtman, *Winter, Holley House, Cos Cob*, c. 1901, oil on canvas, 76.5 x 76.8 (30⅛ x 30¼)
Jordan-Volpe Gallery, New York

13. Hiroshige, *Lumberyard, Fukagawa, One Hundred Famous Views of Edo: Winter*, 1856, woodblock print
Brigham Young University Museum of Fine Arts, Provo, Utah

14. J. Alden Weir, *In the Hammock*, c. 1894, ink wash on paper, 24.1 x 24.8 (9½ x 9¾) (sight)
Private collection

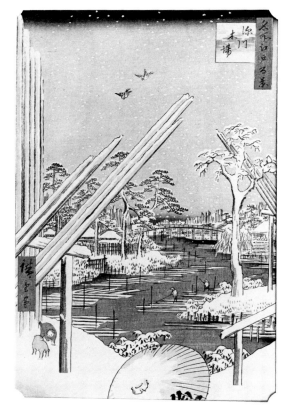

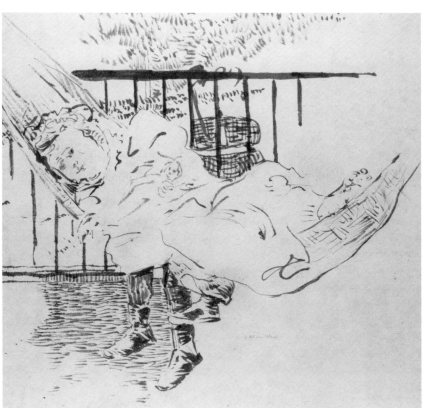

ism. In 1894, the year it was painted, Robinson asserted: "The Japanese work ought to open one's eyes to certain things in nature, before almost invisible and a new enjoyment, their infinite variety of compositions, their extraordinary combination of the convention and the reality."[20] In this sense Japanism seems to have made the greatest contribution to Robinson's own development. Whereas earlier in his career he strove to capture the transitory effects of nature—flickering sunlight or an overcast day in the French countryside—by 1894 he was tempering his observations of reality with the elegance of convention. In *Boats at a Landing* the strong vertical and horizontal lines of his composition—sand, bands of water and sky, the masts, the docks and pilings—are reinforced by his new, broader brushwork, a far cry from the loose, broken strokes usually seen in his work. All these features, the very "combination of the convention and the reality," conspire to make this austere painting a self-conscious rearrangement of observed

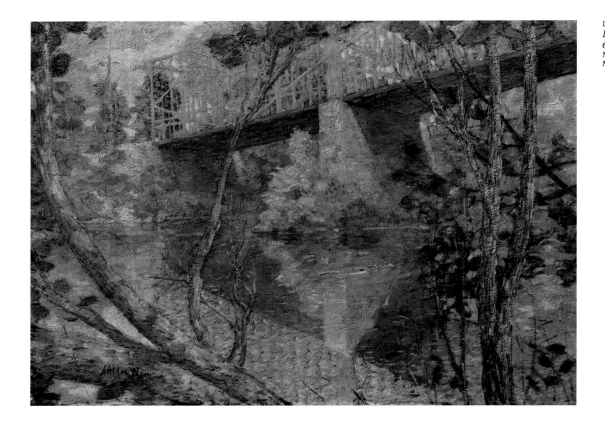

15. J. Alden Weir, *The Red Bridge*, c. 1895, oil on canvas, 61.6 x 85.7 (24¼ x 33¾) Metropolitan Museum of Art, Gift of Mrs. John A. Rutherfurd, 1914 (14.141)

16. Utagawa Kuniyoshi, *Twelfth Act, from the Japanese Kana copybook version of the "Chūshingura,"* 1854, woodblock print Private collection

17. Theodore Robinson, *Low Tide, Riverside Yacht Club*, 1894, oil on canvas, 45.7 x 61 (18 x 24)
Mr. and Mrs. Raymond J. Horowitz

18. Theodore Robinson, *Boats at a Landing*, 1894, oil on canvas, 47 x 55.9 (18½ x 22)
Mr. and Mrs. Meyer P. Potamkin

nature. Even when he worked from photographs, as he is known to have done, the images he drew from them were refined in the spirit of the *ukiyo-e* he admired.[21]

Robinson and his American contemporaries found the admirable aesthetic qualities of Japanese prints in the work of French impressionists. Robinson, who believed that Japanese art could "open one's eyes to certain things in nature," saw its influence in the paintings of Monet, who, he reported, took pleasure "in the 'pattern' often nature gives—leafage against sky, reflections etc."[22] For Robinson and other painters in his circle, the study of Japanese prints played a crucial role in the redirection of their efforts from depicting transitory, ephemeral effects and informally chosen motifs to compositions and subjects more consciously chosen and studied. In 1894 Robinson condemned the paintings exhibited at the annual exhibition of the Society of American Artists as "a lot of poor stuff . . . no end of worthless and insufficient studies and sketches of all sorts of things."[23] This dissatisfaction was undoubtedly fueled by earlier developments in French painting, particularly in the work of his mentor Monet.

In Giverny in June 1892, Robinson had recorded in his diary a conversation with Monet, who "regretted he could not work in the same spirit as once."[24] "At that time," explained Robinson, "any thing that pleased him, no matter how transitory, he painted, regardless of the inability to go further than one painting. Now it is only a long continued effort that satisfies him, and it must be an important motif."[25] Robinson turned to the principles of Japanese art to achieve the effects sought by Monet. As Robinson wrote in his diary on 17 February 1894: "My Japanese print points in a direction that I must try and take, an aim for refinement and a kind of precision seen in the best old as well as modern work. The opposite pole to the slapdash, clumsy . . . sort of thing."[26]

Ironically, Robinson planned to achieve this "refinement" through both innovation and tradition. Several months earlier, in November 1893, he had expressed the regret that "I have too much ignored old art, except such as *immediately* touches what I may be trying for the moment."[27] Surprisingly, it was the quality of "old art" that Robinson and his friends saw in the most Japanesque of their own oil paintings. In February 1894, he called one of Weir's Willimantic views, possibly *U.S. Thread Company Mills* (fig. 2), "modern and yet curiously mediaeval in feeling."[28] Robinson continued: "One feels that Durer

19. Theodore Robinson,
*Drawbridge—Long Branch Rail
Road, near Mianus*, 1894, 30.5
x 45.4 (12 x 17⁷/₈)
Collection of Rita and Daniel Fraad

would have painted it that way (perhaps the feeling is too apparent) but it is tremendously artistic, as is everything Weir puts his hand to. An avoidance of the commonplace, picturesque side of things . . . it is pictorial or perhaps decorative, in a severe . . . way."[29] Robinson's work of that same year, 1894, represented by *Drawbridge—Long Branch Rail Road, near Mianus* (fig. 19), reminded Weir of the seventeenth-century Dutch painter Peter de Hooch.[30] Both these analogies—Robinson's between Weir and Dürer, Weir's between Robinson and de Hooch—may seem strange to the twentieth-century eye, but they must be considered in light of what was engaging Robinson's and Weir's interest at this point in their careers. Their fascination with Japanese prints occurred within a context larger even than their response to impressionism. Robinson spent time studying Weir's old master print collection, which was considerable, and as Robinson reported in 1893, he and Weir "looked at a lot of Durers and others of his school."[31] In his effort to "aim for refinement and a kind of precision seen in the best old as well as modern work," Robinson combined working at Giverny with

Monet and visits to the Louvre, where he "looked at Ingres' portraits with much interest."[32] The American impressionists' devotion to both Japanese prints and the works of the old masters followed ideas already current in Europe. The French writer Louis Gonse, author of *L'Art Japonais* (1883), asserted that "the complete works of Hokusai would be the glory of any print collection and could be placed beside those of Rembrandt."[33] Vincent van Gogh called "even the most vulgar Japanese sheets colored in flat tones . . . as admirable as Rubens and Veronese."[34]

If the strong influence of the Japanese print on Weir, Twachtman, and Robinson is placed in its larger context, it demonstrates that Japanism was an aesthetic choice allied to many other considerations—not the least of which was these artists' heightened appreciation of draftsmanship, as seen in the "old art" of Dürer and Ingres. The enduring commitment to draftsmanship evident in the work of the American impressionists, once attributed to a native preference for the linear and conceptual, is actually multiple in inspiration, an artful blend of old and new, academic and avant-garde, and East and West.

NOTES

I am grateful to the Metropolitan Museum of Art for a travel grant that enabled me to pursue research for this essay. Lois Stainman, a volunteer, and Nancy Gillette, administrative assistant, both in the American Paintings and Sculpture Department at the Metropolitan, generously assisted with my research.

1. See, for example: William H. Gerdts, *American Impressionism* [exh. cat., Henry Art Gallery, University of Washington] (Seattle, 1980); and Gerdts, *American Impressionism* (New York, 1984).

2. For discussions of the influence of Japanese art on French artists, see: *Le Japonisme* [exh. cat., Musée d'Orsay] (Paris, 1984), with essays by Shûji Takashina, Geneviève Lacambre, Akiko Mabuchi, and Caroline Mathieu; and Colta Feller Ives, *The Great Wave: The Influence of Japanese Woodcuts on French Prints* [exh. cat., Metropolitan Museum of Art] (New York, 1974).

3. Theodore Duret, "The Impressionist Painters," in *Special Exhibition: Works in Oil and Pastel by the Impressionists of Paris* [exh. cat., National Academy of Design] (New York, 1886).

4. Theodore Child, "A Note in Impressionist Painting," *Harpers New Monthly Magazine* 74 (January 1887), 315.

5. Child 1887, 315.

6. William Howe Downes, "Impressionism in Painting," *New England Magazine* n.s. 6 (July 1892), 602.

7. Greta [pseud.], "Art in Boston," *Art Amateur* 24 (May 1891), 141.

8. For a discussion of the Japanese influence on American decorative arts, see Doreen B. Burke et al., *In Pursuit of Beauty: Americans and the Aesthetic Movement* (New York, 1986).

9. Henry Adams, "John La Farge's Discovery of Japanese Art: A New Perspective on the Origins of *Japonisme*," *Art Bulletin* 67 (September 1985), 449–485.

10. Weir and Twachtman were among those painters who seceded from the society in 1897 to establish the Ten American Painters; it seems inevitable that Robinson would have joined the group if he had not died in April 1896.

11. Theodore Robinson diary, 6 January 1894; 10 December 1893, Frick Art Reference Library, New York. I am grateful to the Frick for granting me access to this important document.

12. Robinson diary, 14 January 1893; 25 November 1893. Blum's collection of Japanese prints is now in the Cincinnati Art Museum.

13. Robinson diary, 30 November 1893.

14. Robinson diary, 11 February 1894.

15. Robinson diary, 31 October 1893; 16 February 1894; 14 April 1894; 28 January and 30 January 1895.

16. See Doreen Bolger Burke, *J. Alden Weir: An American Impressionist* (Newark, Del., 1983), 202–216.

17. A recently discovered drawing in this style (Kennedy Galleries, Inc., New York) is dated 1890.

18. Burke 1983, 203.

19. Robinson diary, 31 January 1895.

20. Robinson diary, 17 February 1894.

21. See John I. H. Baur, "Photographic Studies by an Impressionist," *Gazette des beaux-arts*, ser. 6, 30 (October 1947), 319–330.

22. Robinson diary, 17 February 1894.

23. Robinson diary, 1 March 1894.

24. Robinson diary, 3 June 1892.

25. Robinson diary, 3 June 1892.

26. Robinson diary, 17 February 1894.

27. Robinson diary, 30 November 1893.

28. Robinson diary, 27 February 1894.

29. Robinson diary, 27 February 1894.

30. Robinson diary, 26 November 1894.

31. Robinson diary, 16 February 1893.

32. Robinson diary, 27 November 1892.

33. Louis Gonse, *L'Art Japonais* (Paris, 1883), 2:354–355, quoted in Ives 1974, 13.

34. Van Gogh, letter no. 542, quoted in Ives 1974, 11.

TREVOR FAIRBROTHER
Museum of Fine Arts, Boston

Sargent's Genre Paintings and the Issues of Suppression and Privacy

Two paintings by John Singer Sargent (1856–1925) in the collection formed by Rita and Daniel Fraad—*Venetian Street* and *Group with Parasols*—are my point of departure in appealing for a study of Sargent's work as a whole, rather than as a group of separate activities dominated by portraiture, but also including genre and landscape painting and mural decoration. Such an integrated approach to the work offers the richest understanding of Sargent as a person. Separated by a period of about twenty-five years, the canvases (figs. 3, 13) belong to distinct phases of Sargent's career: his flirtation in early 1880s Paris with moderately progressive attitudes to art and his later sustained triumph as a bravura painter at the heart of Edwardian London's art establishment. A superficial comparison of the two pictures might suggest a development from insinuating monochromatic atmosphere to robust and colorful sunlight and a growing attraction to the lyrical potential of the loaded brush and the abstraction implicit in the lights and darks of well-organized composition. Indeed, such generalizations prevail in the Sargent literature. They fuel the restrictive approach to his genre paintings as a separate category of paintings produced under the informal working conditions of his "private world" as opposed to the social rigors of his portrait studio.[1]

Sargent's great-nephew, Richard Ormond, characterized the later landscapes and figure works as "off duty" productions, writing: "[They] are primarily vehicles for statements about color and light, and even paint itself. . . . The descriptive aspects of the subject are much less important than the realization of certain pictorial ideals."[2] In 1986 Patricia Hills dubbed Sargent "an intellectual tourist permanently on holiday" and described his outlook in terms of the Marxist social theory of "spectacle" (which T. J. Clark had used in discussing the art of Manet a year earlier).[3] To quote Hills, Sargent's post-1906 subject pictures are "the *fêtes galantes* of the era. . . . The bright sunlight creates a sensuousness of surface, and the ensuing spectacle deflects any concern for what might be a deeper, intrinsic meaning. . . . [What he] wanted to see was not reality, but the holiday, aestheticized world [of the day]."[4] But these approaches are unhelpfully narrow: one says that the subject is unimportant, the other says that Sargent, because of his social conditioning, is incapable of making meaningful statements, political or otherwise. Both imply that no major insight can be gained from a detailed consideration of the genre pictures and the motivations behind them. Making a special case for them as "private" works, like the habitual scholarly isolation of his

Detail fig. 13

American mural decorations, deters holistic considerations of Sargent and of his work.

The myth of Sargent's "off duty" work fails to stress that his idea of a holiday was virtually nonstop painting and that the fruits of his "private" labors were often exhibited and sold to the advantage of his very public career. If any category of Sargent's work deserves to be called private, it is the overtly sensual male nudes that he never exhibited. I will not construct a pyramid of assumptions about aspects of his personality that Sargent may have kept hidden, but I take it for granted that a homoerotic sensibility is visually evident in his work. Indeed, this assumption provides more insight into the art, and thus the man, than does ignoring his nature or skewing it by seeing him as an asexual bachelor, or married to his work, or just as a mystery. These euphemisms are too readily applied to avoid confronting historic figures directly. Many details of Sargent's own private world—his preoccupations when he was *not* seated before a sheet of watercolor paper or a canvas—are lost to us. Even though his executors and his two sisters saved every scrap of a drawing or painting from his hand, generously distributing many works to museums, they apparently destroyed the correspondence and papers in his studios. One wonders if those materials included the album that he showed to a young American man during a 1922 sitting for a charcoal portrait: an "enormous scrap album, filled for the greater part with photographs and reproductions of aboriginal types the world over."[5]

I want to explore privacy, as a propriety, and suppression, for fear of losing status, as they affected Sargent's dealings with people, including his general art world acquaintances, his portrait subjects, and those unidentified "subjects" of his genre paintings. Both issues arose when Sargent and these people confronted the businesslike facade the artist used for protection and control when confronting clients, critics, and the public; the respect the sitter required of the artist for their joint public venture; the insightful revelation expected of any portraitist considered great; the contrast between the publicity and lionization engendered by Sargent's careerism and his innate shyness; the private moments in other people's lives that he wanted to deliver to a public audience in his nonportrait works; and the hidden, if not suppressed, nature of similar private moments in his own personal life.

Genre work entered Sargent's career as soon as he had completed his professional training in Paris, for he submitted several examples to the juried Salon exhibitions. Characteristics that are perhaps more familiar in his later nonportrait works can be observed in fact in his early projects for the Salon: *languor and repose*, ideals that Sargent the sketching onlooker or voyeur savored in foreign races and encouraged among his holiday entourage; *sensuality*, which occurs in the two main examples of this essay as a Venetian flirtation scenario and in the body language of well-heeled Edwardian picnickers; and *dramatic presentation of the subject*, aided by such formal devices as bold diagonals and sharp perspectives.

Sargent's first genre work for the Salon, *The Oyster Gatherers of Cancale* (exhibited in 1878, Corcoran Gallery of Art) was a carefully planned affair, involving a sojourn in Brittany sketching local people he paid to model. Executed in his Paris studio from these studies, the Salon entry depicts a peasant group straggling to the sea from the harbor rampart in a sharp diagonal. They were in no hurry to get to work, according to Sargent. The urban bourgeois audience for such paintings savored imagery of preindustrial life and the ethnic picturesque. Patricia Hills has observed that Sargent saw with "the eyes of a passing tourist."[6] This comment, however, does not credit the degree to which Sargent the realist scrutinized the peasants, their movements, and their locale, and it fails to indicate that he remained considerably less mawkish in his observations than most tourists and most Salon artists of *le juste milieu*. His imagery conformed to the prevailing interest in the touristic, but his choice and interpretation of subjects bore the stamp of his personality. We should consider the kinds of people and behavior that attracted him; and in so doing we

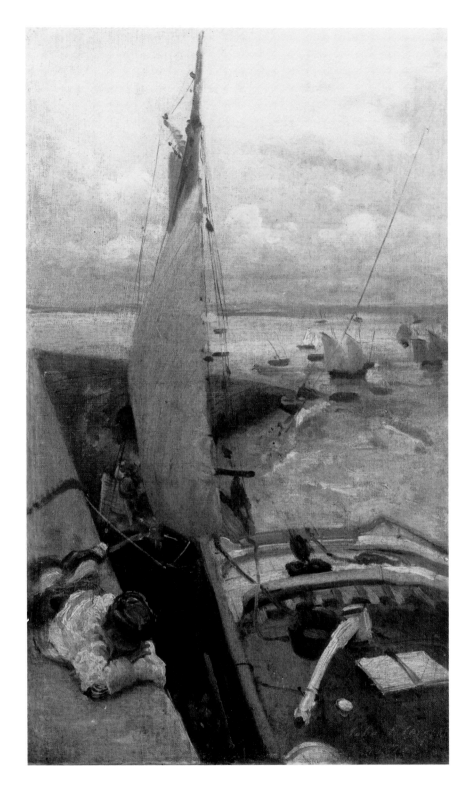

1. John Singer Sargent, *Low Tide at Cancale Harbor*, 1877, oil on canvas, 47.7 x 27.9 (18¾ x 11)
Museum of Fine Arts, Boston

work be brown-haired in the smaller, slightly less bright version of the same composition that he shipped to a New York exhibition that same spring.[7] Depending on the occasion, the final look of the picture could be more important to him than the objective truth of details such as a model's hair color.

Low Tide at Cancale Harbor is a small sketch made in situ and apparently never exhibited by Sargent (fig. 1). It shows clearly those aspects of his genre work that concern me here. A youth sleeps or daydreams at the quay's edge, his relaxed body given prominence through its alignment with the major diagonals of the composition. Sargent expresses a mood of sad and quiet longing with exquisite grays and browns, cloudy weather, low tide, and a wistful figure aligned with a boat (which one might see as a symbol of escape). One wonders if this early instance of a distracted reclining person is not already the expression of something wanting in the life of the twenty-one-year-old artist. A similar mood recurs in the oil painting *Boys on the Beach* (1879, Sterling and Francine Clark Art Institute). The low vantage point of this sunny Neapolitan scene places the artist on the level of the two naked boys lying on their backs. Conceivably as a child he knew little of such carefree moments, which may be one of many reasons why he focused on them so often in paintings and watercolors. According to Stanley Olson (the biographer recently chosen by the descendants of Sargent's youngest sister Violet [Mrs. Francis Ormond]), the artist's mother was "wilful . . . spoiled . . . and driven by a strange abstract dissatisfaction," while his father, a doctor, was "taciturn," "extremely careful and vigilant."[8] There was the added complication of his unmarried younger sister Emily, who grew up deformed and inevitably hypersensitive as a result of a twisted spine. Home life must have been psychologically oppressive, and it is reasonable to assume that Sargent's greatest pleasure became the continual travel to which his mother subjected the family.

Sargent's rise to prominence at the Paris Salon depended as much on genre painting as on portraiture. Searches for imagery

must be prepared for added complications resulting from his overriding concern with final aesthetic effect. For example, he was happy to have the blond boy in the Salon

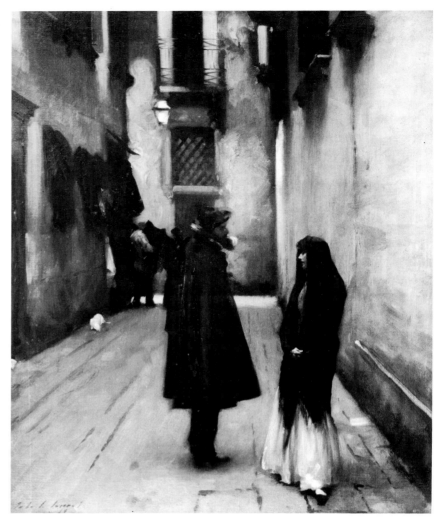

with which to make a bigger splash each successive year took him away from his parents and sisters for extended periods. Both *Fumée d'Ambre Gris* (exhibited in the Salon of 1880, Sterling and Francine Clark Art Institute) and *El Jaleo* (exhibited in the Salon of 1882, Isabella Stewart Gardner Museum) evolved from the same five-month trip to Spain and Morocco. The former shows in the sunlit privacy of a courtyard the ritual of a North African woman inhaling and perfuming herself and her clothes with intoxicant ambergris. The latter captures the ecstatic climax of a Spanish dancer and her musical accompanists, dramatically intensified by the glare of the cabaret footlights. Both distilled his observations of the otherness of foreign races and cultures, following the pattern of much of his genre work. Compared with the Brittany beach scene exhibited in 1878, *Fumée d'Ambre Gris* shows Sargent's new attraction to aestheticism, which is particularly evident in the strict refinement of the predominantly white palette.

Sargent's 1880 Moroccan sketches include works such as a study of empty white-walled streets enlivened by the play of light and shadow (fig. 2). Having just studied and copied Velázquez at the Prado, he worked his pigment fluently and relished subtle color effects. Tetuan pleased him as an "odd town" of "little white tortuous streets," and he wrote to a friend: "The aspect of the place is striking, the costume grand and the Arabs often magnificent."[9] Precisely such an enclosed maze also inspired him in Venice during two vis-

its in the early 1880s (probably late September 1880 through February 1881 and June through October 1882).

His main Venetian themes were alley scenes with suggestive exchanges between men and women and views of hallways in an old palazzo where women leisurely strolled and chatted and strung beads. He emphasized the spatial dynamic of these long narrow spaces and the dramatic light effects they engendered. The lighting phenomenon he painted in Venice reversed that of the Tangier streets, for he articulated shafts of sunlight caught between dark, richly textured, and somber colored walls, as opposed to the play of luminous shadow across bright white Moroccan stucco. Italy was far more familiar to him than Morocco, and he spoke the language

2. John Singer Sargent, *White Walls in Sunlight, Morocco*, 1879–1880, oil on wood, 26 x 34.9 (10¼ x 13¾) Metropolitan Museum of Art

3. John Singer Sargent, *Venetian Street*, 1880–1882, oil on canvas, 73.7 x 60.3 (29 x 23¾) Collection of Rita and Daniel Fraad

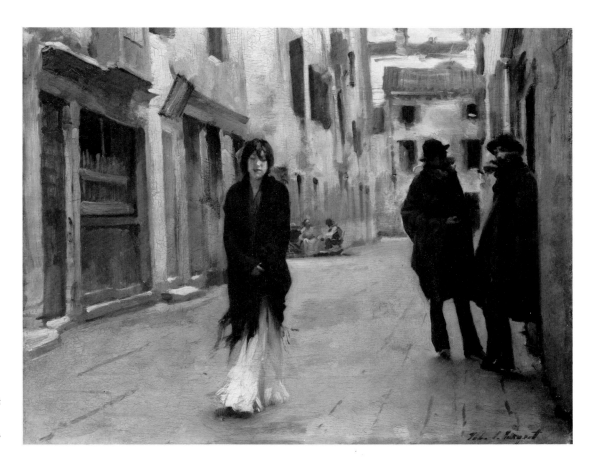

4. John Singer Sargent, *Street in Venice*, 1880–1882, oil on wood, 45.1 x 53.9 (17³/₄ x 21¹/₄) National Gallery of Art, Washington, Gift of the Avalon Foundation

fluently. Nonetheless, he chose to depict Venetian subjects that were provocative to conventional taste. He avoided sunny settings and stereotypical depictions of the local urban poor as colorful, picturesque, lazy, and childlike. He painted young Venetians of his age, whom he had watched conducting their lives and their amorous exchanges naturally and openly. Perhaps with a certain envy he saw that in their daily lives they were as in touch with their senses and as free with their emotions as the Spaniards of *El Jaleo* in their music and dance. He may have thought the Venetians fortunate to be able to mix work and pleasure easily and to live in a city infused by visual and emotional drama. A variety of social exchanges captured his attention: a man and woman turning to talk to each other in the street (fig. 3); a woman observed by two men on the street (fig. 4); a man apparently following a woman into a tavern (*Venetian Street Scene*, 1880–1882, Sterling and Francine Clark Art Institute);

and a man and a woman sitting smoking together, presumably having drunk from the wine bottle and broken the glass visible at their feet (*The Sulphur Match*, 1880–1882, private collection). The latter work reveals the fact that Sargent adored the gusto with which this man and woman lived. No member of his social circle would publicly lean back in a chair in the uncouth manner practiced by the Venetian woman. Her body is totally relaxed, and even her hand touches the wall with extraordinary poise and implied boldness. (A similarly relaxed body and expressive hand painted about seven years later belong to the man lying in the boat in fig. 10.)

As with his earlier genre pictures Sargent used models in Venice. He devoted at least one sheet of drawings to the man always seen wearing a fur-trimmed cloak and a low-brimmed hat (fig. 5). I assume the model is a Venetian of the same class as the women he is seen with, but he might also be a bohemian figure in the artist's

circle. In his Venetian pastel, *Riva degli Schiavoni at Sunset* (1880, Fogg Museum of Art), James McNeill Whistler (1834–1903) featured a solitary, mysterious man with similar facial features, wearing a hat and a fur-trimmed cape and standing at a gondola mooring. This particular image does not cause the viewer to doubt that the man and his costume are any less Venetian than the shapely boats and spectacular sunset behind him. Details about the people who modeled for Sargent's Venetian street scenes await scholarly clarification, but I doubt that knowing more about them will alter radically these paintings' narrative ambivalence. Their fascination lies in our not being sure whether the people depicted know each other and whether their encounters are innocent or not.

The drawings of the caped man (fig. 5) raise the possibility that Sargent may have added figures to paintings of empty streets that he had already completed. The physical evidence of the paintings seems to confirm this, because certain thickly painted sections of the background continue underneath the figures. In *Venetian Street* (fig. 3), for example, the horizontal brushstrokes that render the brightly lit section of pavement at the end of the alley do not stop on either side of the male figure; close examination shows that they continue uninterrupted beneath his cape. It also appears that preliminary drawings of one model (as in fig. 5) gave Sargent the later option of suggesting more than one character in a given painting. For example, the two caped men in *Street in Venice* (fig. 4) seem to be depictions of the same person. At least two empty Venetian street scenes by Sargent survive—a rather dark oil painting (private collection) and a watercolor (fig. 6). Both remained in the artist's collection during his lifetime. He had developed his compositional treatment of such spaces sketching deserted Tangier streets early in 1880 (fig. 2). But these moody, skyless Venetian examples are almost claustrophobic as urban landscapes, and, as beautiful as they are, one wonders whether Sargent had planned to populate them later with Venetian people, thereby making them genre works.

On arrival in Venice in the fall of 1880

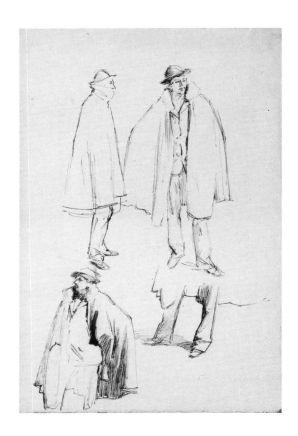

5. John Singer Sargent, *Studies for Venetian Street Scenes*, 1880–1882, pen and ink on paper, 34.9 x 23.5 (13¾ x 9¼) Collection of Rita and Daniel Fraad

Sargent encountered two slightly older London-based artists of different persuasions: Whistler and Luke Fildes (1843–1927). He was much more attuned to the former's unconventional and antinarrative tonalism than the latter's cheerful distillation of the picturesque. Whistler, in the aftermath of bankruptcy proceedings, was in Venice to execute the now-famous portfolio of etchings commissioned by the Fine Art Society, London. The composition of *The Beggars* (fig. 7), an image from Whistler's "First Venice Set," anticipates the tunnellike spaces that appealed to Sargent. The aesthetic savoring of Venetian architectural decay evident in the etching was frequently echoed in Sargent's early 1880s paintings. But Whistler's use of the indigent poor as subjects (an older woman and a child) cannot be found in Sargent's works, which focus on sensuous young adults. In this respect alone Sargent comes closer to Fildes than Whistler. Fildes' *An Al-fresco Toilet* (fig. 8) typifies the pictorialism of most European and American

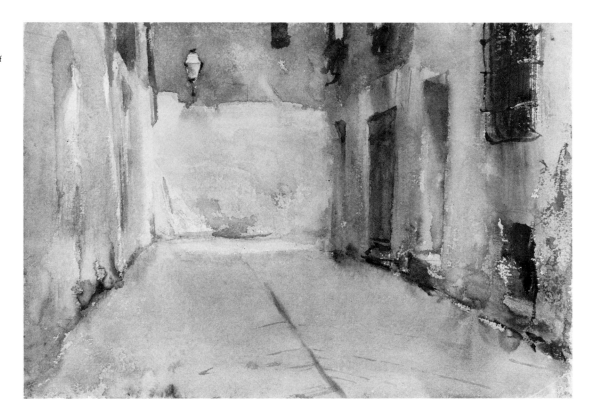

6. John Singer Sargent, *Venice*, 1880–1882, watercolor on paper, 25.1 x 35.6 (9⁷/₈ x 14) Metropolitan Museum of Art, Gift of Mrs. Francis Ormond, 1950

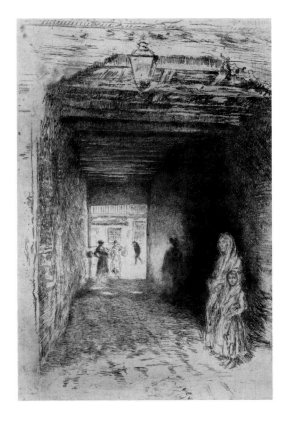

7. James Abbott McNeill Whistler, *The Beggars*, 1880, etching (state VII), 30.5 x 21 (12 x 8¼) National Gallery of Art, Washington, Gift of Mr. and Mrs. J. Watson Webb in memory of Mr. and Mrs. H. O. Havemeyer, 1943

paintings of lower-class Venetians in the 1880s: the subjects resemble so many exotic birds in a fabulous setting. Fildes clearly chose to paint Italy in a holiday frame of mind, because his greatest contributions to British art make trenchant moral statements about situations such as homeless families queuing outside a workhouse, as in *Applicants for Admission to a Casual Ward* (1874, Royal Holloway College, University of London). We do not know Whistler's opinion of Sargent's earliest Venetian works, but Fildes remembered them vividly after a visit to the young American's Venetian studio (probably late in 1880): "His color is black, but very strong painting."[10]

At approximately the same time in Germany, Max Liebermann (1847–1935) was making a painting based on earlier sketches of an Amsterdam orphanage: the dramatic walled perspective of his composition (fig. 9) bears comparison to both Whistler and Sargent. He painted in a broad, fluent style similar to that of Sargent, but if one

contrasts their work it becomes clear that Liebermann painted mostly for the effect of paint as paint, and his observations of details were less acute than Sargent's. Nonetheless, both artists were responding independently to similar mixtures of modern and historicist trends. Immediately before going to Venice in 1880 Sargent had visited Holland, primarily to study and copy Frans Hals portraits. But while there he probably took the opportunity to see a variety of art, from the recent landscape and genre work of the Hague School to painters contemporary with Hals. For example, the early courtyard scenes of Pieter de Hooch (outdoor genre pictures with orderly, uncluttered compositions) bear a formal resemblance to Sargent's Venetian street scenes. For a fuller contextual understanding of such Sargents they should be examined in the light of all the work that he would have been aware of as a painter of such a subject, ranging from seventeenth-century Dutch and Spanish masters of portraiture and genre painting to the various "schools" of figurative painting (Dutch, Spanish, Italian, German, French, and British) of the 1870s. Those instances with strong formal and substantive connections will then illuminate his careful and inquisitive sampling, which was manifested in a style whose eclecticism precludes radicality, while conveniently camouflaging its conventional underpinnings.

Despite all the sketches and small pictures Sargent made during the two 1880–1882 visits to Venice, he never produced from them the large Salon work he had planned. When he exhibited some of the Venetian street scenes and interiors in small group exhibitions in London and Paris in 1882 he learned from at least one critic that the settings, the people, and the mood were all too dismal to satisfy popular expectations of Venetian imagery.[11] However, the Venetian genre pictures benefited Sargent in at least three ways. First, the experience of painting such compositions and effects of light laid the way for his great Salon success of 1883, *The Daughters of Edward D. Boit* (Museum of Fine Arts, Boston). Second, the Venetian pictures were a success as painter's paintings: they

were much admired by Sargent's artistic associates and were often presented to them as gifts over the next decade. Finally, the decision not to use them for a large Salon work may have influenced his plan of showing only portraits at the Salon after 1882. The group portrait of the Boit children, followed in 1884 by *Madame X (Madame Pierre Gautreau)* (Metropolitan Museum of Art) confirmed his importance as a major portraitist. But the Gautreau portrait became a watershed in his career. It excited the French press for a few weeks, scandalized the subject, and taught Sargent a lesson about using a portrait commission as a Salon show-stopper celebrating the sensualism of the fashions of the Parisian demi-monde. Ironically, his first drawings in preparation for a portrait showed her not as an erect, haughty personage, but in indolent (and even sexier) reclining poses common in his genre works.[12]

In the wake of the Gautreau fiasco Sargent began a serious study of impressionism. He was cautious about where he exhibited the few experimental works that he completed. To avoid compromising the growing success of his portraits at large, widely reviewed exhibitions such as the Royal Academy Annual in London, he showed his *plein-air* experiments with less conspicuous, more progressive, and more Francophilic groups such as the New English Art Club. With typical eclecticism he emulated both Edouard Manet (1832–1885) and Claude Monet (1840–1926) and acquired works by both for himself. Eleven years after Manet painted Monet working in his floating studio (1874, Bayerische Staatsgemäldesammlung), Sargent painted Monet painting a hay field at Giverny (1885, Tate Gallery). In the landscape upper half of Sargent's *A Boating Party* (fig. 10), painted in the English countryside, his flickering touch was indebted to Monet. However, the firmly modeled execution of the foreground figures, which typifies Sargent's later genre works, was indebted to Manet (one might compare it with Manet's canvas, *The Monet Family in the Garden*, 1874, Metropolitan Museum of Art). His *Boating Party* demonstrates the continuity of the concerns I identified in his genre works. There is a strong diagonal (the side of the punt from which Sargent is sketching), and it intersects with a beautifully foreshortened figure of a lolling, fashionably dressed man, who called forth a great deal more of Sargent's skill and attention than his three women companions. William H. Gerdts has pointed out that few of Sargent's nonportrait impressionist works "substantially enhanced his reputation" and that this episode in his career was largely "a private affair."[13] But we should not overlook the fact that in the mid-1880s Sargent was excited by the cachet of mingling with a few of these French artists and dealers and being labeled as their "follower" by English and American critics.

By the end of the decade he was living in London, enjoying the first hard-won successes of his Frenchified portraiture in the comparatively conservative Anglo-American art markets. Moreover, he had

contracted to paint a mural decoration for the new Boston Public Library on the subject of pagan religion. In 1890 he traveled in Egypt and the Middle East gathering source material just as he would for a genre work. More secure in his professional success and less dependent on his standing in large annual exhibitions, he sketched what took his fancy. He completed a substantial group of drawings and oil studies, which for the most part did not leave his studio until dispersed by his executors. They are vignettes that emphasize architecture and costume in particular. In *Door of a Mosque* (fig. 11) Sargent centers himself directly before the pedestrian traffic in a sharply receding vista, creating an effect comparable to *Street in Venice* (fig. 4). When one considers his response to these people as characters in his drama, he is seen to be voicing the intrigue that such fully concealed bodies and faces can excite in Western viewers. In *Interior of a Bathhouse—Massage* he sketches a dark-skinned man massaging the chest of a man who appears to be Caucasian (fig. 12). For a foreign tourist it was and remains as common an occurrence to visit a bathhouse in Istanbul as it does to relish the back streets of Venice. Sargent felt the urge to sketch such haunts (loved by the curious and by circumspect libertines), and his observations hint at the pleasures of the settings. It is important not to overlook the fact that bathhouse routines have religious overtones in their Eastern cultural context. No evidence exists to suggest that his visit there was to do more than look and spend time at his easel. Nonetheless, one can take a Freudian interest in his response to the setting and its details, including the brown phallic fountain and its spouting white water, which is flanked on the picture plane by the recumbent man's feet. The sensualism of the massage he depicts and the ambience Sargent found in its mysterious, dimly lit seclusion have erotic overtones. It happens that Sargent put more faith in the therapeutic power of massage than in physicians and medicine (which is odd, given that he was a doctor's son). Nicola D'Inverno, Sargent's valet for almost twenty-five years, said after his master's death: "Whenever he was feeling poorly he

would call upon me for a good massage, or he might send me out to the chemists, but no doctor."[14]

The reclining figures encountered in Sargent's post-1900 genre paintings were often friends and relatives. He occupied himself both pleasurably and productively in doing such work on his holidays. When the paintings completed on these later trips depict the artist's traveling companions they are not usually considered as genre pieces in the Sargent literature, but they function in much the same way, being moderately sized canvases that show people in supposedly characteristic attitudes and situations. On some holidays he also chose foreign subjects more consistent with the genre tradition. The paintings of his companions tend to feature women (particularly his sisters and nieces), while those of local foreign subjects focus on men, for example, convalescent Spanish soldiers in Santiago de Compostela (1903), workers in the Carrara marble quarries (1911), farm people in the Austrian Tyrol (1914), or black laborers bathing in Florida (1917). The subjects of his early genre works (such as Spanish dancers and Venetian working girls) were never treated as moralistically or sentimentally as the most successful works of their day: they were

11. John Singer Sargent, *Door of a Mosque*, 1891, oil on canvas, 63.5 x 80 (25 x 31½) Museum of Fine Arts, Boston, Gift of Mrs. Francis Ormond

distinguished as rather objective renderings of people and situations that appealed to his taste for the strange or curious. In contrast, his later holiday paintings were often less self-conscious in terms of this need for striking imagery, but their impact was as strong as the earlier works due to the added effect of Sargent's increasingly exhibitionistic technique.

Group with Parasols, a superb example from one of the Alpine holidays, exemplifies the special contradictions inherent in his approach to genre, for Sargent turned a casual moment from a private holiday scene into a seductive image and object that would eventually be exhibited (fig. 13). After the delectable pleasures of its paint surface, the work's most striking aspect is the easy familiarity of the people napping together. In a sense it is quite ordinary as a snapshot image one might remember from a successful picnic. The man in the brown pants rests his head on the belly of a woman and one shin across the thigh of

a man. Its grouping of bodies proves to have been carefully calculated. Surely Sargent arranged the people and chose to sketch from a position in which he looks into the groins of both men, whose legs set up various diagonal rhythms that articulate the viewer's entry into the picture. Had he so wished he could have composed the group with the women in the foreground.

The subjects were never identified when these "holiday" works were exhibited; instead they were given descriptive titles such as *Dolce Far Niente* (c. 1908–1910, Brooklyn Museum) and *Simplon Pass: At the Top* (fig. 14). In the latter case the identities of the people do not even concern the viewer, since, swathed and sheltered, they function principally as a temporary accent in a vast setting that the artist probably found boring on its own. In the case of *Group with Parasols* (fig. 13) only a member of the Sargent circle could know that the two men were brothers; that the woman on the left was the mistress of the

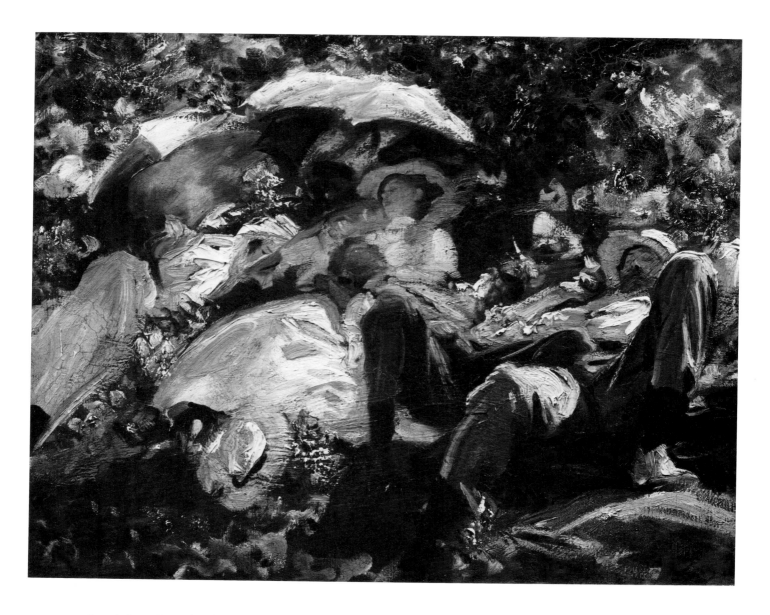

man on the right; that the latter's wife (thirteen years his senior) was on holiday with them but not in the picture.[15] In one watercolor (*Alfresco Group*, inscribed "to the Comaniacs, Purtud, 1909," private collection), the same two reclining brothers sandwich an unrecognizable woman between them: her presence is indicated most clearly by her boots in the center foreground, emerging from a blue blanket or skirt. This watercolor was recently described as a "chance and informal" grouping and discussed in terms of "the witty and light-hearted camaraderie that existed between this tight-knit group of friends," with no acknowledgement of Sargent's at-

traction to their refreshingly open sensuality.[16] From within the Sargent circle the relationships he was depicting were far more involved than the cheerful holiday imagery he presented as his artistic statement.

It is difficult to identify the people in these Alpine works, particularly when they are shaded by umbrellas and the women are draped in shawls. The artist's sisters Emily Sargent and Violet Ormond, Violet's daughters Reine and Rose-Marie Ormond, and their friends Polly and Dolly Barnard appear most frequently. Sargent called the four youngest women the Intertwingles. The literature suggests that this

13. John Singer Sargent, *Group with Parasols*, c. 1908, oil on canvas, 55.2 x 70.8 (21¾ x 27⅞) Collection of Rita and Daniel Fraad

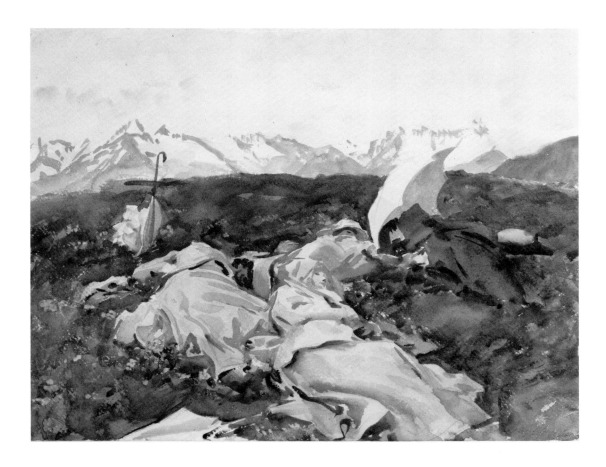

referred to "their easy exchange of poses," but the word—an amusing (almost vaudeville) hybrid of intertwine and intermingle—surely alludes also to the convoluted poses he asked them to assume.[17]

Throughout his career Sargent enjoyed painting people lying down at rest or in sleep. Early examples include the beach view with a Brittany youth (fig. 1), as well as the fantasy work with three naked boys, *A Summer Idyll* (c. 1877, Brooklyn Museum). Occasionally the result was an informal portrait sketch of a friend, such as the depiction of American artist Ralph Curtis reclining in the dunes during their 1880 visit to Holland (High Museum of Art) or that of French artist Paul Helleu lying in a field (c. 1889, British Museum). In his 1905 watercolor *Gondoliers' Siesta* (Mr. and Mrs. Raymond J. Horowitz) Sargent presents two workmen resting on the Grand Canal. Like the man and woman in *Venetian Street* (fig. 3), these men embody an essential aspect of Venice for Sargent; they

are as important to his statement as the palazzo behind them. The gentle, somewhat melancholic beauty that he sees in the gondoliers surely expresses his own attraction to them as types and to Venice as their context. Once a full-scale commissioned portrait became the opportunity for a reclining, outdoor pose. The 1901 painting of Alec McCulloch, painted when the subject was on a fishing holiday in Norway, shows the youth and his catch beside a river (Lady Lever Art Gallery, National Museums and Galleries on Merseyside). When he exhibited it at the New Gallery, London, in 1902 Sargent gave it the genre-like title *On His Holidays*.

A watercolor of one of the Harrison brothers napping outdoors (fig. 15) clearly belongs to the same holiday activities as the oil *Group with Parasols* (fig. 13). With a single male figure, whose open legs fill half the composition, the homoerotic aspect was heightened, whether or not it was intended. The Barberini Faun, displayed in

Munich's Glyptothek since 1827, readily comes to mind when one considers Sargent's reiterations of poses such as this. The technically challenging, languid, open-legged poses of his vacationing male friends were perhaps exercises he liked to carry over from the hundreds of nude drawings made in preparation for his mural decorations. From 1890 until his death he was committed to various Boston mural projects, and one might argue that the pleasures of academic contour drawing and such classical precedents as the Barberini Faun never left his mind, not even in the Alps. The large drawing of a reclining model (fig. 16) typifies the kind of preliminary study he made for every figure in all his decorations. Perhaps Sargent had the Harrison brothers assume similar poses in their hiking clothes to keep his foreshortening skills in practice.

Each image in the torrent of naked men in the decorative lunette *Hell* (1916, Boston Public Library), including the sprawling, green, open-mouthed monster, had its origin in a charcoal drawing of a model, such as figure 16. Seeing Sargent's finished oil study for *Hell*, Andy Warhol observed to me that he thought it showed a "gang-bang."[18] As crude as that remark might seem, I find its irreverence healthy and necessary to understanding Sargent's creative urges. The sensuality of so much of his work has been ignored, in part because it would mar celebrations of him as a recorder and defender of upper-class privilege, but also because some of its flavor is unmistakably erotic. Even Sargent's official description of *Hell* suggests that he felt a mixture of fascination and repulsion toward the sensuality of his invented image: "In the 'Hell' is seen a Satanic monster swimming in a sea of flame and devouring the multitude of lost souls. The handling suggests interminability, temptestuous with evil—a unity of discordance."[19]

An appreciation of sensuality in both men and women should be seen as a strength of Sargent's individuality. Sprawling men constitute some of his most odd and intriguing images. For example, his visit to the French front as an official British war artist in the summer of 1918 pro-

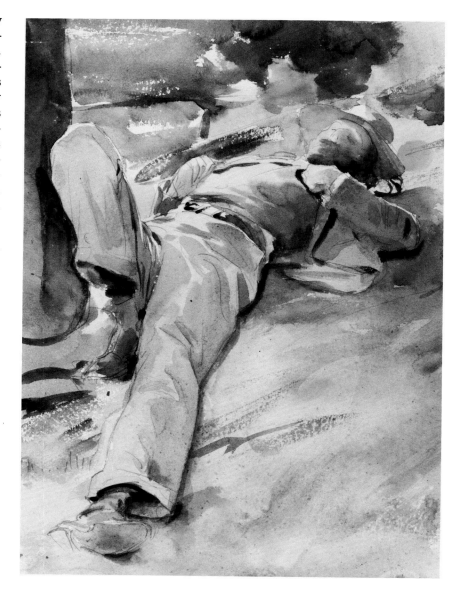

15. John Singer Sargent, *Lawrence ("Peter") Harrison Reclining*, c. 1908, watercolor and pencil on paper, 33 x 24.7 (13 x 9¾) Private collection, courtesy Coe Kerr Gallery, New York

duced several unusual glimpses of male society behind the lines. In one watercolor two soldiers seen napping in uniform (fig. 17) have the unexpected power to evoke all kinds of associations. The man in the gas mask projects power simply because he is protected and hidden by a uniform and gas mask, while the man whose face we see looks all the more vulnerable and sorrowful; poetically this pair of men might be read as two sides of the same person. Another watercolor (fig. 18) shows two naked soldiers resting together after bathing in a river or stream; were it not titled *Tommies*

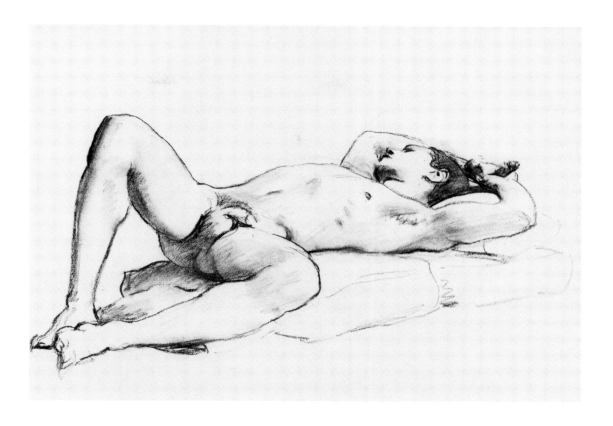

16. John Singer Sargent, *Life Drawing (Male Nude Reclining)*, c. 1905–1915, charcoal on paper, 47 x 61.5 (18½ x 24¼)
Yale University Art Gallery, Gift of Miss Emily Sargent and Mrs. Francis Ormond

Bathing, one would surely give its intimacy a utopian or idyllic association (akin to the earlier expressions of Walt Whitman and Thomas Eakins). The impact of *Gassed* (1918–1919, Imperial War Museum), a twenty-foot painting made after this visit to the front, depends largely on its setting being a flat terrain filled with sprawling soldiers with bandaged eyes, victims of mustard gas. It is curious to see Sargent painting a tangle of friends sprawling indolently in a prewar landscape (fig. 14) and then, about a decade later, to recognize his attraction in *Gassed* to similar poses on a vastly expanded stage. The main difference is the soldier's attributes of war-inflicted suffering.

Sargent's nude reclining figures are not always male. In the decorations at the Museum of Fine Arts, Boston, for example, two naked female couples intertwine in the ceiling panel that shows Atlas and his sleeping daughters, the Hesperides (fig. 19). In certain commissioned female portraits he chose to present the subject as the essence of refined sexual allure (for instance,

Lady Agnew, 1893, National Galleries of Scotland). And a few genre works, the Venetian street scenes included, suggest seductions with female protagonists: one Spanish drawing (1879, Isabella Stewart Gardner Museum) shows a man and woman in a Seville café drinking a toast to what may be a sexual liaison; and an early 1880s Venetian watercolor (Ormond Family Collection) features a coy local woman sitting within the mosquito netting of a bed beckoning the viewer, and hence the artist.

Sargent played down the sexuality of certain images destined for the public. For me this awareness and control of his work relate to his repainting the fallen shoulder strap of Madame Gautreau's gown to its more respectable upright position immediately after the portrait's Salon debut in 1884. Thereafter he monitored his public statements, and, one could argue, he suppressed his natural sensualism. The only nude that Sargent exhibited with any consistency, and the only one reproduced in the deluxe monograph on his work published in 1903, was a full-length oil paint-

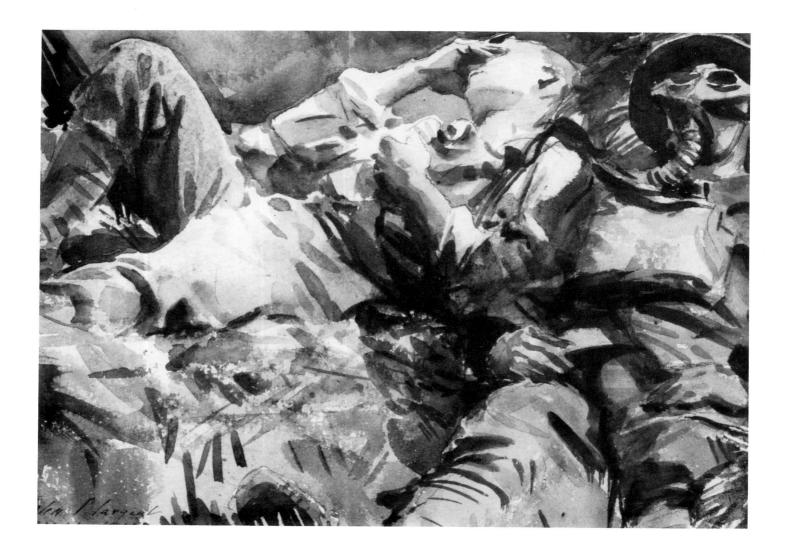

ing that he titled *Egyptian Girl* (1891, private collection, on loan to the Art Institute of Chicago).[20] Viewed from behind, with her upper body turned so that her face and left breast are presented in profile, the woman cannot be considered immodest; her eyes are lowered, and her nipple is obscured by her braided hair. In the nude figure drawings for Sargent's murals, women are in the minority and always appear more demure and less physical than the men. On several occasions he used men to model for female characters in the painted decorations.[21]

In Boston Sargent used a black bellman to model for many of the Caucasian figures in his murals for the Museum of Fine Arts. In an apparently unique instance he made

a large frontal nude oil painting of him (*Nude Study of Thomas E. McKeller*, c. 1917, Museum of Fine Arts, Boston). It is really a portrait of a model at work, since the kneeling posture has no close relationship to any of the figures in the mural decorations. Sargent never exhibited or published it, but it is a finer example of his painting skills than *Egyptian Girl*: the brushwork is freer, its surface is fresh and lacks the belabored overpainting of the flesh in *Egyptian Woman*, and it is much more responsive to the model's aura and physicality.[22] A clear boundary was maintained between Sargent's portraits, genre paintings, and murals that constituted his public work and the private work that he kept to himself. Genre works such as

17. John Singer Sargent, *Two Soldiers at Arras*, 1918, watercolor and pencil on paper, 17.5 x 24.2 (6⁷/₈ x 9¹/₂) Private collection, courtesy Christie, Manson, and Woods International, Inc.

18. John Singer Sargent, *Tommies Bathing, France*, 1918, watercolor and pencil on paper, 39.1 x 132.1 (15³/₈ x 20⁷/₈) Metropolitan Museum of Art, Gift of Mrs. Francis Ormond, 1950

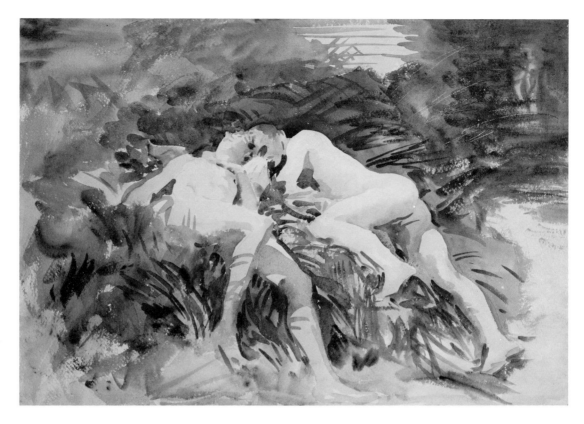

19. John Singer Sargent, *Study for "Atlas and the Hesperides,"* 1921–1925, oil on canvas, 87 x 87 (34¹/₄ x 34¹/₄) Museum of Fine Arts, Boston, Gift of Miss Emily Sargent and Mrs. Francis Ormond

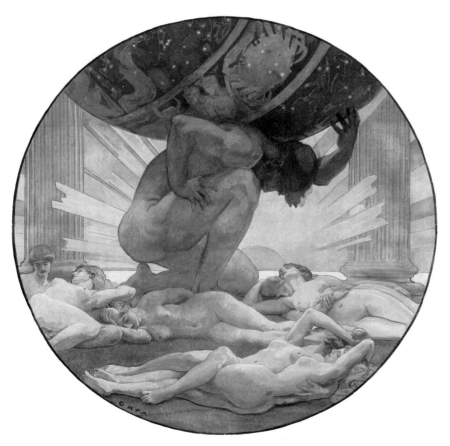

Egyptian Girl and the two outdoor figure groups I am focusing on here do have a publicly acceptable modicum of sexuality that makes them stronger and more memorable. All works with erotic affinities were kept private.

Many of Sargent's genre paintings quickly found their way into fashionable interiors: a photograph from 1888 (fig. 20) shows Sargent's *Street in Venice* hanging in the dressing room of the French actor Benoit-Constant Coquelin. The painting's muted suggestion of flirtation melds into the accumulated bric-à-brac that no doubt signaled many memories and stories for the actor. My final point is inspired by this photographic record of one painting in a specific context. Sargent's best genre scenes succeed by being loose and open-ended enough to excite us still as memories and to help us picture and even anticipate experiences that we will later remember. A postcard sent from Morocco in 1921 by Boston artist Denman Ross to Boston collector Isabella Stewart Gardner (fig. 21) shows a busy street in Marrakech. Ross

149. MARRAKECH — Souk des Chaudronniers

writes: "The people and the life are what they have been for ages. We are fortunate in seeing it all at this time. . . . In staying here there is considerable discomfort to be endured. Our life is not altogether easy and pleasant. It is what we pay for the privilege of being here ahead of civilization. . . . The condition of the lower classes is shocking: but when it is all cleaned up and made safe and proper we shall have no occasion to come here. . . . Here is a subject for John Sargent. The town is an intricacy of narrow lanes, shaded by branches over which vines are festooned, with charming effect. You can imagine the glitter of sunspots on the people passing below. . . ."[23]

Such attitudes—particularly the projection of memory and desire onto a setting being experienced as a tourist—exist behind all Sargent's genre paintings. By being in Venice ahead of the next wave of civilization, he was privileged to observe the external poetry of one period's local life, which has since been "cleaned up" and in essence destroyed. He was driven less by the tourist's urge for recreation than a personal hunger for imagery and experiences to satisfy his personal psychological needs. And when in later years he was not wandering in the Near East or Spain to capture the "glitter of the sunspots" on an exotic foreign race, he was satisfied to find them on his friends and relatives (whom he occasionally dressed up in picturesque Turkish costumes) taking their naps hidden away in the Italian Alps. Sargent wrote to an old acquaintance in 1908: "My hatred of my fellow creatures extends to the entire race, or to the entire white race, and when I escape from London to a foreign country my principle is to fly from the species. To call on a Caucasian when abroad is a thing I never do."[24] On his escapes he inevitably took a few white people for company (including his Italian valet, of course), but they were ones who did not mind lying around. It was crucial that they excited his visual interest, which could range from the decorous to the subtly risqué. Once inspired, he produced superb paintings such as *Venetian Street* and *Group with Parasols*—works that are accomplished and sensuous in execution and intriguing and sensual in content.

Conclusion

Sargent's genre scenes and the ways and contexts in which he created them illuminate his life and career. The paintings had a significant early influence on his rise to international fame. Later, after he had assumed the more massive responsibilities of society portraiture and mural decoration for public institutions, he cherished genre and casual figurative painting among the simpler pleasures of his life. But there are other subtle aspects to this part of his oeuvre. Whether it be portraiture, mural decoration, or genre painting, there lies behind so much of his work the activity of relating to people through looking at them and registering his perceptions. Sargent was brilliant at this, and he is justly famous for his best visual interpretations. But one thing he realized and we, his public, often forget is that in looking at so many depictions of other people we habitually focus on the subjects and overlook the maker. Being publicly known for images of other people was perhaps Sargent's best way of remaining private himself.

In formal portraiture there exists the question of whether the artist will idealize or flatter the subjects by articulating what they think they look like, or stand for, or by suggesting what a subject dreams of being. And from the subject's point of view, there is the issue of how open to be with the artist. Sargent obviously liked to look, and he knew how to appeal to sitters to get them to expose pictorially useful airs and attributes. At the height of this fame clichés held that Sargent could perceive a person's inner being and that his prosecuting attorney's eye constituted a personal risk for clients. This many-layered issue of revelation and privacy can be sensed in the following discussion of the portrait of General Leonard Wood (1903, private collection) by Wood's biographer: "Sargent, who had a brutal habit of looking through the pretentious mask to the quivering creature behind, had painted a man such as Wood had longed since his boyhood to be: a Saxon warrior, straightforward, fearless; a commander and leader, poised and ready; proud without arrogance, romantic, but undismayed by the unromantic reality."[25]

Sargent could put all this on canvas, distilling an image whose levels of meaning depend on the knowledge the viewer brings to it. To an uninformed viewer it is a conventionally stiff military portrait, but to anyone familiar with Wood's biography it is much more nuanced. Similar contradictions seemingly existed between Sargent the artist and Sargent the man. He was exceptionally fluent and articulate in addressing what he found visually alluring, whether the public attractions of Lady Agnew or Madame Gautreau or the physicality of male models. Personal friends, however, knew his "almost morbid shrinking from notoriety" and remembered him as a hopeless stammerer when it came to speaking at public appearances.[26]

One must go beyond the paint and holiday pictorialism of Sargent's genre works and see them as extensions of their creator's personality. The issues of privacy and display, and of passion as it is generated, exercised, and recorded, are rich and convoluted. It is thus inappropriate to expect, or accept, simple interpretations. His handling of paint has long been praised as "delicious" and "appetizing," and it is time to regard his approach to some of his sitters and models in similar terms.[27] It may be wise in this endeavor to assume Sargent's energetic spirit of curiosity, as evoked by his friend and biographer Evan Charteris: "To the end of his days he had the supreme gift of being able to look forward, with the certainty of discovering excitement in new scenes and places. He habitually took thought for the morrow, but not of the anxious kind; it was rich in anticipation of what the next day would bring forth."[28]

NOTES

I am particularly grateful to the following people for their help and advice: Jay E. Cantor, William Cuffe, Odile Duff, Karen Haas, John T. Kirk, Jane B. Neet, Richard Ormond, Harriet Rome Pemstein, Eric Rosenberg, Janice Sorkow, and Paul Tucker.

1. See, for example, Donelson F. Hoopes, *The Private World of John Singer Sargent* [exh. cat., Corcoran Gallery of Art] (Washington, D.C., 1964) and Warren Adelson, *John Singer Sargent, His Own Work* [exh. cat., Coe Kerr Gallery] (New York, 1980).

2. Richard Ormond, *John Singer Sargent: Paintings, Drawings, Watercolors* (New York, 1970), 69–76. I question Ormond's observation that Sargent exhibited and sold his "off duty" oil sketches and watercolors "haphazardly and without caring." The exhibition and sale of these works to collectors and museums was frequent and extensive.

3. Patricia Hills, *John Singer Sargent* [exh. cat., Whitney Museum of American Art] (New York, 1986), 29. Although Hills cited his book on Manet, she ignored T. J. Clark's warning about indiscriminate use of the notion of spectacle out of the context intended by Guy Debord: "I wish at least to alert the reader to the absurdity involved in making 'spectacle' part of the canon of academic Marxism"; *The Painting of Modern Life: Paris in the Art of Manet and His Followers* (New York, 1985), 10.

4. Hills 1986, 203.

5. Martin Birnbaum, *John Singer Sargent: A Conversation Piece* (New York, 1941), 33. Charles Merrill Mount, who was aided in his research by Sargent's sister Violet, stated that Sargent's "own papers were destroyed in the cleaning out of his studio subsequent to his death." *John Singer Sargent: A Biography* (New York, 1955), xi. Richard Ormond suspects that "there were hardly any [papers] left to destroy. I don't think Sargent bothered to keep a thing." Letter to the author, 31 May 1989. Ormond notes that he knows nothing about the album of "aboriginal types" that Sargent showed to Birnbaum.

6. Hills 1986, 28.

7. The smaller work, *Oyster Gatherers of Cancale*, is owned by the Museum of Fine Arts, Boston. It was the first work Sargent exhibited in the United States (Society of American Artists, New York, 1878). See Trevor Fairbrother, *John Singer Sargent and America* (New York, 1986), 32–35.

8. Stanley Olson, *John Singer Sargent: His Portrait* (New York, 1986), 1–5. Vernon Lee, a lifelong friend of Sargent's, held a contrasting view of his parents, seeing dissatisfaction in the father rather than the mother: "[Sargent inherited a double nature] from his exuberantly gifted, expressive, and *lebenslustige* mother, on the one hand, and from his puritan, reserved, and rather sternly dissatisfied father, on the other." Vernon Lee, "J. S. S. In Memoriam," in Evan Charteris, *John Sargent* (New York, 1927), 249.

9. Sargent to Ben Castillo, Tetuan, Morocco, 4 January 1880, quoted in Charteris 1927, 50.

10. Undated journal entry, quoted in L. V. Fildes, *Luke Fildes, R.A.; A Victorian Painter* (London, 1968), 67.

11. A French critic complained that Sargent's Venetian women were not recognizably the descendants of Titian's beauties: "We discern [them] with difficulty beneath their unkempt hair, draped old black shawls as though shivering from the fever. What is the good of going to Italy to gather such impressions? With much less travel one finds in Villette and Belleville streets that are similarly dismal [*triste*] and women with equally disagreeable looks." Arthur Baigneres, "Première Exposition de la Société Internationale de Peintres et Sculpteurs," *Gazette des Beaux-Arts* 27 (February 1883), 190 (author's translation). For other early discussions of these works see Trevor Fairbrother, "Sargent's 'Venetian Interior,' " in *A New World: Masterpieces of American Painting, 1760–1910*, ed. Theodore E. Stebbins, Jr. [exh. cat., Museum of Fine Arts, Boston] (Boston, 1983), 311–312.

12. See Trevor Fairbrother, "The Shock of John Singer Sargent's 'Madame Gautreau,' " *Arts Magazine* 55 (January 1981), 90–97.

13. William H. Gerdts, "The Arch-Apostle of the Dab-and-Spot School: John Singer Sargent as an Impressionist," in Hills 1986, 112, 131.

14. Nicola D'Inverno, "The Real John Singer Sargent as His Valet Saw Him," *Boston Sunday Advertiser* (7 February 1926), 3.

15. The people in *Group with Parasols*, from left to right, are: Mrs. Dorothy Palmer (mistress of "Peter" Harrison), Miss Lillian Mellor (later Mrs. Hare), Leonard F. ("Ginx") Harrison, and Lawrence A. ("Peter") Harrison. This information is from the most recent discussion of the painting, Linda Ayres' catalogue entry in *American Paintings, Watercolors, and Drawings from the Collection of Rita and Daniel Fraad* [exh. cat., Amon Carter Museum] (Fort Worth, 1985), 34–36. Mrs. "Peter" Harrison (née Alma Strettell), a friend of Sargent's since the mid-1880s, appears in some of his English "impressionist" sketches. Her 1887 book, *Spanish and Italian Folksongs*, reproduced several of Sargent's Spanish paintings. The research notes of David McKibbin (courtesy Coe Kerr Gallery, New York) record Violet Hunt's 1890 diary entry stating that Miss Strettell was in love with Sargent.

16. James Lomax and Richard Ormond, *John Singer Sargent and the Edwardian Age* [exh. cat., Leeds Art Galleries and National Portrait Gallery, London] (London, 1979), 97.

17. Quoted in David McKibbin, *Sargent's Boston* [exh. cat., Museum of Fine Arts, Boston] (Boston, 1956), 114. In addition to "Intertwingles," Charteris 1927, 178, lists other "derogatory" titles that Sargent gave to his genre paintings, including "Blokes," "Idiots of the Mountains," and "A Worm's Eye View."

18. Trevor Fairbrother, "Warhol Meets Sargent at Whitney," *Arts Magazine* 61 (February 1987), 69.

19. John Singer Sargent, "Judaism and Christianity" (brochure text, Boston Public Library, Boston, 1916).

20. *The Work of John S. Sargent, with an Introductory Note by Mrs. Meynell* (London, 1903), n.p. *Egyptian Girl* (now titled *Study from Life*) is also illustrated in Hills 1986, 182.

21. Male models posed for the personification of *The Synagogue* (1919, Boston Public Library) as a haggard old woman and for the *The Danaides* (1925, Museum of Fine Arts, Boston). Several preliminary drawings for both these subjects in which the model is obviously a man are owned by the Museum of Fine Arts, Boston. On *The Synagogue*, see Fairbrother 1986, 253–256.

22. For a discussion of the painting of McKeller, see Trevor Fairbrother, "John Singer Sargent's 'Gift' and His Early Critics," *Art Magazine* 61 (February 1987), 56–63.

23. Denman Ross to Isabella Stewart Gardner, Marrakech, Morocco (written on six postcards), 6 April 1921, Archives of the Isabella Stewart Gardner Museum, Boston.

24. Sargent to Miss Popert, London, 7 April 1908, quoted in Mount 1955, 273. Sargent's awareness of and exploitation of his being a foreigner in Europe is suggested by a letter to Mrs. Adrian Stokes, quoted in Charteris 1927, 171: "With the common [Spanish] people it is no disadvantage being an American, for their newspapers told them that they gave us the most tremendous licking in Cuba. And the Artists and better people will do anything for a stranger."

25. Herman Hagedorn, *Leonard Wood: A Biography*, 2 vols. (New York, 1931), 1:403.

26. Evan Charteris suggested Sargent's double nature as follows: "His burly full-blooded aspect was deceptive: it gave no warrant of the diffidence and gentleness that lay beneath. A stranger would never have suspected that behind such alacrity and power was an almost morbid shrinking from notoriety and an invincible repulsion from public appearances. In this respect he presented a continual paradox." Charteris 1927, 227. Sargent's Boston friend Thomas A. Fox wrote: "To be absolutely truthful there was a trace of fear in Sargent's make-up, and it was manifest in at least two instances; one in anticipation of a formal interview with the representatives of the press, and the other when called upon unexpectedly to make an after-dinner speech." "John S. Sargent, 1856–1925: The man and Something of His Work," 48–49, unpublished manuscript, Harvard University Archives.

27. "[He] . . . was pursued by the fear of sliding into what he himself had already done, of yielding and losing himself in the deliciousness of his marvellous facility." Vernon Lee, quoted in Charteris 1927, 236. "Nothing more clever or appetizing than [Sargent's] . . . rendering of the famous *Santa Maria della Salute* has ever been done in watercolor." Harold Bentley, "In the Galleries," *International Studio* 37 (April 1909), 55.

28. Charteris 1927, 95.

LINDA S. FERBER
Brooklyn Museum

Stagestruck:

The Theater Subjects of Everett Shinn

Art-historical surveys of the Eight always acknowledge that Everett Shinn was different from his fellow Philadelphians Robert Henri, George Luks, William Glackens, and John Sloan. He had the distinctions of being the one, among the four younger of these men, who was famous first, the one with the least allegiance to whatever group agenda or social philosophy there may have been among them, and the one who lived the longest. The latter circumstance made him, with John Sloan, an official though not altogether reliable chronicler of the events around 1908 and before. Adding yet another dimension to Shinn's story is his election by Theodore Dreiser as the model for the artist protagonist, Eugene Witla, in *The "Genius,"* Dreiser's sensational novel of 1915.[1] In the 1940s—long after Shinn had ceased to paint seriously—a revival of interest in his biography and his work came in the form of literary and art-historical inquiry about the early decades of the century. Subsequent monographic study of Shinn's career has been, in general, uncritical in approach but useful.[2] The artist diminished his own contribution by turning late in life, no doubt in response to this renewed interest, to sad reprises of his early work.

In the decade before the exhibition that made the Eight famous, Everett Shinn was a promising talent who had already made a series of successful debuts in New York: as a pastelist in 1900, as a painter in 1905, and as a muralist in 1907. The world of the theater was a critical element in all three, not only as a source of artistic inspiration, but as a well-connected social and professional milieu providing patronage and support. Shinn was of course not alone in his attraction to the spectacle of performance and dance, to behind the scenes, and to the stage personality as portrait. Henri, Luks, Sloan, and Glackens also treated these subjects. Shinn, however, was acknowledged early on as the one among the Philadelphia circle who was truly stagestruck. This essay will approach Shinn's brilliant early career in the context of this central theme, concluding with the Macbeth Gallery exhibition in which eight theater paintings consolidated his place in the history of American art as a chronicler of the world of performance. We now recognize that these works also represented the peak of his performance as a painter. Shinn's world at the turn of the century was a complex and conflicting mixture of styles, ideas, and opportunities. This survey of a relatively brief but rich period will touch on a number of issues and little-known aspects of his career that invite further investigation.

In 1893, Shinn, who was seventeen years old, left the drafting rooms of a Philadelphia manufacturer of chandeliers to join the staff of the *Philadelphia Press*. He also entered the Pennsylvania Academy of the Fine Arts and the circle of artists who met

at Henri's weekly studio open-houses.[3] Sloan recalled Shinn in those early Philadelphia years as "the youngest of the group that met at Henri's studio talk-fests, an amazingly talented boy, clever, and with a facile pencil."[4] Shinn's association with more mature fellow artists, all of whom were familiar with contemporary European illustration (Henri and Luks had already studied abroad), provided him with valuable models.[5] His own experience as a newspaper artist accustomed Shinn to regard the contemporary scene as a worthy subject. At the same time, from his mentors he mastered the most stylish visual conventions of the modern life subject years before he went to Europe. The Philadelphia circle especially admired the illustrations of Jean-Louis Forain and Theodore Steinlen.[6] Shinn's world in Philadelphia also included the theater. We know he participated in the amateur theatricals that were part of bohemian studio life in the Henri circle and which would remain a lifelong interest.[7]

In 1897, Shinn left Philadelphia for New York City. For the twenty-one-year-old Shinn the move from the "drowsy gait of Philadelphia" was a critical decision, a change he experienced like a "jump from a slow freight [train] to an express."[8] He worked first for Joseph Pulitzer's *New York World*, joining Luks, who had been at the *World* since 1896. Glackens had settled in the city on his return from Europe late in 1896. Henri would arrive in 1900 after a lengthy sojourn in France. Sloan would finally relocate in 1904.[9] New York's extensive publishing industry offered greater professional opportunity for Shinn and his new wife, illustrator Florence Scovel, a Philadelphian whom he married in 1898.[10] Like his fellow newspaper artists, Shinn sought to make a transition to magazine illustration, a step up from the relentless daily pressure of on-the-spot graphic reporting to the more leisurely working pace and creative latitude of interpreting the text of an article or a short story or preparing an illustration of the local scene for weekly and monthly magazines. In New York his talents as an illustrator were quickly recognized. In January 1899, he joined the staff of *Ainslee's Magazine*,

probably as art editor.[11] There he met Theodore Dreiser, who would become an admirer of Henri's circle of urban realists and would support them in the press as well as draw on their work as inspiration for his own. That year Shinn also received his first important commission to illustrate a book, a literary and visual survey of the nocturnal metropolis by the novelist William Dean Howells titled *New York by Night*.[12] Although it was never published, the commission was an important one. For it Shinn completed some thirty-six pastel drawings over several years, focusing his energy on the urban imagery and the medium that brought him early critical recognition.[13]

Pastel was a natural and familiar medium for Shinn, closely related to his work as a draftsman and illustrator, but also associated with higher artistic ambitions.[14] Earlier in 1899 he had exhibited for the first time at the Pennsylvania Academy a selection of five pastels of New York subjects. One of these, *Street Scene*, was purchased by William Merritt Chase, a tribute to a young talent from an acknowledged master of the medium.[15] The American vogue for pastel was at its height around 1900. The medium, associated with the French impressionists, was favored by Chase, Robert Blum, John Twachtman, and other American practitioners of various forms of impressionism. Shinn and Glackens, however, used pastel in rather a different manner, with a darker palette and a more linear, less painterly application—the latter linked no doubt to their work as illustrators.[16] These pastels would serve as Shinn's transition from journalist-illustrator to artist, and they were in fact the vehicle for his early fame.

Four pastels were shown in December 1899 at Chase's New York School of Art, where Shinn, like Henri, would later teach.[17] This event had been preceded in November by a private exhibition of five pastels at Irving House, the home of the actress Elsie de Wolfe. Among the works shown were three theater subjects appropriate to the interests of his benefactress. Clyde Fitch, the well-known playwright and producer, bought one of these, *Scene—Julia Marlow* (unlocated), probably depict-

ing the actress in performance as Barbara Fritchie in his current successful Civil War drama of that name. "Many nights I had stood in the wings," Shinn later recalled, "watching [her] performance," indicating that a behind-the-scenes involvement with the New York theater world began soon after his arrival.[18] Another title shown at de Wolfe's—*Interior Keith's* (unlocated)—was drawn from a different world, that of vaudeville, depicting one of the theaters on Benjamin Franklin Keith's famous vaudeville circuit.[19] A distinctly American form of variety entertainment just beginning to flourish around 1900, vaudeville was popular with both working- and middle-class urban audiences and would be a source for many of Shinn's best works (figs. 9, 10, 14).[20]

The exhibition at de Wolfe's was not only the debut of the theater subject, but led to Shinn's first gallery exhibition through the influence of de Wolfe's friend and Irving Place neighbor, the architect Stanford White. In February 1900, Boussod, Valadon, and Company mounted an ambitious show of forty-four pastels of New York subjects. Among the works shown were five theater portraits, several in character, and three performance subjects. A fourth title, *During the Biograph* (unlocated), referred to the short films that were shown between the live acts in vaudeville. "The best of the 40 pastels and watercolors here," wrote the *New York Evening Sun*, "are scenes in theatres and in the streets."[21] Chase loaned *Street Scene* to the exhibition, and Fitch wrote to the artist enthusiastically: "It *IS* a *ripping* show!" In a letter to his daughter, Howells commented on the good fortune of his collaborator: "He is the most unaffected charming boy I've seen in a long time; has an exhibition at Bussod and Voladen's [*sic*]." Then, quoting Shinn, Howells said: "'Of course, I can't *sell* anything so queer, but the papers have treated me well.'"[22]

The New York papers had indeed treated Shinn well, and his career as an artist was launched. In what would become a familiar pattern, youth and artistic immaturity were duly noted: "Mr. Shinn seems to be feeling his way," the *New York Tribune* said, but most critics focused on his poten-

tial: "He so abounds in cleverness, in vivacity of color and of line that his most dubious sketches are forgiven," wrote the *Philadelphia Times*. His European sources were readily recognized; his figure types were singled out by the *Tribune* as somehow "foreign rather than American," suggesting "the formative influence on a not yet mature talent of some of the French masters." "Perhaps," wrote the *Tribune*, "Degas and Forain have given him some hints." The *Times* dubbed him "an American Raffaelli," predicting "when he shall have learned to draw better . . . he will realize what he now shows of promise."[23] The most perceptive commentary on the discovery of Shinn's work appeared in the *Bookman*, where Regina Armstrong, recognizing him, with Glackens and Luks, among the progessives in the field of illustration, also noted: "This young impressionist makes a direct attack on the essential, and gives little care to the manner of expressing it, being a careless draughtsman, but possessing a technical facility that is more likely to run away with him than to guide him to surer and saner methods." Armstrong also observed the impact of his recent gallery debut: "Mr. Everett Shinn may have had the usual difficulties and preparation that seem to be part of the schooling of an artist, but in New York, at least, he had simply 'arrived' before he had been heard of to any extent."[24]

By early 1900, then, only three years after coming to New York, through a combination of talent, luck, and the right connections, Shinn had "arrived." While Glackens, Luks, and Sloan were still working primarily as newspaper and magazine illustrators and Henri was still living abroad, Shinn had quickly emerged as a promising "impressionist" interpreter of the urban scene "who has only to go forward to fill the full measure of success in the work of making the life of the day and the pavement express the emotion and observation of all time."[25]

That summer, Shinn and his wife left for Paris. We know little about this trip abroad, apparently his only one. His record book places him in early July in Paris where he might have visited de Wolfe, who was living for the summer at Versailles.

Thumbnail pencil sketches (fig. 1), some annotated, are known from the Paris sojourn, and the titles of pastels and paintings document a visit to London.[26] This stay of only a few months yielded a corpus of sketches and studies to be drawn upon repeatedly for years to come. The Shinns returned to New York around September, and in January 1901, eighty-five pastels were shown at Boussod, Valadon in Shinn's second major New York exhibition, "Paris Types." Nearly a third of the titles were theater subjects.[27] Shinn's repertoire had expanded to include distinctly French types: the outdoor theater (fig. 2), the café chantant, and the ballet—the latter certainly stimulated by what was now a first-hand knowledge of the works of Degas and Forain.

Versions of "Paris Types" and New York subjects went on the road in 1901, taking

1. Everett Shinn, *Paris Theatre*, c. 1900, watercolor on envelope, 8.3 x 10.8 (3¼ x 4¼)
Collection of Diana and Arthur G. Altschul

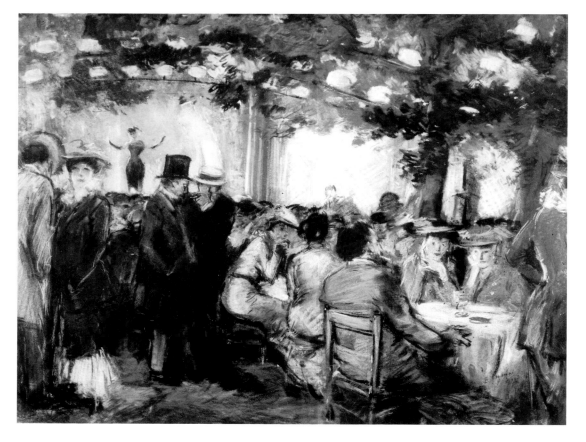

2. Everett Shinn, *Matinee, Outdoor Stage, Paris*, 1902, pastel on paper, 45.7 x 66 (18 x 26)
Collection of Mr. and Mrs. Raymond J. Horowitz

3. Everett Shinn, *Knoedler Poster*, 1903, pastel on paper, 43.5 x 36.8 (17¹/₈ x 14¹/₂) Collection of Diana and Arthur G. Altschul

4. Everett Shinn, *The Love Song*, 1903, pastel on paper, 61 x 30.5 (24 x 12) Private collection. Photograph courtesy of Arthur G. Altschul

Shinn's pastels to Boston, Philadelphia, Cincinnati, Buffalo, and St. Louis and closing the year with another big exhibition at Boussod, Valadon. "It would be a kindness on the part of his friends," wrote the *Tribune* of the final New York show, "if they were to urge him to refrain from exhibiting for a time, while he bent himself to the acquisition of that fundamental knowledge which a man of his talent can far less than a mediocrity afford to neglect."[28] Shinn exhibited New York and Paris pastels annually in big shows at M. Knoedler and Company in 1903 and at Durand-Ruel Galleries in 1904.[29] These exhibitions reinforced the perception of a preoccupation with the theater. Poster and catalogue cover designs for the 1903 and 1904 exhibitions (figs. 3, 4) both featured performance subjects. Henri Pène du Bois wrote of the latter, titled *The Love Song*: "No one ever painted better than Everett Shinn the poor players and dancers that Paris knows." Shinn's single brief sojourn in that city had apparently been sufficient to establish him in American circles as a prime interpreter of this subject, a role he seems to have relished. "His great haunt," according to the *Times*, "is the open-air stage, the café chantant, or the small Parisian theatre."[30]

Even before his work in oils was recognized, Shinn's pastels had established him as a progressive artist, a position demonstrated for contemporary critics and audience in his choice of subjects—the theater and the urban street were the epitome of the modern life subject—as well as in

his style: "Mr. Shinn paints life, vibration, movement, sensation—the fleeting glimpse of the onward moving crowd—never the literal, obvious reality. He is in a way the most typical of all the modern men who lead the reaction against the academic school."[31] "Modern" meant the fragmentary glimpse, a disregard for traditional notions of finish, and a preference for socially marginal and picturesque character types. All of these characteristics were demonstrated in works such as *Matinee, Outdoor Stage, Paris*, 1902 (fig. 2) and *The Love Song*, 1903 (fig. 4). Shinn's characteristic application of the pastel medium

in short, nervous strokes energizes and infuses "life, vibration, sensation" into the best of these early pastels. Equally modern is the slice-of-life composition of *The Love Song*, with its abrupt juxtaposition of the stage performers' mock rapture and close embrace with the random placement of foreground figures, who may be an alienated couple or simply passing strangers.

This same visual vocabulary served in Shinn's work in oils. While there are dated works in oils from the first years of the twentieth century, Shinn was known from 1900 to 1904 almost exclusively as a pastelist and an illustrator. Current evidence

5. Everett Shinn, *The Balcony*, c. 1900, oil on board, 38.1 x 47 (15 x 18½) Private collection. Photograph courtesy of Arthur G. Altschul

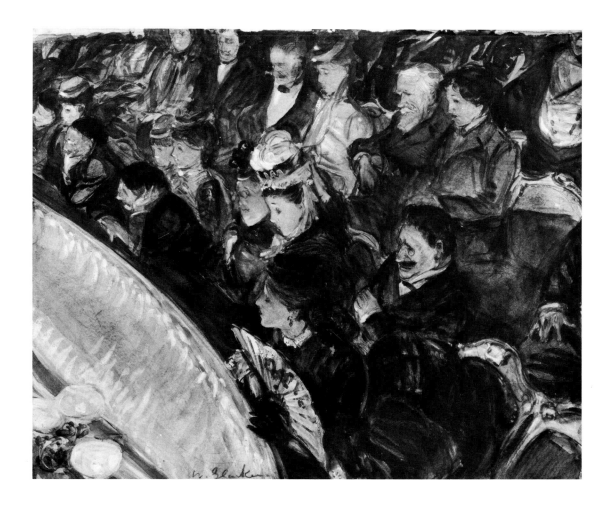

6. William Glackens, *The Balcony*, 1899, sepia and black heightened with white on paper, 24.3 x 30.5 (9⅝ x 12) Illustration for "The Hermit of Rue Madame," by William Le Queux, *Ainslee's Magazine*, April 1899. Collection of Diana and Arthur G. Altschul

suggests that he seems to have been the last of the Philadelphia circle to begin the regular use of oils.[32] The earliest known theater painting is one of the best. *The Balcony*, an oil on board, is inscribed on the back "Paris" and dated 1900 (fig. 5). The manner of laying on the pigment is in fact akin to the strokes and sharp linear outline of pastel, especially in the features and gestures of the figures who peer toward the stage from their unusual vantage point. It is tempting to speculate that Shinn might have recalled a striking illustration by his friend William Glackens, *The Balcony*, 1899 (fig. 6) executed for a story in *Ainslee's Magazine* while Shinn was art editor.[33] Such a link to Glackens in no way diminishes the power of Shinn's conception. The powerful swelling serpentine form of the balcony structure dominates the painting, organizing the figures

into two zones. Light from below highlights the features of the motley crowd in the upper balcony—the "gallery gods." Eagerly, they lean forward toward the unseen stage, in contrast to the static, vertical posture of the well-dressed couple in the box below. The best known of these early paintings, also focusing on the audience rather than the stage, is *London Hippodrome*, 1902 (fig. 7). The painting shows a shapely trapeze performer, muscular legs extended in mid-swing, poised in the dark above a restless audience whose gestures and expressions range from rapt attention to boredom. This work is decidedly more painterly in manner than *The Balcony*, suggesting that Shinn, like Glackens, Sloan, and Luks, felt the influence of Henri's technique. This rich, juicy handling of the oil medium would become Shinn's signature style.

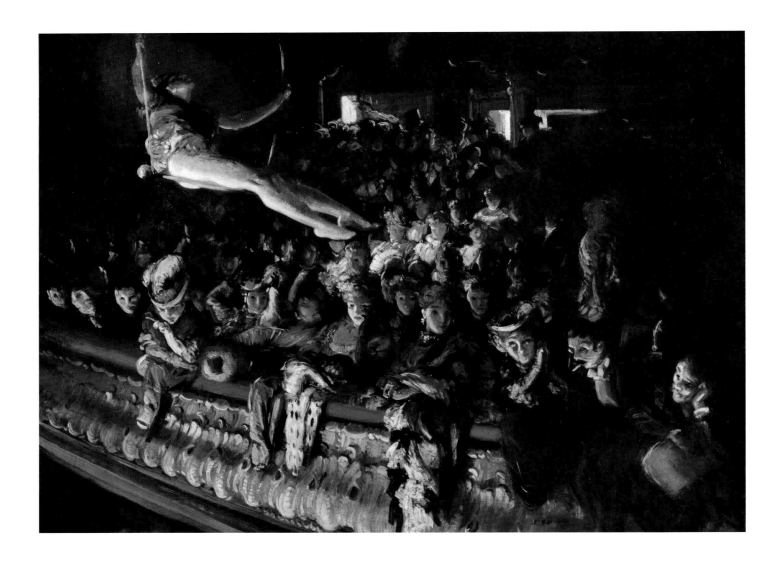

Shinn's work in oils came to public attention early in 1905, when the E. Gimpel and Wildenstein Gallery mounted an exhibition of twenty-four paintings, a second debut marking, as Henri Pène Du Bois observed, a "new phase in his career." Shinn's paintings, most of which were probably executed in 1903 and 1904, were of those subjects for which he was by then well known in pastel and were divided about equally between the urban street and the theater.[34] Albert E. Gallatin devoted several pages to Shinn's achievements in both oil and pastel in the October 1906 issue of the *Studio*. As in the pastels, Gallatin saw Shinn as a modern painter in his choice of subjects ("Shinn possesses a great contempt for everything academic") and in his style ("These paintings are as vigorously exe-

cuted as the pastels: they have the same daring color schemes, painted with a full and rapidly manipulated brush").[35]

The oils were well received critically and the theater duly noted and admired as Shinn's specialty. Henri Pène Du Bois was especially enthusiastic about his performance subjects: "Everett Shinn is fond of the playhouse because of its lines and lights. He shows their captivating deformation in 'The Ballet' where the dancers with arms curved above their heads are similar to baskets of flowers and the air which is around them is green and glazed like a Persian vase; [and] . . . in the 'Funny Man' at his monologue, a band of yellow light at his feet" (figs. 8, 9). Gallatin concluded: "The artist is still rather new to oils, and in consequence his paintings are occasionally

7. Everett Shinn, *London Hippodrome*, 1902, oil on canvas, 67 x 89.5 (26³/₈ x 35¹/₄) Friends of American Art Collection, 1928.197. ©1989 Art Institute of Chicago. All rights reserved

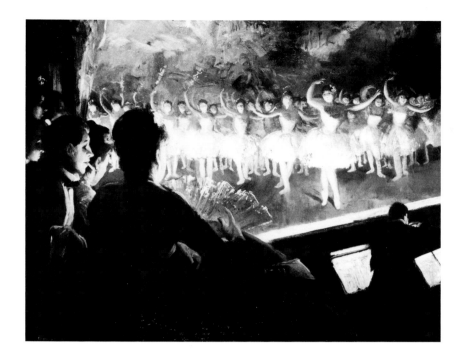

somewhat raw, but they hold out every expectation for great work in the future when he becomes more familiar with his medium."[36]

In this important article Gallatin published two theater paintings: *Keith's Union Square*, c. 1906 (fig. 10), one of several "Spanish" song-and-dance motifs, and *A French Music Hall*, 1906 (formerly known as *Stage Scene*) (fig. 11).[37] The evolution of the latter can be traced in a pastel of 1903 (fig. 12) in which the motifs are easily recognized: the pose and costume of the actress, the painted scenery, the spiral of the fiddle head silhouetted against the stage light. Another pastel of 1907, *Julie Bonbon* (fig. 13), reworks the same motifs, and in a late painting, *Dancer in White*, c. 1952 (Butler Institute of American Art), the subject is recognizable in a debased form. In the oil of 1906, Shinn enriched and ex-

8. Everett Shinn, *The White Ballet*, 1904, oil on canvas, 72.7 x 91.1 (28⅝ x 35⅞)
Collection of Diana and Arthur G. Altschul

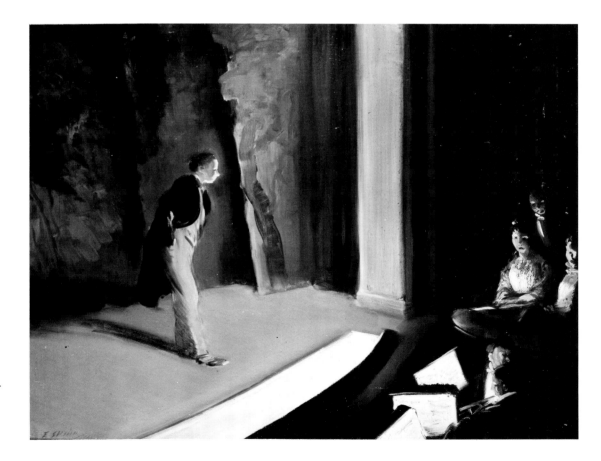

9. Everett Shinn, *The Funny Man*, c. 1904, oil on canvas (dimensions unknown)
Present location unknown. Photograph courtesy of Arthur G. Altschul

panded the image by shifting the point of
view to the rear of the left balcony and
adding a blonde companion as a foil to the
brunette performer. We now peer over the
shoulders of the audience, and, in a realist
device to convey a sense of immediacy, one
of them turns to confront us. Even more
unusual is the point from which we view
the vaudeville performance in Proctor's
Fifth Avenue Theatre (fig. 14). We are
thrust into the pit, our glimpse of the stage
reduced to a brilliantly colored wedge of
light visible behind the dark silhouette of
a musician looming above the brass rod
and curtain dividing the unseen audience
from the orchestra.

Theater scenes like these, with their un-
usual perspectives, strong contrasts of light
and shadow, and sharp character studies of
urban types in the audience, in the pit, and
on the stage are subjects with visual con-
ventions long established by 1908 in French
realist painting of the 1860s and 1870s. The

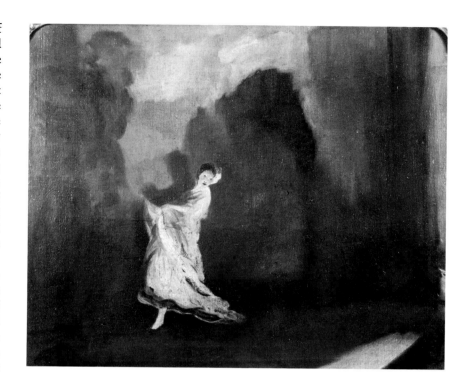

10. Everett Shinn, *Keith's
Union Square*, c. 1906, oil on
canvas, 51.8 x 61.9 (20³/₈ x 24³/₈)
Brooklyn Museum,
Dick S. Ramsay Fund

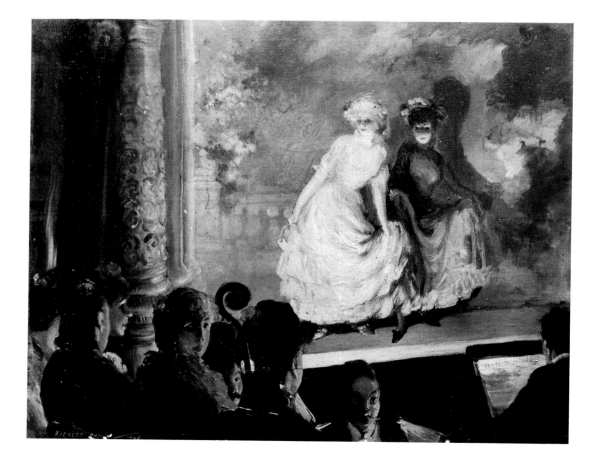

11. Everett Shinn, *A French
Music Hall*, 1906, oil on
canvas, 61.1 x 74.6 (24¹/₁₆ x 29³/₈)
Collection of Rita and Daniel Fraad

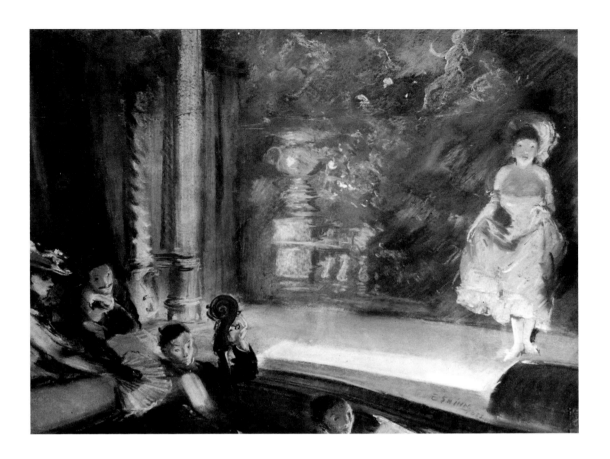

12. Everett Shinn, *Theatre Scene*, 1903, pastel on paper, 40.6 x 50.8 (16 x 20) (Present location unknown) Photograph courtesy of Arthur G. Altschul

lineage of Shinn's subjects and his approach were readily recognized from the first exhibition of pastels; an identification that one suspects strongly was afterward actually cultivated by the artist. Shinn's earlier identification with Raffaëlli, for example, was reinforced not only by his appropriation of certain themes such as *le chiffonnier*, but by calling the 1901 exhibition "Paris Types," surely a reference to Raffaëlli's popular illustrations, *Les Types de Paris* (1889).[38]

Critics were divided in their interpretation of Shinn's obvious debt to these sources. Like Henri Pène Du Bois, Gallatin admired the theater subjects yet felt that Shinn's adept use of French models in his own interpretations of the "gaslighted music hall" often approached derivativeness. "Some French stage scenes done in this medium are extremely clever," he wrote, "but what they lack is the spark of real genius which has gone into the making of the pastels: their models are too apparent."[39] Most, however, in these early years accepted these models as providing appropriate pictorial vehicles with which to interpret experience once excluded from the canon of acceptable subjects for American artists. In the habit of glamorizing home-grown talent by association with European masters, many even took a measure of pride in dubbing Shinn the "American" Degas, Forain, or Raffaëlli.

In his 1906 article, Gallatin also illustrated another work titled simply *Decorative Painting* (unlocated), a landscape of frankly rococo inspiration and an example of the revivalist ornamental work that comprises a little-known aspect of Shinn's early career. The stage scenery in *A French Music Hall* (fig. 11)—the balustrade, urn, and cascade of flowers—offers a hint of the pastel palette and ornamental motifs of his

decorative work. At this time Shinn was also producing red chalk sketches of dainty costumed figures in imitation of eighteenth-century sanguine drawings. An interest in rococo revival and eighteenth-century French decorative arts in America was evident in the 1890s, paralleling the dominant preoccupation with the Roman-inspired classical vocabulary of the American Renaissance. Edith Wharton and Ogden Codman's influential book, *The Decoration of Houses*, published in 1897, pointed out the value of eighteenth-century French models as examples of correct taste in interior decoration. From about 1895, expatriate artist Walter Gay recorded vintage French interiors in meticulously detailed oil paintings.[40] By 1897, the Hewitt sisters had founded the Cooper Union Museum (now the Cooper-Hewitt), forming collections based on a belief that French design of the eighteenth century represented a high point in the history of decorative arts. In 1906, J. Pierpont Morgan donated the Georges Hoentschel Collection of French decorative arts to the Metropolitan Museum of Art.[41]

Shinn would have been in touch with these currents early on through Elsie de Wolfe, whose circle included all the figures mentioned above and whose own admiration for French decorative arts had begun with her sojourns in France in the 1890s. She had selected a domestic decorative vocabulary drawn from French eighteenth-century sources in her remodeling of Irving House.[42] De Wolfe may well have introduced Shinn to Walter Gay and, perhaps, to the Cluny Museum on his 1900 stay in Paris where he later claimed to have spent months studying the decorative arts collections.[43] By 1904 de Wolfe had retired from the stage, and in the spring of 1905 she had established what would quickly become a highly successful interior decorating business.[44] They had remained in touch since 1900, Shinn recording her on several occasions in her final dramatic roles. By 1905 (and probably earlier) de Wolfe and other theater friends were calling on Shinn's services as a decorative painter for domestic interiors.[45] Stanford White proved once again to be a powerful ally. Before his murder in June 1906, White

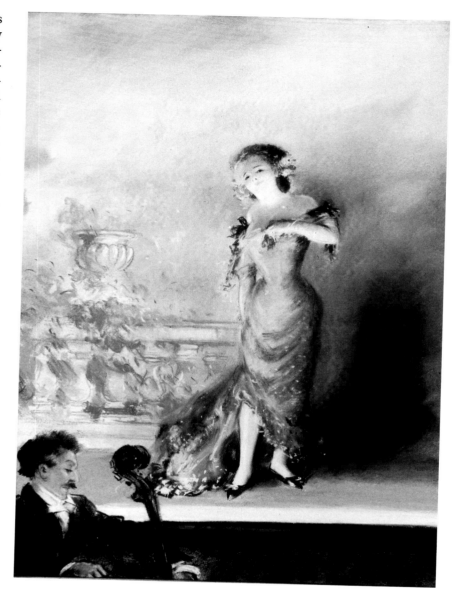

was instrumental in bringing Shinn his most important New York City decorative commission, the murals in David Belasco's Stuyvesant Theater.[46]

Sometime in 1906, Belasco selected Shinn, along with Tiffany and Company and the theater designers John Rapp and Wilfred Buckland, to execute the interior decorations for the theater designed by the architect George Keister on West 44th Street (now the Belasco Theater) being built to Belasco's own specification.[47] In October 1907, Shinn was once again celebrated in his public debut as a muralist with the opening of the Stuyvesant Thea-

13. Everett Shinn, *Julie Bonbon*, 1907, pastel on paper, 54.6 x 39.4 (21¹/₂ x 15¹/₂) Metropolitan Museum of Art, Gift of Mrs. Maurice Stern, 1970 (1970.306)

14. Everett Shinn, *The Orchestra Pit, Old Proctor's Fifth Avenue Theatre*, c. 1906–1907, oil on canvas, 44.3 x 49.5 (17⁷/₁₆ x 19¹/₂) Collection of Diana and Arthur G. Altschul

15. Detail, Everett Shinn, *Mural over proscenium arch* (medium and dimensions unknown) Belasco Theater, New York. Photograph courtesy of Archives of American Art, Smithsonian Institution, Washington, D.C.

ter: "When the theatre is thrown open to the public this week it will not only mark the entrance of a new playhouse for the amusement of the public, but it will introduce a new mural painter who, though young, has taken his place among the foremost artists of this country."[48]

Throughout the theater, along the side and rear walls, are decorative panels in Shinn's neo-rococo mode: landscapes peopled with "figures of the Louis period." Over the proscenium arch on a panel some thirty-five feet by eight feet is an ambitious and complex figural composition. In a program worked out with Belasco, Shinn painted twenty-nine figures enacting an allegory of the passions excited by the dramatic arts. Related figural motifs appear on panels and lunettes above the boxes.[49] These are not the academically correct figures familiar in the classical canon of contemporary mural painting, but a peculiar elongated and mannered type that was admired but whose pecularities were duly noted by commentators as "impressively personal" and as "real and yet intensely unreal at once" (fig. 15).[50] These characteristics place Shinn's figures much closer to the nudes and nymphs inhabiting the dreamlike realm painted by American symbolist Arthur B. Davies than to the American Renaissance.

The two were certainly acquainted. In fact, when the Stuyvesant Theater opened late in October 1907, Davies, Henri, and Sloan were already working with William Macbeth on plans for the exhibition of independent progressive artists to be held at his gallery in February 1908. Shinn, who had drifted away from the Philadelphia group, returned in late 1907 to join forces for the Macbeth exhibition.[51] So some four and one-half months after the triumph of the Stuyvesant Theater, the Macbeth show brought Shinn's work back to public notice in a different context: that of an insurgent modernist.

Shinn's selection of eight theater paintings to represent him in the exhibition suggests both the central importance of the theme to him and its function as a demonstration of modernism: "Mr. Shinn shows eight of his characteristic theatre subjects, racy glimpses of stage life, pun-

gently wrought, and not without a forcible, vivid expressiveness. He is not a draughtsman like Degas of course, but he has an impressive dramatic note."[52] Another element in his decision to focus on this subject may well lie in the fact that a year earlier two theater paintings had been rejected for exhibition by the National Academy of Design.[53] There must have been, therefore, a special satisfaction in the positive critical reception of these works: "They are strong and convincing and they portray phases of the life of the stage, the ballet, the rehearsal and the like. They would pass as strong and individual even if they were not hall-marked as belonging to the epoch-making eight."[54]

In fact, these eight paintings virtually summarize Shinn's theater subject matter, from the English and French music hall (fig. 7), to American vaudeville (fig. 14) and the ballet (fig. 8). These themes had been worked repeatedly in pastel and in the oil medium and represented the culmination of Shinn's creative effort as a painter. They also represented his limitations. In a perceptive review of Shinn's contribution to the Macbeth exhibition, a writer for the *New York Tribune* summarized his continuing problematic kinship with earlier masters:

Mr. Shinn is, indeed, extraordinarily adroit. But between the personality that it is to be inferred he is endeavoring to express and the sympathetic but unprejudiced eye there stand the brilliant figures of Degas and Forain. It is not that Mr. Shinn has borrowed their motives. Theatrical scenes, ballet girls, have been painted by unnumbered artists. It is that what these Frenchmen mean as regards style keeps getting into the foreground of the young American's work, only there it wears the air of a mannerism, of a derivative thing. It is impossible to consider this situation without regret. A man of such ability ought surely to be doing fresher and finer things.[55]

Shinn participated in the Exhibition of Independent Artists in April 1910, a sequel to the Macbeth exhibition, but by then was becoming involved with the theater. Perhaps the Belasco commission of 1907 had rekindled his early interest in performance and stagecraft. Late in that year, Shinn had built a studio in the back of his Waverly Place house.[56] By 1910, it was reported to contain "tiny models of stages set with scenery and fully equipped with electric lights no bigger than peas—for Mr. Shinn designs many theatrical effects."[57] In 1912, the studio served as a private little theater where his so-called Waverly Street Players (a troupe including Florence Shinn, Wilfred Buckland, and William Glackens) performed Shinn's own farcical melodramas.[58] The end of this halcyon period, and indeed of Shinn's productive career as a painter, was signaled by his divorce in the summer of 1912.[59] By 1917, while continuing to paint and work as an illustrator and decorator, he had begun a second career as an art director in the motion picture industry.[60]

Thrust by early association into a circle of progressive artists, Shinn had assimilated the pictorial vocabulary of the modern life subject with the same ease with which he later mastered the rococo revivalist idiom that dominated his ornamental work. Given his preoccupation from the beginning with style and surface effect, the theater was a natural arena for his talents as both painter and decorator. While he was ultimately content to quote—albeit brilliantly—from earlier masters rather than to push beyond his distinguished models to forge a true personal style, nevertheless, from 1900 to 1912, Everett Shinn produced a series of memorable theater paintings and pastels for which he is justly remembered today.

I wish to acknowledge Arthur G. Altschul for his kind cooperation, not only in allowing me to study the works in the collection, but in giving me access to his extensive files on the artist. Rita Fraad was also most helpful in opening collection files to me. Elizabeth Milroy, Wesleyan University, generously shared her knowledge of Shinn with me early in this project, as did Jan Seidler Ramirez, Museum of the City of New York, and Richard Wattenmaker. Anthony W. Robins, New York Landmarks Preservation Commission, provided the commission's extensive and well-documented report on the Belasco Theater. Elizabeth M. Wright, the Saint Louis Art Museum, and Andrew Walker, the Brooklyn Museum, provided prompt research assistance for which I am grateful. Sandra Leff, Graham Gallery, and David Henry, Spanierman Gallery, were very cooperative in consulting gallery files. For special assistance in obtaining photographs, slides and permissions, I would like to thank Nancy K. Anderson, National Gallery of Art; Kevin J. Avery, the Metropolitan Museum of Art; Fred Bernaski, Kennedy Galleries, Inc.; Larry Clark, the Brooklyn Museum; Jane Myers, Amon Carter Museum; Milo Naeve, the Art Institute of Chicago; Ira Spanierman, Spanierman Gallery; and Judith Throm, Archives of American Art.

1. Joseph J. Kwiat, "Dreiser's *The 'Genius'* and Everett Shinn, The 'Ash-Can' Painter," *Publications of the Modern Language Association of America* 67 (March 1952), 16–31. The novel has been a source of confusion, since some later writers on Shinn have accepted the contents as a biography without accounting for Dreiser's considerable poetic license. In his article, Kwiat records Shinn's annotations of the book indicating which episodes are actually based on his early life.

2. The most useful recent monographs and catalogues include: *Everett Shinn—An Exhibition of His Work* [exh. cat., Henry Clay Frick Fine Arts Department of the University of Pittsburgh] (Pittsburgh, 1959); Edgar John Bullard III, "John Sloan and the Philadelphia Realists as Illustrators, 1890–1920" (master's thesis, University of California, Los Angeles, 1968); Edith DeShazo, *Everett Shinn 1876–1953* [exh. cat., New Jersey State Museum, Delaware Art Museum, and Munson-Williams-Proctor Institute] (Trenton, N.J., 1973); Edith DeShazo, *Everett Shinn 1876–1953: A Figure in His Time* (New York, 1974). Shinn papers are deposited at the Archives of American Art, Smithsonian Institution, Washington, D.C., and at the Delaware Art Museum, Wilmington.

3. William Innes Homer, *Robert Henri and His Circle* (Ithaca, N.Y., 1969), 73, 80.

4. "Artists of the Philadelphia Press," *Philadelphia Museum Bulletin* 41 (November 1945), 8.

5. Henri studied in Paris from 1888 to 1891 (Homer 1969, 38–67). Luks studied painting at Dusseldorf, Munich, Paris, and London, returning in the early nineties (Homer 1969, 80–81). Glackens' older brother was a cartoonist for *Puck*, and his own newspaper career began in 1891 (Bullard 1968, 44). Sloan worked for a book and print dealer before becoming a commercial artist. He joined the *Philadelphia Inquirer* in 1892 (Homer 1969, 80).

6. Bullard 1968, 40. In 1895, drawings by Shinn in the manner of Steinlen were published in *Gil Blas*, a magazine named for the Parisian journal (Bullard 1968, 63). An 1898 article on Shinn's illustrations (J. Warner Pemberton, "Artist Shinn: His Summer Girls and Some Others," *Illustrated American* [22 July 1898]) included a deftly drawn "French Café Scene." Everett Shinn Papers, roll 952, frame 0002, Archives of American Art, Smithsonian Institution, gift of Howard Lipman (hereafter Shinn Papers).

7. Homer 1969, 79.

8. Everett Shinn, "I Remember New York," typescript, Shinn Papers, roll 794, frame 661. Shinn states in error that he was nineteen at the time of the move.

9. Bullard 1968, 57, 63, 47; Homer 1969, 98; Bruce St. John, *John Sloan* (New York, 1971), 29.

10. DeShazo 1974, 34. For Florence Scovel Shinn see *A Circle of Friends: Art Colonies of Cornish and Dublin* [exh. cat., Thorne-Sagendorph Art Gallery, Keene State College; Saint-Gaudens National Historic Site; Hood Museum of Art, Dartmouth College; and University Art Galleries, University of New Hampshire (Keene, N.H., 1985), 115, 137.

11. Bullard 1968, 65.

12. Kwiat 1952, 25.

13. Early in 1901, *Town Topics* noted "the remarkable book, 'New York By Night,' lying about his studio." "Passing Up a Few Facts," *Town Topics*, undated clipping (January–February 1901), Shinn Papers, roll D179, frame 0029. Shinn's record book traces efforts to have the book published as late as 1902. Shinn Papers, rolls 952, 953. The 1959 Pittsburgh exhibition included the "portfolio of 35 pastels of night scenes of New York planned for publication 1899. In wood box made by Everett Shinn" (no. 1 lent by Charles T. Henry). The cover drawing is in the Saint Louis Art Museum. See Ruth L. Bohan, "American Drawings and Watercolors, 1900–1945," *Saint Louis Art Museum Bulletin* 9 (Summer 1989), 44–45.

14. Shinn's two record books reflect his dual ambitions. Begun in 1899 and kept until 1911, one records primarily his pastels, oil paintings, and decorative commissions, the other, his and his wife's work as illustrators. There is some duplication, but generally the contents reflect Shinn's own desire to distinguish between illustration commissions and his more autonomous work. They are also a highly valuable and informative record of his early patronage and support. Shinn Papers, rolls 952, 953.

15. From 16 January to 25 February, he showed: 1. *Ele-*

vated Station 33rd St. 2. *Fifth Avenue*. 3. *The Docks*. 4. *House-tops—Rainy Day*. 5. *Street Scene*—Sold. Wm. M. Chase. Record book, Shinn Papers, 1. Chase had begun teaching at the Pennsylvania Academy in 1896, dividing his time between Philadelphia and his own Chase School of Art, renamed the New York School of Art in 1898. Ronald G. Pisano, *A Leading Spirit in American Art: William Merritt Chase, 1849–1916* (Seattle, 1983), 95–96.

16. Dianne H. Pilgrim, "The Revival of Pastels in Late Nineteenth-Century America: The Society of Painters in Pastel," *American Art Journal* 10 (November 1978), 43–44; Pilgrim, "Introduction," in *Painters in Pastel: A Survey of American Works* [exh. cat., Hirschl and Adler Galleries] (New York, 1987), 10–11.

17. Record book, Shinn Papers, 4. Shinn taught the sketch class there in the 1901–02 season. Printed notice, Shinn Papers, roll D179, frame 0064.

18. Record book, Shinn Papers, 5. Shinn, "I Remember New York."

19. Charles W. Stein, ed., *American Vaudeville as Seen by Its Contemporaries* (New York, 1984), 4–5.

20. Stein 1984, xi–xiii.

21. The artist acknowledged White's support and advice in Everett Shinn, "Recollection of the Eight," in *The Eight* [exh. cat., Brooklyn Museum] (New York, 1944), 20. White's name comes up on several occasions in a study of Shinn's early career and their association remains to be studied. The exhibition was held from 26 February to 4 April 1900. Theater titles were: 20. *The Theatre*. 21. *14th St. Theatre*. 26. *The Lime-Light*. 30. *During the Biograph*. Portraits: 1. *Miss Elsie de Wolfe*. 2. *Miss Julia Marlowe*. 3. *Miss Marlowe—(as Viola)*. 4. [Miss Julia Marlowe] (*Barbara Frietchie*). 5. *Mr. Clyde Fitch*. Record book, Shinn Papers, 5–7. "Art Notes," *New York Evening Sun*, 24 February 1900, Shinn Papers, roll 952, frame 007. Shinn often mixed body color or gouache with the pastel medium, hence the references to "watercolors."

22. Clyde Fitch to Everett Shinn, New York, undated, Shinn Papers, roll 952, frame 1047. William Dean Howells to Mildred Howells, 5 March 1900, quoted in Kwiat 1952, 25 n. 18.

23. *New York Tribune*, 27 February 1900, Shinn Papers, roll D179, frame 0007. "At the Academy," *Philadelphia Times*, 17 April 1900, Shinn Papers, roll D179, frame 0014. *New York Tribune*, 27 February 1900. *New York Times*, 3 March 1900, Shinn Papers, roll D179, frame 0008.

24. Regina Armstrong, "New Leaders in American Illustration: IV—The Typists: McCarter, Yohn, Glackens, Shinn and Luks," *Bookman* 2 (May 1900), 248–49.

25. Unidentified clipping, "The Academy Exhibition," January 1900. Shinn Papers, roll D179, frame 0006.

26. Four works, undoubtedly pastels, were placed at Goupils, Paris, on 3 July 1900, and the undated entry that follows immediately records a *Portrait* presented to Miss de Wolfe as a gift, perhaps for hospitality at Versailles. Record Book, Shinn Papers, 13. In an article based on an interview, Shinn incorrectly dated this trip to 1903, causing confusion among later writers who assumed two trips. Shinn, however, conformed its uniqueness: "He liked it but he never went back." James Fitzsimmons, "Everett Shinn: Lone Survivor of 'The Ashcan School,'" *Art Digest* 27 (15 November 1952), 10. Although Shinn was abroad during the summer months, he often depicted Paris in the snow, a device he had found very successful in his New York subjects and which he apparently did not hesitate to apply to his French views, although it could not have been based upon direct experience. Jane S. Smith, *Elsie de Wolfe: A Life in the High Style* (New York, 1982), 77–78.

27. The exhibition, which ran from January 15 to February 23, included: 4. *Grand Ballet*, e. *Back Row. Folies Bergere*. 23. *Behind Scenes*. 24. *Ballet Dance (orchestra)*. 28. *Gaieté Montparnasse*. 29–32. *Madame L. of the Chatalet* [a dancer]. 37. *The Theatre*. Uncatalogued works included thirteen "ballet girl" subjects, added, one assumes, to meet popular demand and 5. *In the Wings*. 33. *French Cabaret*. Record book, Shinn Papers, 16–19.

28. Record book, Shinn Papers, 20–30. *New York Tribune*, 9 November 1901, Shinn Papers, roll D179, frame 0038.

29. M. Knoedler and Co., "Exhibition of Pastels by Everett Shinn," 9–21 March 1903; Durand-Ruel Galleries, "Exhibition of Pastels by Everett Shinn," 2–16 March 1904. Record book, Shinn Papers, 40, 48.

30. "Airs and Acts by Everett Shinn." Unidentified clipping. Shinn Papers, roll D179, frame 0011. "Everett Shinn's Work," *New York Times*, 12 March 1904. Shinn Papers, roll D179, frame 0058. The work here illustrated is a second version of *The Love Song*.

31. "Life Is Depicted in Shinn's Pastels," *Philadelphia Inquirer*, 14 March 1901. Shinn Papers, roll D179, frame 0004.

32. The earliest dated painting known is *London Hippodrome*, 1902. A *Ballet Girl* in oil and pastel was among the uncatalogued works shown at Boussod, Valadon in 1901, and that same year, a "Ballet girl—(oil) dancing" was shown at Kraushaar. Record book, Shinn Papers, 19, 32.

33. William Le Queux, "The Hermit of Rue Madame," *Ainslee's Magazine* 3 (April 1899), 268.

34. Henri Pène du Bois, "A Fragonard of the Present Time," *New York American*, 22 February 1905, Shinn Papers, roll D179, frame 0011. The exhibition ran from 20 February to 6 March 1905. Theater titles were: 1. *The Ballet*. 4. *The Song—French Stage*. 5. *The Spanish Dance*. 6. *Outdoor Stage. France*. 7. *Carmen*. 8. *Funny Man*. 9. *Rehearsal*. 10. *Stage—France*. 14. *Box. French Theatre*. 16. *French Theatre*. 18. *Poster Curtain. Paris Music Hall*. Record book, Shinn Papers, 57–58.

35. Albert E. Gallatin, "Studio-Talk," *Studio* 39 (October 1906), 86–87.

36. Henri Pène du Bois, 22 February 1905. Gallatin 1906, 86.

37. He mistakenly refers to them in the text as pastels, probably a typographical error since his topic is

oil painting, and titles the Brooklyn Museum's painting *Outdoor Stage, France*.

38. Arsene Alexandre, *Jean-Francois Raffaëlli: Peinteur, Graveur et Sculpteur* (Paris, 1909), 131, 148.

39. Gallatin 1906, 86.

40. Dianne H. Pilgrim, "Decorative Art: The Domestic Environment," in *The American Renaissance: 1876–1917* [exh. cat., Brooklyn Museum, National Collection of Fine Arts, Fine Arts Museums of San Francisco, and Denver Art Museum] (Brooklyn, 1979), 149. Gary A. Reynolds, *Walter Gay: A Retrospective* [exh. cat., Grey Art Gallery and Study Center, New York University] (New York, 1980), 12, 81–82.

41. Smith 1982, 96–97. Russell Lynes, *More than Meets the Eye: The History and Collections of Cooper-Hewitt Museum* (Washington, D.C., 1981), 19–21. Reynolds 1980, 75.

42. Smith 1982, 61–68.

43. Elsie de Wolfe met Gay about 1899. Smith 1982, 75. An article on Shinn's decorative work noted: "In the Cluny Museum in Paris are examples of what can be done in the way of decorating musical instruments. There Mr. Shinn spent months studying their decorations." "The Transformed Piano," *The Sun*, 15 October 1905, Shinn Papers, roll D179, frame 0061.

44. Smith 1982, 90–100.

45. Sometime in 1905, Clyde Fitch asked Shinn to decorate his New York house—a commission that included ceilings, wall panels, and a grand piano—all in the rococo manner. Donald Wilhelm, "Everett Shinn, Versatilist," *Independent*, 4 December 1916, 398. Early that year, the Gimpel and Wildenstein exhibition had included two decorative works: 2. *Decoration* and 17. *Decoration for over-door—Sketch*, perhaps related to the Fitch commission. Between November 1905 and January 1909, the record book lists executed commissions and regular exhibitions of ornamental projects, including photographs of completed commissions as well as drawings for decorative designs, including several for theaters. Record book, Shinn Papers, 74, 77, 81. In a letter of 1906, de Wolfe instructs Shinn to make designs for a mantel and drawers. Elsie de Wolfe to Everett Shinn, New York, 3 March 1906, Shinn Papers, roll 952, frame 0921.

46. Shinn himself indicated that White had played a role in his securing the commission, if not by introduction before his death, then by association afterward: "Belasco knew that Stanford White had been my friend and that by my proximity to his unerring taste I must have gleaned something of selectiveness. It assured him of guidance toward those objects that would advertise still further his reputation for impeccable taste." DeShazo 1974, 87.

47. Janet Adams, "The Belasco Theatre" (Report, New York Landmarks Preservation Commission, 4 November 1987), 2, 10–12. Adams states that Fitch introduced Shinn to Belasco.

48. "New Stuyvesant Decorations Will Bring Fame to Shinn," *New York American*, undated clipping (October 1907), Shinn Papers, roll 952, frame 1295.

While the scale of the project—a public building—was beyond the domestic nature of Shinn's previous work, he was not without some experience on the grand scale, having executed whole ceilings on residential projects and, in 1906–07, assisting Henry Brown Fuller on a mural executed for Principia College, Illinois, *Triumph of Truth Over Error*. A Circle of Friends 1985, 87, 133, 113, 136. Shinn's American Renaissance connections like this one remain to be explored. A particularly fascinating and unstudied episode is Shinn's sojourn as a member of the art colony at Cornish, New Hampshire, established by Augustus Saint-Gaudens in 1885. Shinn's own country house was built there sometime in 1903 from plans acquired from architect Harry T. Lindeberg in trade for a pastel. A Circle of Friends 1985, 113–114, 136–137. Record Book, 46. This short interlude included Shinn's participation in the masque of June 20, 1905, in the form of a Greek festival given in honor of Saint-Gaudens and the twentieth anniversary of the Cornish colony—an event that must have appealed strongly to Shinn's love of theater. A delightful letter with Shinn's quick pen sketch of the finale—a triumphal procession drawing Mr. and Mrs. Saint-Gaudens in a chariot—thanks the sculptor for the commemorative bronze plaque Saint-Gaudens presented to all participants. A Circle of Friends 1985, 113–114; Shinn to Augustus Saint-Gaudens, New York, 30 September 1906, Dartmouth College Library.

49. "Most Beautiful Theater in World," *Chicago Examiner*, 20 October 1907, Shinn Papers, roll 952, frame 1299. *Philadelphia Inquirer*, 13 October 1907, Shinn Papers, roll 952, frame 1298. Adams 1987, 13–14.

50. *New York American*, undated clipping (October 1907), Shinn Papers, roll 952, frame 1295.

51. Homer 1969, 136.

52. "Exhibition of the Eight," *Boston Transcript*, 4 February 1908, Shinn Papers, roll 952, frame 1315.

53. According to his record book, Shinn sent *A Glimpse of the Stage* and *In The Orchestra*. The entry is crossed out with an "X." Record book, Shinn Papers, 80. At Macbeth Gallery he exhibited the following works: 1. *Gaieté Montparnasse*. 2. *Rehearsal of the Ballet*. 3. *White Ballet*. 4. *Leader of the Orchestra*. 5. *The Gingerbread Man*. 6. *Orchestra Pit*. 7. *Girl in Blue*. 9. *Hippodrome London*. Record book, Shinn Papers, 83.

54. "Showing Pictures by Eight 'Rebels,'" *New York Herald*, 4 February 1908, Shinn Papers, roll 952, frame 1315.

55. "New Pictures by American Artists and Some Old Prints," *New York Tribune*, 5 February 1908, Shinn Papers, roll 952, frame 1319.

56. *Philadelphia Inquirer*, 13 October 1904, Shinn Papers, roll 952, frame 1298.

57. Walter Pritchard Eaton, "The Latin Quarter of New York," *Metropolitan Magazine*, May 1901, 166–167.

58. DeShazo 1974, 71–81.

59. DeShazo 1974, 70, 121–123.

60. DeShazo 1974, 113.

KATHLEEN A. FOSTER

Indiana University Art Museum

Realism or Impressionism?

The Landscapes of Thomas Eakins

The discovery of an unexamined cache of oil sketches, drawings, sculptures, photographs, and manuscripts from the studio of Thomas Eakins presents a rare and exciting opportunity.[1] The material hoarded by Eakins' student, Charles Bregler, and acquired by the Pennsylvania Academy of the Fine Arts in 1985 offers fresh perspectives on some well-known aspects of Eakins' work and presents the chance to refine, revise, and even overturn earlier observations and conclusions. The challenge of new-found work is especially useful and stimulating in the study of Eakins' work, for no American artist of the nineteenth century has risen from relative obscurity in his own day to a present celebrity so closely identified with American realism.[2] Eakins, more than other painters of his period, tends to be typecast as a realist, an academic and scientific naturalist opposed to the more subjective, abstract or expressionistic currents of progressive late nineteenth-century art. In purifying this opposition to define something "American" about Eakins, his realism becomes too easily understood as either "honest" illusionism or a descriptiveness based on both known "truth" and surface appearances. The simplicity of this approach to Eakins has been intentionally muddied by recent scholarship seeking a more complex understanding of the artist in the context of his contemporaries, but the popular conception of him as the paradigmatic American realist remains dominant.[3] The emergence of a new body of work from Eakins, representing the most informal and personal aspects of his method, allows an opportunity to test these truisms—which are based on important kernels of truth and many sound observations—and correct their tendency to settle into falsehood through exaggeration or oversimplification.

The revision of cliché is potentially most striking in the realm of Eakins' landscape painting, for the conventional view would have him be a painter whose forays into genre and history can be read as expressions of his dominant interest in portraiture. While this perception is neither false nor without use, as Elizabeth Johns has shown, the landscape factor in his oeuvre is surprisingly large: 30 percent of his lifetime work in painting and drawing included a landscape component. This percentage swells in importance in a survey of work up to 1888, when he completed his last landscape, *Cowboys in the Badlands* (private collection); in the first three decades of his career outdoor subjects, including figures in landscape and pure landscape studies, constituted nearly half of Eakins' efforts as a painter.[4] The meaning of this large body of work in his oeuvre is expanded by examination of the many new landscape drawings, photographs, and oil

1. Thomas Eakins, after James D. Harding, *Tree Studies: Elm, Oak*, c. 1858–1860, graphite on wove paper, 23 x 37.5 (9¹/₁₆ x 14³/₄)
Courtesy of the Pennsylvania Academy of the Fine Arts, Philadelphia. Charles Bregler's Thomas Eakins Collection, purchased with the partial support of the Pew Memorial Trust and the John S. Phillips Fund

sketches that have emerged from Charles Bregler's collection. These items, many of them uncatalogued by Lloyd Goodrich in 1933 and all of them unseen since then, help us reconsider Eakins' training in landscape painting, his stylistic sources, and the method that he developed uniting photographs and outdoor sketches in the service of a realism more complex and paradoxical than his portraits—or his reputation—might suggest.

The first surprise in this recent trove is the early appearance of Eakins' interest in landscape study. Previously known juvenile drawings have illustrated the impact of his high school curriculum, with its emphasis on mechanical drawing and perspective,[5] but among these early items only one tiny watercolor of a cottage and two pencil drawings of figures in outdoor settings have shown evidence of experience with landscape subjects before 1870. None of these three images seems to have been done from life; the two drawings were evidently copied in 1858 from European lithographs, as exercises during the first two terms of his Central High School drawing class.[6] The newly discovered group of drawings from Bregler's collection repeats the copy-book method of these classroom drawings, but with a more focused attention to landscape problems (fig. 1). More competent than the 1858 drawings, but boyishly prone to doodling, these new pages seem to be from these same high school years, perhaps 1858 to 1860. The source of these drawings is betrayed in the conventionalized foliage patterns—mannerisms to depict the character of different tree species that were developed by the masters of the romantic landscape school and taught in the self-instruction manuals that proliferated throughout the nineteenth century. Such shorthand devices are typically learned, not spontaneously invented, and their use, especially by a young artist, suggests the copying of other art, not study from nature. The neat labels under each vignette ("Elm," "Oak") and the replication of one subject twice on the same page also imply a bookish source, and the tiny monogram on one (JDH) reveals the author.

James Duffield Harding (1798–1863), a British landscapist in a popular romantic mode, was well regarded at mid-century on both sides of the Atlantic, but he was best known in America as "the author of

2. James D. Harding, *Lessons on Trees: Plate 7*, 1855, lithograph on white wove paper
Courtesy of the Pennsylvania Academy of the Fine Arts, Philadelphia

tral, Alexander MacNeill, or the school library might have held a copy of Harding's recent work, *Lessons on Trees*, first published in London in 1855 and reprinted, with new or revised plates, in 1858.[9]

Among the larger group of Eakins' juvenile drawings found in Bregler's collection are eight subjects (on four sheets) showing a progression of copied plates from Harding's *Lessons on Trees* (fig. 2). This study from Harding confirms attitudes seen much later in Eakins' work, here expressed at about age fourteen to sixteen. He chose, notably, an up-to-the-minute publication by an authoritative (albeit conservative) contemporary author, suggesting a search for the best and most recent source, one well recommended by people he respected. As Elizabeth Johns has shown, Eakins was attentive to both modernity and expertise; he did not choose old-fashioned or offbeat models. His decision to spend long hours out of school teaching himself from a book also demonstrates a modern and American enthusiasm for self-improvement. The popularity of do-it-yourself art instruction manuals is especially characteristic of American culture; Eakins, as one representative of this spirit, was not going to be held back by the absence of teachers.[10]

By his choice of Harding, Eakins placed himself squarely in the mainstream of American landscape painting around 1858. The members of the Hudson River school had begun as young men with the same sources, mostly from British romantic painting. Gradually, this heritage was modified by a national attention to the particularities of the American scene, an interest that grew more observant under the influence of John Ruskin's aesthetics in the 1850s. Harding practiced a pre-Ruskinian method, dependent on "recipes" and generalizing conventions that were anathema to the most progressive American painters in this period, but the galleries were nonetheless full of landscapes produced in the more formulaic style of Harding and his contemporaries, or in a gentle compromise of the older, "broad" manner and the new, crisply observed factuality. The most fanatical phase of Ruskinism, seen in the work of the American Pre-Raphaelites between 1858 and about

several text-books for schools, and other highly-regarded works on art subjects."[7] Indeed, Harding's work was known and recommended by Rembrandt Peale, who was the author of *Graphics*, the principal drawing manual used at Central High School, and the architect of the larger drawing curriculum for the Philadelphia public schools.[8] No unit on landscape drawing seems to have been included in Peale's standard course of study, but Harding's work may have been recommended to Eakins by the drawing teacher at Cen-

3. Thomas Eakins, *Tree Studies*, c. 1858–1860, graphite on buff wove paper, 17.9 x 25.6 (7¹/₁₆ x 10¹/₁₆)
Courtesy of the Pennsylvania Academy of the Fine Arts, Philadelphia. Charles Bregler's Thomas Eakins Collection, purchased with the partial support of the Pew Memorial Trust and the John S. Phillips Fund

1865, was just beginning, inspired by Ruskin's prose and by the traveling exhibition of English painting that appeared in Boston, New York, and Philadelphia (at the Pennsylvania Academy of the Fine Arts) in 1857 and 1858. Many American painters, including the Philadelphian William T. Richards, were galvanized by this exhibition, which included controversial examples of the work of the English Pre-Raphaelites. Eakins, for his part, seems to have been moved by the more conventional work of the British old guard, including Harding, that dominated this show.[11]

If the loan exhibition inspired Eakins, like others, to take up landscape study with seriousness, his approach—by way of the library—was typical of his own methodical style. Unlike Richards, who abandoned studio artifice at this moment in favor of work entirely from nature, Eakins sought a systematic approach that equipped the artist with skills and strategies to control his subject before ever stepping outdoors. Richards was more experienced; Eakins, a beginner, needed to absorb the conventional wisdom of a seasoned practitioner like Harding before venturing into the field. The impulse toward premeditated, disciplined study—as opposed to confronting the chaotic environment of nature all at once, unarmed—remained characteristic of Eakins. Evidently, he soon discovered that Harding, while systematic, was hardly scientific. The extant drawings suggest that Eakins proceeded dutifully to about lesson 30, learning the foliage, trunk, branch, and bark conventions for several different tree types. But then (if the surviving examples are a complete or representative selection), after about eight sheets, he stopped, copying only one of the more complex subjects (lesson 46) that depicted incidental landscape groupings—boulders, bushes, fallen trees, fence posts—or fully developed landscape compositions (fig. 3). These lessons are instead enacted in similar motifs that Eakins evidently studied himself, outdoors (fig. 4). This progression implies two things: that Eakins became

4. James D. Harding, *Lessons on Trees: Lesson 46*, 1855, lithograph on white wove paper
Courtesy of the Pennsylvania Academy of the Fine Arts, Philadelphia

bored or dissatisfied with Harding's synthetic approach (or his own approach by way of Harding) and decided to observe and compose on his own; and that he could inventively recapitulate, from his own experience, structures suggested by others. These landscape studies *not* done from Harding show an understanding of Harding's grammar, if not a graceful command of his surface manner. The ability to generalize creatively from academic examples was one of Eakins' strengths. Later, his

similar absorption and re-creation of models learned from the work of his master, Jean-Léon Gérôme, led to some of Eakins' most innovative, "American" work.[12] This early self-instruction in landscape displays qualities of initiative and self-reliance, discipline, emphasis on personal observation from nature, and the creative assimilation of models—all qualities that would be turned to good use later.

If extant drawings can be trusted, Eakins abandoned landscape work after this period, perhaps because he was dissatisfied with landscape drawing in general, or more likely because his attention was stolen by figure subjects, which became the center of his work from the time of his enrollment at the Pennsylvania Academy in 1862. Few examples of his work in any medium survive from the 1860s, and those that do suggest an unrelenting interest in the figure. Late in 1869, after three years of work in Europe, he concluded his student phase and left Paris for Seville, where he began his first "picture." Years spent painting from the model in Gérôme's atelier did not prepare Eakins for the problems of outdoor light that he encountered in this first composition, *Street Scene in Seville* (collection of Mrs. John Randolph Garrett, Sr.). Months of struggle, documented in his letters home as well as in the labored surface of the painting, brought only a small success. Eakins complained about the difficulties of shifting light, so infuriating to a painter who was constitutionally a slow and deliberate worker. Equally frustrating was the balancing of color values, so much brighter and more wide-ranging in Spain than in Gérôme's atelier, with its steady northern light and typically overcast sky. "I had to change & bother, paint in & out," he wrote. "Picture making is new to me, there is the sun & gay colors & a hundred things you never see in a studio light & ever so many botherations that no one out of the trade could ever guess at. I hope to soon be over the worst part."[13]

Eakins returned to Philadelphia in the summer of 1870 with *Street Scene in Seville* in his baggage and a determination to conquer the "worst part" of outdoor figure painting that this first picture had introduced into his work. Within a year, as if by

5. Thomas Eakins, *Max Schmitt in a Single Scull*, 1871, oil on canvas, 81.9 x 117.5 (32¼ x 46¼) Metropolitan Museum of Art, Alfred N. Punnett Fund and Gift of George D. Pratt, 1934 (34.92)

a miracle, he produced a masterpiece: *Max Schmitt in a Single Scull* (or *The Champion Single Sculls*) of 1871 (fig. 5). In the interval he attempted no other landscape work—only interior scenes depicting his family.[14] The startling competence of this painting in both color and drawing has always been a wonder; now, the distance traversed from his landscape drawings a decade earlier must be measured with surprise as well. There remains little of Harding here, either in linear formula or structure. Instead we meet a mature statement of the contemporary American landscape school, crossed by exposure to recent French painting. In the intervening years it is clear that Eakins has not just put Harding behind him in favor of personal observation: he has also carefully studied the work of American artists such as John F. Kensett, working in a style now described as luminism, and also absorbed lessons from French Barbizon and preimpressionist landscape painting easily seen in Paris and occasion-

ally accessible in the United States. The scrubbed and scratchy brushwork in the foliage and background, reminiscent of late Kensett or Albert Bierstadt, and the cool, blue-and-brown tonality of the scene partake of both American and French contemporary landscape art. Distinctly French is the tendency to scumble and generalize his foliage, in the manner of Courbet; some of the sky and landscape backgrounds in these early 1870s pictures show broad work with the palette knife. Peculiarly American is the luminist character of the picture: its deep space, reflected sky and water, thinly painted surface, and tranquil, almost breathless suspension.[15] Also like Kensett, and like the early impressionists in exactly this year, is Eakins' bold division of the canvas into abstract shapes of light and dark that read flatly while suggesting an enormous wedge into space. If the modernity of this style is striking, perhaps even more remarkable is the successful suggestion of afternoon sunlight and the high,

6. Thomas Eakins, *The Artist and His Father Hunting Reed Birds: Marsh Landscape Sketch*, c. 1873, oil on canvas, 14 x 21.4 (5¹/₂ x 8⁷/₁₆) Courtesy of the Pennsylvania Academy of the Fine Arts, Philadelphia. Charles Bregler's Thomas Eakins Collection, purchased with the partial support of the Pew Memorial Trust and the Henry S. McNeil Fund

hazy North American sky; within a year, Eakins had gone from insecure student status, much dependent on Gérôme (whose example offered little assistance to landscape painters), to a confident mastery of contemporary landscape techniques from both sides of the Atlantic.

How Eakins accomplished this transition remains, at least in respect to *Max Schmitt*, something of a mystery, for there are no preparatory materials extant for this painting aside from a tiny pencil sketch of a bridge pier (Hirshhorn Museum). Surviving oil sketches and perspective drawings for his other rowing subjects do not explain how he conquered the difficulties of an expansive subject with such atmospheric finesse. The available preparatory studies do show him struggling with placement of figures and boats in space and with correctly, scientifically rendered reflections, but they show little work on color and light. As Theodor Siegl has shown, the problem of reflections was attacked geometrically in these years, ultimately arriving at a formula to depict the reflecting surfaces of ripples that posited mechanical, standardized waves—not the actual, impossible complexity of curving water surfaces.[16] It was a systematic, scientific way to handle the overwhelming variables of outdoor conditions. In an attempt to isolate other factors, Eakins made "rag figures" dressed in scraps of appropriate col-

ors and "put them out into the sunlight on the roof and painted them, and tried to get the true tones."[17] These sketches do not survive, and only a few others from this period suggest work done on the sites of his major paintings.[18] The divide-and-conquer strategy of Eakins' overall method suggests, however, that he undertook special landscape studies, now lost, that were integrated with separate figure studies (informed by the experience of anatomical research), color sketches, perspective drawings, and plans. Methodologically, this approach was a model of academic procedures, driving at a realism based on the known as well as the seen. No system of landscape painting would seem to be so antiposed to the immediacy of impressionism, with its all-at-once attack and visual priority. What the impressionists lost by way of precision, however, they gained in overall unity, and Eakins' method in these early landscape pictures was always threatened by the tendency of the parts to disassociate. In *Max Schmitt* they were brilliantly integrated; in other paintings, the separate study of landscape, foliage, and sky remains awkwardly clear.

One small sketch and the draft of a letter, both discovered in Bregler's collection, indicate the actual method of these early outdoor subjects and the problems that assailed Eakins as he grappled with *plein air* technique. The sketch (fig. 6), catalogued by Goodrich among a group of undated landscape studies assigned to the period around 1881, appears upon examination to be a study for the marsh and trees in the background of *The Artist and His Father Hunting Reed Birds in the Cohansey Marshes* of c. 1874 (fig. 7). Like his other early sketches, it is done on canvas, not panel; its small size and the speedy, choppy brushwork suggest work done on the spot. Transferred to the final canvas at exactly the same scale, the subject was subdued and generalized in its new location, so as not to compete with the foreground figures, although the spatial and tonal relationships remained unaltered.[19] It must have been one among many such studies made in the fall of 1873, according to Eakins' own account of his method—and its problems—contained in the draft of a let-

7. Thomas Eakins, *The Artist and His Father Hunting Reed Birds in the Cohansey Marshes*, c. 1874, oil on canvas, 43.5 x 67.3 (17¹/₈ x 26¹/₂) Virginia Museum of Fine Arts, Richmond, Gift of Paul Mellon

ter to Gérôme, evidently written in the spring of 1874. Eakins tells of the malaria he contracted while hunting and sketching in the marshes the previous fall. Delirious for eight weeks and near death, Eakins recovered to find that "les arbres n'avait plus de feuilles." The following year his doctor forbade hunting, and Eakins was forced to complete his rail shooting pictures from "des peu d'études que j'avais faites et d'impressions qui n'était plus récentes."[20]

Eakins apparently wrote this letter to explain the circumstances—and modestly anticipate Gérôme's criticisms—of the two hunting scenes he sent to Paris in the spring of 1874. Gérôme was in fact enthusiastic (although criticizing the evenness of effect), according to a letter sent to Eakins from Paris on 18 September 1874.[21] Unmentioned in Gérôme's critique, however, were several issues raised in Eakins' draft: queries that he framed but may have never included in his actual letter. These ques-

tions indicate the frustration Eakins felt in attempting to paint outdoor light, which he found impossible to capture truthfully if the circumstances of a second, different light source on the painting, when it was moved to the studio or a gallery, had to be anticipated. Eakins complained in his draft that his tonal balance kept shifting when the painting was moved into another light; from warm to cool, or bright to diffuse, whatever the change, he found that the lights or the darks slid together, yielding weakness or unnaturalness of effect. "Quelle est l'habitude des mellieurs peintres? Y a-t'il un convenance?" he asked in desperation—seeking, perhaps, the kind of rule of thumb that Harding's manuals had cheerfully supplied in the 1850s. Gérôme's silence on this subject may be explained by the fact that Eakins realized his query appeared naive, or hopelessly elaborate, or fundamentally unanswerable, and so he never asked. "On devrait savoir l'en-

droit de l'exposition d'un tableau avant de la commencer," he wrote in slightly smaller script across the top of the page, as if replying to his own question. The impossibility of always knowing the circumstances of a painting's future exhibition must have stopped him here.[22] He had confronted a truism of illusionistic painting: that the challenge was not as simple as transferring what you see to the canvas by imitation of color and texture. Instead, in order to suggest a "natural" effect the painter had to create within the restricted world of a two-dimensional surface a system of artificial relationships based on pigment qualities or perspective grids. His sense that the most conscientious outdoor studies lost their truthfulness when seen in another light could only have redoubled his belief that a convincing realism was based more on artifice—that is, science and contrivance—than on spontaneous, imitative work. As he had written to his father in 1868, the artist does not copy nature, he "steals her tools" in order to fashion a convincing artistic reality, "parallel to Nature's sailing."[23]

The way Eakins fussed about the unknowable contingencies of a painting's future display reiterates the pattern of his search for a control over landscape painting akin to the scientific methods of inquiry and planning that he developed to handle problems of anatomy and perspective. In pursuit of this control his method grew ever more fastidious and elaborate, reaching a pinnacle of complexity in *The Fairman Rogers Four-in-Hand* (Philadelphia Museum of Art) of 1879–1880. Evidently without direct copying from photographs, the figures and horses in this painting became almost uncomfortably photographic in their inclusion of detail and the seemingly unnatural, frozen quality of "stop-action" presentation.[24] And, as the figures grew more precise, the disjunction between them and the painterly, Barbizon-style landscape increased. Perhaps, following upon Gérôme's suggestion, Eakins was determined to avoid evenness of emphasis. His mixed results, after so much effort, may have suggested an impasse to him that could only be broken by the intrusion of novel methods.

One new tool may have been suggested by the Fairman Rogers project itself, which was inspired by photographic studies of moving horses by Eadweard Muybridge. Ever alert to the possibilities for a yet-more-scientific approach, Eakins acquired his own camera, probably in 1880 or 1881. Predictably, given his interest in figure subjects, his first photographs include family portraits and figure studies; surprisingly, there are no motion studies until 1883. Instead, "pure landscapes" (along the Atlantic coast of New Jersey) and figures in landscapes (his family at the beach or fishermen at Gloucester, New Jersey) dominate the first two years of his work with the camera. The discovery of many unknown prints and glass negatives in Bregler's collection makes it possible to consider the impact of this new tool on his round of landscape work in 1881–1882.

In the spring of 1881 Eakins began the first of what would be a series of eight paintings depicting the shad fisheries at Gloucester, New Jersey. As before, his method included single figure studies in oil, such as the sunlit *Woman's Head* (probably his sister Margaret) (fig. 8), later integrated into the larger group composition of *Shad Fishing at Gloucester on the Delaware River* (fig. 9). Such painted studies were greatly outnumbered, however, by dozens of photographs taken in connection with these paintings. Prior to the emergence of Charles Bregler's collection, a half-dozen vintage prints indicated Eakins' new work with the camera, but only one extant photograph showed a close connection to a painting (*Drawing the Seine* of 1882).[25] Nearly fifty new images in Bregler's collection, mostly from glass negatives with no known prints, show how influential this new enthusiasm had become, for photographs in this new group can be seen to contribute to seven of Eakins' eight Gloucester paintings.[26] The family group that appears in *Shad Fishing*, for example, seems to have been based on two photographs, including figure 10. Most of the figures—Margaret, Caroline (?), Susan MacDowell (?), and Benjamin Eakins—appear in this photograph as they do in the painting; Harry, Margaret's red setter, was taken from a variant negative of the same

subject, photographed a moment earlier or later.[27] The selective, composite method used in the creation of this group of figures was repeated within the canvas, for the shad fishermen were derived from a different negative (fig. 11). Appropriately, they are taken from a photograph where they appear further away, slightly shrouded by distance and the haze from the river. Eakins' own family was dropped into the place of another group of onlookers, also with dogs.

The most complex assemblage of photographic sources appears, predictably, in the most important painting from the Gloucester series: *Mending the Net* of 1881 (fig. 12). Thirty-one photographic studies have now emerged for this painting; only one—a study of geese (Hendricks 29, Hirshhorn Museum) was previously known. Theodor Siegl, in his attentive study of Eakins' work in the collection of the Philadelphia Museum of Art, predicted the use of photographs in the preparation of this painting, and the Bregler collection proves his instincts correct.[28] Sources now appear behind many of the figures as well

8. Thomas Eakins, *Shad Fishing at Gloucester on the Delaware River: Study of a Woman's Head*, c. 1881, oil on panel, 22.5 x 15.2 (8⅞ x 6) Courtesy of the Pennsylvania Academy of the Fine Arts, Philadelphia. Charles Bregler's Thomas Eakins Collection, purchased with the partial support of the Pew Memorial Trust and the Henry S. McNeil Fund

9. Thomas Eakins, *Shad Fishing at Gloucester on the Delaware River*, 1881, oil on canvas, 30.8 x 46.4 (12⅛ x 18¼) Philadelphia Museum of Art, Given by Mrs. Thomas Eakins and Miss Mary Adeline Williams

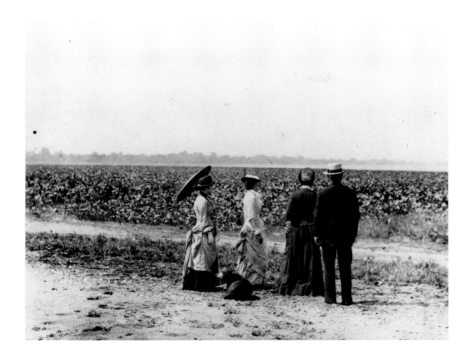

as the geese, beginning with the figure of a man reading, seated on a dismantled capstan under the tree at center (fig. 13). Eliminated from the photograph in its transfer to the painting was Eakins' father, Benjamin, seen at the left, who may have seemed inappropriately cosmopolitan in this scene. This photograph stands out because of the independent success of its composition (with Benjamin Eakins), which seems to have been carefully considered apart from its possible use in the painting. From such photographs it would seem that Eakins was aiming his camera at interesting figures and scenes without a predetermined sense of their usefulness. Later, in the darkroom, he must have assessed the potential of these photographs for use in his paintings and pulled together figures from available images. This does not seem to have been the case in *Shad*

10. Thomas Eakins, *Benjamin Eakins, Three Women, and the Setter "Harry": Study for "Shad Fishing at Gloucester on the Delaware River,"* 1881, modern print from glass negative
Courtesy of the Pennsylvania Academy of the Fine Arts, Philadelphia. Charles Bregler's Thomas Eakins Collection, purchased with the partial support of the Pew Memorial Trust

11. Thomas Eakins, *Fishermen Setting Their Nets: Study for "Shad Fishing at Gloucester on the Delaware River,"* 1881, modern print from glass negative
Courtesy of the Pennsylvania Academy of the Fine Arts, Philadelphia. Charles Bregler's Thomas Eakins Collection, purchased with the partial support of the Pew Memorial Trust

12. Thomas Eakins, *Mending
the Net*, 1881, oil on canvas,
81.9 x 114.9 (32¼ x 45¼)
Philadelphia Museum of Art,
Given by Mrs. Thomas Eakins
and Miss Mary Adeline Williams

13. Thomas Eakins, *Benjamin
Eakins and an Unidentified
Man under a Tree: Study for
"Mending the Net,"* 1881,
modern print from glass
negative
Courtesy of the Pennsylvania
Academy of the Fine Arts,
Philadelphia. Charles Bregler's
Thomas Eakins Collection, purchased
with the partial support of the Pew
Memorial Trust

14. Thomas Eakins, *Women
and Children on a Rooftop:
Study for "Mending the Net,"*
1881, modern print from glass
negative
Courtesy of the Pennsylvania
Academy of the Fine Arts,
Philadelphia. Charles Bregler's
Thomas Eakins Collection, purchased
with the partial support of the Pew
Memorial Trust

15. Thomas Eakins, *Two
Fishermen Mending Nets:
Study for "Mending the Net,"*
1881, modern print from glass
negative
Courtesy of the Pennsylvania
Academy of the Fine Arts,
Philadelphia. Charles Bregler's
Thomas Eakins Collection, purchased
with the partial support of the Pew
Memorial Trust

16. Thomas Eakins, *Mending
the Net: Study for the Head of
a Fisherman*, 1881, oil on
panel, 10.2 x 14.6 (4 x 5¾)
Courtesy of the Pennsylvania
Academy of the Fine Arts,
Philadelphia. Charles Bregler's
Thomas Eakins Collection, purchased
with the partial support of the Pew
Memorial Trust and the Henry S.
McNeil Fund

Fishing's study (fig. 10), where the figures
seem posed to overlook an imaginary
scene. Eakins' opportunism is more appar-
ent in photographic sources that have less
interest as independent compositions, such
as figure 14. This image, which has all the
hallmarks of amateur family photogra-
phy—figures cropped and blurred, a seem-
ingly instantaneous, slice-of-life informal-
ity—may well have been posed on the roof
of the Eakins house, just outside the win-
dows of the north studio, where the earlier
rowing subjects as well as the *Crucifixion*
were set up for sunlight studies.[29] Recon-
sidering this as a set-piece, rather than as
an impromptu snapshot, we are reminded
of the dreadful gap in time between the
photographer's last glance into the viewing
glass and the actual moment of the expo-
sure. Restless children and animals made
for much guesswork and surprise in these
early photographs.

A study of the photographs for *Mending
the Net* and extant oil studies of the same

figures, such as the fisherman seen in figures 15 and 16, reveals Eakins' method, which relied on both sources to gain his final effect. Clearly, the photographs were useful for contour and detail; the oil studies defined color and the colored light of intervening atmosphere. In such cases, the photograph merely helped Eakins do better, or more quickly, the painting of detail and characteristic posture that his pre-camera paintings show he already did very well. Since his models were away from his studio and in action pursuing their livelihood, it was not easy to ask them to interrupt their work by posing for hours; the camera swiftly documented their authentic working gestures without intruding in their lives or interrupting the natural sequence of their motions. It saved both the artist and the fisherman time and guaranteed Eakins the truthfulness of posture and dress that he desired. The composite use of sources produced the effect of self-containment felt in many of the figures in *Mending the Net* that has been observed often, and appreciatively, by critics and scholars from 1881 until the present. Ironically, *The Fairman Rogers Four-in-Hand*, made without such direct recourse to photographs, inspired uncomfortable analogies with photography; *Mending the Net*, which relied heavily on them, has never been criticized in such terms. Instead, the assembled parts create a mood of quiet, preoccupied industry, wherein the authenticity of the figures and their detachment from the viewer—and from one another—create a sense of the timeless poetry of the everyday.[30]

The success of *Mending the Net* may have encouraged Eakins to experiment with the use of photographs as the basis for a pure landscape, even though his camera had been of little use in capturing the quality of outdoor light in this picture.[31] The handling of the landscape part of this painting still shows the same Barbizon style, by now typical of many American landscapists, most notably George Inness. Soft and scrubbed, then layered over with broad strokes or palette knife, the landscape is painted in a manner unlike the figures, but it breathes around them comfortably rather than locking them in. Siegl

has argued that part of the aesthetic of this painting was derived from camera work, particularly a gradual shift from crispness to softness across the picture from left to right—which I find difficult to see—and from middleground to foreground, as if in imitation of the blurred effects of "the photographs of his day."[32] The blurred foreground is surely part of Eakins' photographs of geese—who moved during his exposures—but the rest of the foreground detail in these photographs is much sharper than the foreground of the painting. In fact, none of Eakins' own photographs for *Mending the Net* show the degree or type of variable focus combined in this painting. Although Siegl notes Eakins' increased experimentation with selective focus in the years around 1881–1882, just when he first acquired a camera, the new photographs discovered in the Bregler collection show that this "camera vision" was more complex than the imitation or copying of effects seen in his photographic studies.

The problematic issue of a "photographic aesthetic" is clearer in *The Meadows, Gloucester, New Jersey* (fig. 17), undertaken about 1882 and finished by 1884, perhaps in pursuit of possibilities opened by the success of *Mending the Net*. This painting is Eakins' lone attempt at "pure" landscape, and therefore it shows his landscape style unadulterated by compromises made for the sake of enhancing human interest. His fraternity with Courbet is clearest here, in the palette of greens, olives, brown, and blue and in the heavy paint surface. The size of the canvas (32 x 45 in.) makes it unlikely, but not impossible, that Eakins toted it across the Delaware into the Jersey meadows behind the shad fisheries. A small, fresh oil sketch of the composition (fig. 18) suggests the scale of work probably done in the field. A question arises in imagining the transition from this small panel to such a relatively detailed canvas, ten times larger in area. The painting includes information not seen in the sketch and, like the earlier study of the marsh (fig. 6), details in the sketch do not appear in the finished work. Siegl again proposed a "camera vision" for this painting, if not an actual photographic source,

17. Thomas Eakins, *The Meadows, Gloucester, New Jersey*, c. 1882, oil on canvas, 26.7 x 34.9 (32¼ x 45¼) Philadelphia Museum of Art, Given by Mrs. Thomas Eakins and Miss Mary Adeline Williams

noting the selective focus on the cows in the middleground and hazy blurring in the foreground and distance, as well as at the edges of the canvas.[33] A glass negative found in the Bregler collection (fig. 19) confirms Siegl's suspicions of a photographic source, but it is not in the photographic "style" he predicted. Eakins' own photograph contains the deep, focused field and edge-to-edge detail common to standard contemporary photography. His camera included a special landscape lens with a wide angle and a deep focal length, well suited to the uniformly detailed recording of such spacious, sunny landscapes, and his view of the meadows shows the competent use of this equipment for a "good" (that is, correct and proper) photograph, according to the taste of the early 1880s. The trans-

formation of this crisp image into the broadly painted, selectively focused painting involves a profoundly antiphotographic mission. Translated into "camera vision," the effects in the finished oil would have required Eakins to use the "wrong" lens (his narrower portrait lens, for example), or enlist "bad," amateurish effects (as in fig. 11), or resort to manipulations, anticipating the fashion of the pictorial photographers of the late 1890s. Such practices would have been uncharacteristic of Eakins, who typically entered as an amateur into other arenas (anatomical dissection, for example) with respect for the canons of professional procedure. Instead, his suppression of certain details in the photograph and the sketch seems to be inspired less by "camera vision" than by the same

18. Thomas Eakins, *Sketch for "The Meadows, Gloucester,"* c. 1882, oil on panel, 26.7 x 34.9 (10¹/₂ x 13³/₄)
Private collection. Photograph courtesy of Geoffrey Clements

19. Thomas Eakins, *The Meadows, Gloucester,* c. 1882, modern print from glass negative
Courtesy of the Pennsylvania Academy of the Fine Arts, Philadelphia. Charles Bregler's Thomas Eakins Collection, purchased with the partial support of the Pew Memorial Trust

sources that later inspired the pictorial photographers: the contemporary aesthetic of landscape painting.[34]

Eakins himself does not seem to have been confused about the interchange of photographic style and painterly style, for *The Meadows, Gloucester*, his largest picture reliant on a single, all-inclusive photographic source, is much less photographic (in the sense of finely, unselectively detailed) than *Max Schmitt* or *The Fairman Rogers Four-in-Hand*. Every year since his introduction to photographic aids his work in landscape had grown broader and less photographic, perhaps in a deliberate attempt to obscure or distance his sources. Clearly able to articulate the two mediums, he could see the potential for a "bad" photograph (e.g., figs. 11 and 14) within a good painting. Nonetheless, he was capable of being misled, an-

ticipating that a good photograph (like fig. 19), enlivened by a good oil sketch taken from the same spot (fig. 18) would necessarily make a good painting. In the case of *Drawing the Seine*, the photograph remains more exciting than the watercolor of the same scene.[35] The photograph of *The Meadows, Gloucester* is likewise more interesting than the painting, which came out too big, too subtle, too empty, perhaps because of the broad suppression of detail and value contrast. It is not a bad painting, but it is not the success of *Mending the Net*. Eakins exhibited the latter painting many times in his life and won prizes with it; *The Meadows* appeared only once, at the Pennsylvania Academy in 1884, and then returned to his studio. He would paint only one more large subject dominated by landscape after this year—*Cowboys in the Badlands* of 1888—and in it he returned to the composite approach of *Mending the Nets*. The dependence on a single photograph in *The Meadows* (and two other paintings from 1882, *Drawing the Seine* and *Hauling the Seine*)[36] would not be repeated again. Perhaps, in learning from these three paintings in 1882, be began to segregate the uses and effects of photography into realms distinct from his painting. Although he would use the camera again in the Dakotas, most of his photography after 1883 concerned the human figure: documentary studies of comparative anatomy in his "naked series," his motion studies, his more "artistic" nude studies, and portraiture.[37] His photographs, although often paralleling or complementing his work in oil after this point (as in the Walt Whitman series), never again show the tight intersection of composition and detail in both media seen in the Gloucester series of 1881–1882.

Eakins' press into photography, if it did not yield the command over landscape light that he might have wished, seems consistent with his alertness to scientific or mechanical methods. Less expected, then, is the enthusiasm for outdoor sketching that accompanied his first camera work at the very same sites in 1881 and 1882. The many sessions of *plein air* work demonstrated in a dozen small panels found in Bregler's collection place Eakins in the arena where he had expressed the most difficulty in the past and where the evidence of his activity has been very slim. Surprisingly, these rediscovered panels show a variety and confidence that indicate delight in the act of outdoor sketching and an independent growth in this category of work akin to the development of a separate photographic oeuvre. The sketch for *The Meadows* is unique in Eakins' work in its exact correlation to a larger landscape oil, for most of the small paintings from this period seem to have been done opportunistically, like the photographs of fishermen, with only a general sense of their potential utility in future work. As color and value studies, or compositional ideas, these small sketches show an aesthetic more progressive than any of his larger, finished oils—a taste in painting analogous to the experimental freshness and modernity of his camera work.

The spontaneous and informal quality of these sketches is clear from their size and presentation, often jumbled together on different corners or sides of small wooden panels. The subsequent division of these panels by Bregler and others has somewhat altered their effect by isolation and cropping, as in *Delaware River and Gloucester Pier* (fig. 20). Never catalogued by Goodrich, this small scene was evidently trimmed down from some larger panel and framed by Bregler, with a resulting sense of self-containment and importance not entirely in keeping with Eakins' intentions. To say, then, that the thin paint, tonal organization, and flat banded composition of the panel recall Whistler's work from this period may be partly to credit Bregler for the construction of a Whistlerian Eakins out of some larger work. But even if ragged edges are imagined, the effect of this sketch is surprisingly modern and certainly not "photographic" in the conventional sense.

Bregler's hand also fell upon another panel, which he divided into four pieces, including the study of Margaret (?) (fig. 8), once the lower left corner of a larger rectangle, and a long Delaware River view (fig. 21), recently recomposed from two separate pieces cut from the upper right and upper

left of the same panel.[38] The discovery of this horizontal composition reopens the subject of luminism, a style that Eakins had clearly absorbed for his own purposes in *Max Schmitt* ten years earlier. The eccentric horizontal canvases of S. R. Gifford and M. J. Heade from the mid-1860s and 1870s may have accustomed Eakins to this format. But his treatment here is much broader and more suggestive than most luminist work, a reflection not only of the smaller scale of these new landscapes, but also a statement of greater confidence and personal assertiveness, even pleasure, in the handling of paint. This is not an Eakins we have seen often before. Nonetheless, before announcing the appearance of impressionist tendencies in Eakins akin to the work of repatriated American students from London, Munich, or Venice in these same years, it must be remembered that Eakins' works were clearly sketches in the traditional sense, without pretense to completion or independent, exhibition status. Eakins surely painted these panels with impressionist intentions—that is, the desire to catch fleeting effects of color and atmosphere—but it is not ideologically impressionist work, as a finished statement. Instead, like the work of many earlier generations of landscape painters, such as Constable or Boudin or Church, this is fluid preparatory work, "impressionist" in the older sense of the word.[39]

Or is it? Another of these "sketches," *Delaware River Scene* (fig. 22) makes a more provoking, less easily categorized statement of this new aesthetic in Eakins' work. Like the earlier sketches, it has been cropped by Bregler to make a more finished effect, but we know from Goodrich's description of the canvas as it appeared before 1933 that Bregler simply trimmed off unpainted margins at the bottom and right.[40] And it is larger than the other paintings, of a size comparable to the work of William Merritt Chase's small oils of the 1880s, J. Alden Weir's similar, Whistlerian watercolors of 1881, or Theodore Robinson's work of the late 1880s and 1890s.[41] Their work was also small and simple, reducing the landscape to a geometry of stripes. Quiet and high-valued, these paintings emphasized tonal harmony

rather than bright color. This style, grown out of Whistler's art and late Barbizon landscape painting, has been described as tonalism, a kind of American postimpressionism.[42] If Eakins is considered among the other painters working in this mood, he becomes a timely, even avant-garde participant in a larger national trend.

In attempting to reconsider Eakins as a realist, has the introduction of new labels (Hudson River school, Barbizon, luminist, photographic, impressionist, tonalist) improved our characterization of his work? Surely all of these terms are useful in bringing him out of isolation, into the con-

20. Thomas Eakins, *Delaware River and Gloucester Pier*, oil on panel, 14 x 10.5 (5½ x 4⅛) Courtesy of the Pennsylvania Academy of the Fine Arts, Philadelphia. Charles Bregler's Thomas Eakins Collection, purchased with the partial support of the Pew Memorial Trust and the Henry S. McNeil Fund

21. Thomas Eakins, *Delaware Riverscape, from Gloucester*, 1881–1882, oil on panel, 11.4 x 36.8 (4½ x 14½) Courtesy of the Pennsylvania Academy of the Fine Arts, Philadelphia. Charles Bregler's Thomas Eakins Collection, purchased with the partial support of the Pew Memorial Trust and the Henry S. McNeil Fund

22. Thomas Eakins, *Delaware River Scene*, 1881–1882, oil on canvas, 16.5 x 23.5 (6¹/₂ x 9¹/₄) Courtesy of the Pennsylvania Academy of the Fine Arts, Philadelphia. Charles Bregler's Thomas Eakins Collection, purchased with the partial support of the Pew Memorial Trust and the Henry S. McNeil Fund

text of his contemporaries. But none of these labels seems to fit Eakins well, or for long. The dissatisfaction created by this array of inadequate stylistic terms may simply reconfirm his position as an independent, but it is also useful in the reconstruction of his identity as a realist. The new material in the Bregler collection shows, even in these few examples, that no tidy or conventional categories exist for his landscape work. In addition to suggesting more open definitions, the encounter with this fresh material serves to remind us that Eakins and his work have an integrity apart from, and prior to, the invention of our descriptive terms. Perhaps it is not

just that Eakins is eccentric, but simply that our categories are too simple to contain him. The best artists will always elude categorization, if only because the assimilation of seemingly contradictory modes or the maintenance of paradoxical attitudes is the hallmark, in Western culture, of the most interesting art. Reminded of our own habits and premises, we can begin anew from this body of work and build from it a definition of realism that expresses the versatility and harmonious integration of purpose within one man. Full of tension, repressed, perhaps occasionally obsessed, Eakins was not insane or even disorderly. Such an artist, who would work with the camera and oils on the same site, perhaps on the same afternoon, believed in a realism that embraced mechanical as well as subjective means to its end. It is an approach more complex and synthetic than just simple imitation, "photographic" description, or the radically personalized perceptual realism of the impressionists. The history of art recollects only the opposition of these modes: Gérôme, whose polished paintings justly earned the term "photographic," is remembered barring visitors at the doorway of the impressionists' gallery at the Salon, decrying the "shame" of French art.[43] Eakins, devoted pupil of Gérôme, calmly drew both modes into complementary alignment. Neither supplied a finished statement for him. To Eakins, a collaboration of techniques corrected the vices inherent in each method alone. The camera, like the anatomy class or the perspective plan, disciplined the painter's tendency to fudge or falsely generalize telling detail. The painter in turn suppressed the unnatural, unselective focus of the lens, supplying color, emphasis, structure, movement. Together, these techniques joined to find truth and create meaning, to translate experience into art. Realism on these terms—Eakins' own—is a method of making art, an attitude, not a style.

NOTES

1. See Kathleen A. Foster, "An Important Eakins Collection," *Antiques* 130 (December 1986), 1228–1237. The history of the Bregler collection, with particular attention to the manuscripts, is given in greater detail in Kathleen A. Foster and Cheryl Leibold, *Writing about Eakins: The Manuscripts in Charles Bregler's Thomas Eakins Collection* (Philadelphia, 1989). The present essay represents work-in-progress on a larger discussion of the art and artifacts in this collection, to be published in a catalogue accompanying the exhibition *Thomas Eakins Rediscovered* at the Pennsylvania Academy of the Fine Arts, 1991.

2. The fountainhead of information and legend on Eakins remains Lloyd Goodrich, *Thomas Eakins: His Life and Works* (New York, 1933), 154. Substantially revised and expanded, this text was republished as *Thomas Eakins*, 2 vols. (Cambridge, Mass., 1982).

3. I refer particularly to Elizabeth Johns' excellent *Thomas Eakins: The Heroism of Modern Life* (Princeton, 1983) and Theodor Siegl, *The Thomas Eakins Collection* (Philadelphia, 1978). Eakins' "realism" was first discussed in terms of his French academic training by Gerald Ackerman in "Thomas Eakins and His Parisian Masters, Gérôme and Bonnat," *Gazette des Beaux-Arts* 79 (April 1969), 235–256. Following on Ackerman's work came my own master's thesis, "Philadelphia and Paris: Thomas Eakins and the Beaux-Arts" (Yale University, 1972); H. Barbara Weinberg, *The American Pupils of Jean-Léon Gérôme* (Fort Worth, Tex., 1984); and Elizabeth Milroy, "Thomas Eakins' Artistic Training, 1860–1870" (Ph. D. diss., University of Pennsylvania, 1986). Michael Fried has broken new ground by applying Freudian perspectives on Eakins' work in an attempt to refresh our sense of his "realism"; see *Realism, Writing, and Disfiguration: Thomas Eakins and Stephen Crane* (Chicago, 1988).

4. Forty-five percent, or 91 out of 203 paintings in oil and watercolor before 1889, as listed in Goodrich 1933, contain landscape. Of these, 27 were "pure" landscapes or marines, although all but three of this group were small sketches, usually made in preparation for or anticipation of larger work with figures. The lifetime percentage (30 percent) includes 9 drawings made for these paintings. The addition of work uncatalogued by Goodrich now discovered in Bregler's collection includes a disproportionate number of landscape works, although the addition of these

items to the larger lifetime list will not alter these percentages significantly. What remains uncountable is the amount of work discarded or lost in the overpainting that Eakins habitually practiced on his small sketch panels. Many items presently listed as figure studies seem to have been painted over landscape sketches from the 1870s and early 1880s. The best source of information about Eakins' work in landscape is Goodrich 1982. Johns discusses landscape as a component of his portraiture in her monograph of 1983. Individual landscape works have been discussed astutely, but in isolation, in Siegl 1978, and in Phyllis D. Rosenzweig, *The Thomas Eakins Collection of the Hirshhorn Museum and Sculpture Garden* (Washington, D. C., 1977). More recently Marc Simpson has discussed the landscape element in the Arcadian subjects of the early 1880s; see "Thomas Eakins and His Arcadian Works," *Smithsonian Studies in American Art* 1 (Fall 1987), 71–95; and Darrel Sewell has surveyed the landscape subjects in *Thomas Eakins, Artist of Philadelphia* [exh. cat., Philadelphia Museum of Art] (Philadelphia, 1982), chapters 3, 4, and 9. Excellent recent scholarship on Eakins and luminism is discussed in note 15.

5. See Elizabeth Johns, "Drawing Instruction at Central High School and Its Impact on Thomas Eakins," *Winterthur Portfolio* 15 (Summer 1980), 139–149.

6. All three items are in the Hirshhorn Museum collection; see Rosenzweig 1977, 22, 24–25. The vignette of a cottage and tree, painted on the back of a calling card, probably dates from the late 1850s, too. Gordon Hendricks speculated that it was from 1853; see *The Life and Works of Thomas Eakins* (New York, 1974), 318. However, Goodrich disputed this date, suggesting a time later in the 1850s, when Eakins was a teenager; see Rosenzweig 1977, 22. These three items remain the earliest extant landscapes by Eakins. From the connection to J. D. Harding found in the landscape drawings discussed below, it may well be that the two figure subjects are also copied from one of Harding's many books on picturesque scenery in Europe.

7. Clara Erskine Clement and Laurence Hutton, *Artists of the Nineteenth Century and Their Works* (1879; rev. ed. Boston, 1907), 330.

8. Johns 1980, 140–142.

9. Other treatises by Harding were used as supplementary texts in Peale's curriculum, which was outlined in the 1840s, prior to the publication of *Lessons on Trees*. See Johns 1980, 142. The library of the Pennsylvania Academy of the Fine Arts (PAFA) owned two copies of Harding's *Lessons on Trees*, although it is not clear when they entered the collection. The illustrations in the present text are from an 1855 edition (at PAFA); a copy of the 1858 edition is in the Boston Public Library. Eakins also may have learned about Harding's book from a family friend, G. W. Holmes, who was a drawing teacher and a landscapist.

10. Eakins' modernity and his respect for expertise are themes expressed in Johns 1983. The rise of do-it-yourself instruction manuals in the arts has been described in Peter C. Marzio, *The Art Crusade: An Analysis of American Drawing Manuals, 1820–1860* (Washington, D.C., 1976) and Diana Korzenik, *Drawn to Art: A Nineteenth-Century American Dream* (Hanover, N.H., 1985).

11. The Pre-Raphaelite moment in American landscape painting has been surveyed in Linda H. Ferber and William H. Gerdts et al., *The New Path: Ruskin and the American Pre-Raphaelites* [exh. cat., Brooklyn Museum] (Brooklyn, N.Y., 1985), particularly Susan P. Casteras, "The 1857–58 Exhibition of English Art in America: Critical Responses to Pre-Raphaelitism," 109–133.

12. The group of Harding copies contains a few very schematic and visually thin exercises; I assume that the more interesting, advanced subjects would have been saved (like the copied views in the Hirshhorn) if they had been completed. Nine landscape drawings, on various papers, are in the non-Harding group; none are dated, although the competence shown in these drawings suggests their production prior to his departure for advanced training in France in 1866 and probably before the commencement of study at the Pennsylvania Academy in 1862. On Eakins' later work based on Gérôme's example, see Ackerman 1969; Foster 1972; and Weinberg 1984.

13. Thomas Eakins to his father, Benjamin Eakins, 14 March 1870. An account of the painting of *Street Scene in Seville*, with this and other relevant quotations from Eakins' letters, is given in Goodrich 1982, 1:54–59.

14. This statement is based on Goodrich's catalogue listing, 1933, excluding the two "Hiawatha" subjects, which have been shown to be from 1874; see Rosenzweig 1977, 53–54. Perhaps from 1871, in advance of *Max Schmitt*, is the unfinished oil, *The Oarsmen* (Goodrich no. 63); see Siegl 1978, 53. Goodrich dates this to 1873; Johns speculates that it may have been painted about the time of a race featuring these four oarsmen in the fall of 1874; see Johns 1983, 41.

15. "Luminism," a term invented by John I. H. Baur in the 1940s, was examined with great subtlety by Barbara Novak in *American Painting of the Nineteenth Century; Realism, Idealism, and the American Experience* (New York, 1969). Her chapter, "Thomas Eakins, Science and Sight," presents a sophisticated analysis of Eakins' "combined process" in *Max Schmitt* and the relationship between this method, the painting's effect, and the luminist style; see 191–196. Novak's understanding of Eakins' complex realism is improved only by the richer sense of the luminist context supplied in more recent scholarship, particularly John Wilmerding et al., *American Light: The Luminist Movement, 1850–1875* [exh. cat., National Gallery of Art] (Washington, D.C., 1980). Wilmerding's "Introduction," 11–19, and Barbara Novak, "On Defining Luminism," 23–29, serve as a good synopsis of the development of this term and the qualities it describes. Using *Max Schmitt* as a point of reference, Wilmerding describes Eakins' work as post-luminist in its emphasis on figures and human psychology, despite the luminist qualities of

space and light; see "The Luminist Movement: Some Reflections," 146-148. In the same book, Theodore E. Stebbins, Jr., comments on the "nearly luminist" *Max Schmitt*, which he understands to be closer to the French mainstream (in America) than to luminism; see 215. Stebbins' essay, "Luminism in Context: A New View," provides an important international perspective on this so-called "American" style; see 211-234. Carol Troyen made a succinct statement on *Max Schmitt*, its methods and sources, in *A New World: Masterpieces of American Painting 1760-1910* [exh. cat., Museum of Fine Arts, Boston] (Boston, 1983), 266. Thorough documentation of this painting, with a detailed visual analysis and bibliography, is given by Natalie Spassky in *American Paintings in the Metropolitan Museum of Art 2* (New York, 1985), 588-594.

16. Siegl 1978, 54-56 and Siegl, "Perspective Drawing for 'The Pair-Oared Shell,' " in *Philadelphia: Three Centuries of American Art* [exh. cat., Philadelphia Museum of Art] (Philadelphia, 1976), 391-393.

17. Goodrich 1982, 1:108.

18. Sketches done outdoors from this period may include *Sketch of Max Schmitt in a Single Scull* (Goodrich no. 64); *Study for "The Oarsmen"* (Goodrich no. 65) and *John Biglin in a Single Scull* (Goodrich no. 59). See Siegl 1978, 53-54.

19. Note the deletion of the sail seen in the sketch, perhaps because it was too distracting, and the simplification of both contour and brushwork.

20. Eakins' French spelling is irregular and often illegible; quotations from his draft have been slightly regularized for greater readability. The text of this letter draft is published and discussed at greater length in Foster and Leibold 1989; see "Correspondence with Gérôme." The first two pages of this letter are published (in English) in Goodrich 1982, 1:93, 320.

21. See Goodrich 1982, 1:116.

22. This same concern inspired Eakins to undertake special compensatory adjustments to later work (the *Knitting* and *Spinning* reliefs) that he knew would be installed in an eccentric location.

23. Thomas Eakins to his father, Benjamin Eakins, 6 March 1868, quoted in Goodrich 1982, 1:30-31. The full text of this letter is published and discussed in Foster and Leibold 1989; see "Learning in Paris." Johns also discusses Eakins' awareness of the realist painter's challenge; see Johns 1980, 146-147.

24. See Siegl 1978, 75-81, for a discussion of the many preparatory studies for this work and its critical reception. Eakins seems to have used Eadweard Muybridge's photographs of horses in motion, published in 1878, as a basis for his sketches and for the construction of his clay models, which were in turn used for his finished canvas.

25. In the Philadelphia Museum of Art. See Siegl 1978, 95. Gordon Hendricks described the relationship between the watercolor and the photograph as "perhaps the most literal example of a transcription

from a photograph known in American art." Hendricks 1974, 151. The glass negative for this image is in Charles Bregler's Thomas Eakins Collection (88.38.m). Hendricks' catalogue raisonné of Eakins' photography remains the basic reference on his work; see *The Photographs of Thomas Eakins* (New York, 1972). Siegl also noted the suggestive similarity between a photograph (Hendricks no. 32) and the oil *Hauling the Seine* (Goodrich no. 160; Hirschl and Adler Galleries), predicting the use of photography in all these fishing scenes. Siegl 1978, 94.

26. The only painting in this series with no related photograph or negative extant is the watercolor *Mending the Net* of 1882. Knowing Eakins' method in watercolor, preliminary studies of some kind surely existed for this work, and probably (given the close relationship with extant negatives in the Bregler collection) photographic studies were made. The Bregler negatives contain dozens of new images, but an equal number of Eakins' prints survive with no surviving glass negative. Many of these plates must have been lost or destroyed; it is conceivable that others will be discovered in the future.

27. As can be seen in figure 9, Harry moved during the exposure; the other image (87.11.j) shows him as he appears in the painting. The identity of the women in the painting remains unclear, although the photographs put to rest speculation that the woman in black was a posthumous portrait of Eakins' mother. Hendricks 1974, 148-149; Siegl 1978, 94. Susan Eakins told Goodrich that the group included "Benjamin [Eakins] and a daughter"; from this, Goodrich went on to speculate that *two* daughters were present (Margaret and Caroline), joined by a "heavier and probably older woman," perhaps Aunt Eliza Cowperthwait. Goodrich 1982, 329 n. 207. The new-found negatives show that this figure in black is neither heavy nor old; the profile and the strap she holds (visible in 87.11.j) suggest that she may be Margaret, carrying the leash of her dog, Harry. Susan Macdowell may have been in this party, too; she elsewhere denied posing for projects that she actually did join. Whatever stories are suggested by the composition of this urbane group amidst the fishermen, it is clear that Eakins' choice of lost profiles and rear views was intended to reduce the portrait-presence of his figures.

28. Siegl 1978, 93. Of the extant glass negatives, six have a tight connection to the figures in the painting; many, such as the eighteen different shots of blurry geese, were not so useful. Other negatives must have existed and are now lost, for there are no photographic studies for the first four figures from the left, even though one is in mid-stride—a pose more difficult than those on the right side of the canvas.

29. The figures seem to be his sisters, Margaret and Frances (or Caroline) at the right, with two small Crowell children, perhaps Eakins' nephews Ben and Willie, who would have been 4 and 2 in 1881.

30. On contemporary reactions to *Mending the Net*, see Siegl 1978, 93.

31. As Siegl has noted (1978, 93) the landscape and sky were overpainted later, perhaps in response to criticism. It is worth considering the impact of his photographs, with their flat, overexposed skies (typical of landscape photography in this period) on the effect of this painting. A newly found glass negative records the appearance of the picture prior to repainting, indicating that Eakins reworked the meadow as well as the sky.

32. Siegl 1978, 93.

33. Siegl 1978, 97–98.

34. I am sure, as Siegl suggests, that Eakins' use of the camera in these years contributed to his interest in selective focus in his paintings. However, it seems that Eakins never took up the suggestion of any single photograph (such as fig. 11) that included the extreme disparity of focus shown in his paintings. The painting dependent upon this study, *Shad Fishing* (fig. 10), was cropped at exactly the place in the photograph where the blurred foreground becomes most assertive. Following Siegl's idea, it is possible that Eakins borrowed and combined effects from different photographic sources into a single painting such as *Mending the Net* or *The Meadows, Gloucester*, using a method analogous to his overall strategy of preparation. The resulting composite would be antiphotographic, however, in its incorporation of effects impossible to achieve in any single photograph and in the willful application of these effects to suit a painter's (rather than a contemporary photographer's) pictorial aesthetic. His lack of interest in the photographs themselves and their intrinsic qualities must be signaled by the rarity of vintage prints from these projects. From the disappearance of these prints as well as the final look of these paintings, it seems that Eakins was not interested in preserving a record of his photographic sources and may have intentionally destroyed such evidence. I am grateful to Kenneth Finkel for his conversations with me concerning Eakins' photographic equipment and procedures. Weston Naef has provided an illuminating discussion of the alliance between the aesthetics of photography and painting in the luminist period; see " 'New Eyes'—Luminism and Photography," in Wilmerding 1982, 267–289.

35. See note 24.

36. *Hauling the Seine*, Goodrich no. 160; Hirschl and Adler Galleries.

37. A selection of the photographs Eakins made in the Dakota Territory, discovered as glass negatives in Bregler's collection, are published in Cheryl Leibold, "Thomas Eakins in the Badlands," *Archives of American Art Journal* 28, no. 2 (1988), 2–15; the "naked series" has recently been reevaluated by Ellwood C. Parry III in "Thomas Eakins' 'Naked Series' Reconsidered: Another Look at the Standing Nude Photographs Made for the Use of Eakins' Students," *American Art Journal* 20 (1988), 53–77.

38. The left-hand portion of the composition was given to the Pennsylvania Academy of the Fine Arts in 1966 by Charles Bregler's widow, Mary. The other part emerged in 1985 with the remainder of her collection. The two halves were expertly joined together by PAFA's conservator, Mark Bockrath, in 1989.

39. Goodrich compared Eakins' rowing subjects of the 1870s to contemporary impressionist work, remarking the shared interest in the activities of modern, outdoor, urban life and a common commitment to direct observation. Goodrich noted the differences, too: Eakins' emphasis on light only as it revealed form and the priority of value structure and drawing over color in his work. Goodrich 1982, 1:98.

40. Goodrich no. 167. The canvas board panel was originally 10½ in. x 13½ in. I thank Darrel Sewell for sharing Goodrich's notebooks, now at the Philadelphia Museum of Art. All Eakins scholars will remain grateful to Goodrich for his careful records, including pencil sketches and descriptive remarks and opinions that remain useful and sound. His papers, including work toward a revision of his 1933 catalogue raisonné, are being organized for use by other scholars.

41. In the lecture presentation of this paper, I compared figure 21 to Chase's *Harbor Scene*, mid-1880s (?), Cleveland Museum of Art; Weir's *Shore Scene*, c. 1881, Williams College Museum of Art; and Robinson's *Drawbridge, Long Branch Railroad*, 1894, in the collection of Rita and Daniel Fraad.

42. This style was defined by Wanda M. Corn in *The Color of Mood: American Tonalism 1880–1910* [exh. cat., M.H. De Young Museum] (San Francisco, 1972).

43. Jean-Paul Crespelle, *Les Maîtres de la belle époque* (Paris, 1966), 113.

NICOLAI CIKOVSKY, JR.
National Gallery of Art

Winslow Homer's Unfinished Business

Detail fig. 16

I am going to discuss not just pictures that Winslow Homer never finished—although my title obliges me to say something of those—but pictures he never really began, ideas or projects he considered but that survive only incompletely or as traces. I will say something, too, about a related matter: the artist that at times throughout his career Homer was tempted to become but never did, at least not for long. Homer was one of the great innovators and individualities of his time. I want to address not his innovation or individuality, but episodes in Homer's flirtation with what we may call variously conventional, conservative, official, fashionable, or (as some auction houses put it) traditionalist art—a kind of art that, if he actually made it or if it survived in greater amounts, would have given a very different complexion to his work and a very different estimate than the one we now have of the quality of his achievement.

Homer's artistic maturity coincided with the Civil War; his first paintings are Civil War subjects. What he would have painted in different circumstances, or how he might have painted it, we can never know. Before the war Homer's only disciplined artistic training, as far as we can tell, derived largely from an apprenticeship as a lithographer—an experience that he thoroughly detested—after which he had only brief lessons in painting and worked a little from the figure at the National Academy of Design. But in 1861 he seems to have felt that his education was not complete. At that time his mother hoped to borrow money to enable her son to go to Europe because, she said, "he so desires to go for improvement."[1] The implication is, of course, that Homer felt he needed the improvement of a more thorough—that is, a more conventionally academic—artistic education than the one he had received in America, and he desired to go to Europe to get it. The war prevented that, however, with the result that Homer remained largely self-taught—and very probably quite unlike the artist he otherwise might have been.

The war was also for him a subject that crowded out all others. That was not automatic. The Civil War did not have the overwhelmingly engaging effect on most American artists that it had on Homer. Perhaps Homer, who earned his livelihood as a freelance illustrator and pictorial reporter, was forced to pay greater attention to it. But that cannot have been the only reason, for surely Homer perceived in the war an unusual character and a special significance. And his perceptive understanding of that character accounts, I think, for his interpretation of it.

Among Homer's early images of the war were two ambitious wood engravings that appeared in *Harper's Weekly* in the sum-

mer of 1862. Depicting scenes of battle—a cavalry charge (fig. 1) and a bayonet charge—they were conceived completely within the current conventions of martial art, such as, for example, Emanuel Leutze's *Washington Rallying the Troops at Monmouth* of 1854 (fig. 2). But by the time Homer made his image of *Sharpshooter* only a few months later (the engraving, fig. 3, made from a painting, was published in *Harper's Weekly* in November 1862), he had discarded those conventions in favor of an image more in keeping with the peculiar nature, which Homer read with astonishing quickness and clarity, of the American Civil War.[2] Focusing on an individual soldier rather than on massed soldiers in combat or on parade and on a figure that embodied the distancing ano-

nymity of mechanical warfare that had replaced the heroic displays of conventional battle, Homer expressed both the novelty—the modernity—of the American Civil War and its democratic character.

What Homer did first in his Civil War paintings and engravings he continued to do for the next fifteen years or so: make images of the special character—which I believe he understood to be the modern and democratic character—of American life, in a style, what is more, conspicuously and deliberately different from the norms of conventional art in the informality both of its conception and its execution. That difference was particularly visible in its violation of standards of finish, of narrative and executive completion. Lack of finish is what most disturbed his

1. Winslow Homer, *The War for the Union, 1862—A Cavalry Charge*, wood engraving, 40.6 x 55.5 (16 x 21⅞)
From *Harper's Weekly* (5 July 1862), National Gallery of Art, Washington, Avalon Fund

2. Emanuel Leutze,
*Washington Rallying the
Troops at Monmouth*, 1853–
1854, oil on canvas, 396.2 x
662.9 (156 x 261)
University Art Museum, University of
California at Berkeley, Gift of Mrs.
Mark Hopkins, San Francisco

3. Winslow Homer, *The Army
of the Potomac: A Sharp-
shooter on Picket Duty*, wood
engraving, 23.2 x 34.8 (9¹⁄₈ x
13³⁄₄)
From *Harper's Weekly* (15 November
1862), National Gallery of Art,
Washington, Print Purchase Fund
(Rosenwald Collection)

critics (even though they admired other as-
pects of his art) and what most distanced
Homer's art from the prevailing artistic ex-
pectations of his time.

From the early 1860s and for the next
fifteen years or so, Homer pursued an ar-
tistic policy that seemed wholly to reject
precedents and proprieties. The writer
who, at the end of this period, spoke of
Homer's "impatience with accepted meth-
ods," the "irritability" and "striving after
the unknown" that "is written upon all of
his works," described the urgency and de-
termination of that policy of innovation
and renovation.[3] As early as 1866, when he
first went to Europe (to France), Homer
was so immune to the force of tradition
that although he experienced the art of the
past (fig. 4), it did not, as far as I am able
to see, influence him in any significant
way.[4]

But was that rejection utterly complete?
Did Homer never, earlier or later, feel the
temptation of convention or act on such a
temptation?

Among Homer's Civil War work is a
group of large chalk drawings that date to
1863 and 1864 (figs. 5–10). They are abso-
lutely splendid, among the freshest, most
spirited drawings Homer ever made. But
they are very different from, and do not
quite fit with, his other drawings of the
period. They are notably larger in size than
the others (sheets measuring roughly fif-
teen to seventeen inches in their largest

4. Winslow Homer, *Art-Students and Copyists in the Louvre Gallery, Paris*, wood engraving, 22.86 x 29.84 (9 x 11³/₄)
From *Harper's Weekly* (11 January 1868), National Gallery of Art, Washington, Print Purchase Fund (Rosenwald Collection)

5. Winslow Homer, *Soldier Loading a Rifle*, 1863–1864, black chalk and white gouache
Courtesy Cooper-Hewitt Museum, Smithsonian Institution/Art Resource, New York, Gift of Charles Savage Homer

6. Winslow Homer, *Soldier Taking Aim*, 1864, black and white chalk, 30.9 x 23.7 (12¹/₈ x 9⁵/₁₆)
National Gallery of Art, Washington, John Davis Hatch Collection, Avalon Fund

7. Winslow Homer, *Studies of Soldiers*, 1863–1865, black and white chalk
Courtesy Cooper-Hewitt Museum, Smithsonian Institution/Art Resource, New York, Gift of Charles Savage Homer

dimension) and in a different medium (others are mostly in pencil, not chalk). What is more they are not, on the whole, drawings that Homer used: the figures and actions they depict do not reappear in his surviving paintings or prints. This suggests that these drawings may be the remnants of a projected but never executed painting (or paintings), a work more orthodox in form, more dramatic in subject, and larger in size than the paintings he actually made—a painting (or paintings) the closest equivalent to which, among Homer's existing works, might be the early engravings of the cavalry charge (fig. 1) and bayonet charge, in which he used figures like these, riding and shooting, falling and dying.

It is not strictly true that Homer used none of these drawings for his paintings. One or two were used for small paintings—paintings that were, however, more in the nature of preparatory considerations than complete conceptions.[5] But at least a couple were used for a large painting, drawings of zouaves (figs. 9, 10) that figured in *Pitching Horseshoes* of 1865 (fig. 11). *Pitching Horseshoes* shares the informal, "democratic" subject matter of Homer's other Civil War paintings (such as *The Briarwood Pipe* of 1864 [fig. 12]), subject matter that was an important aspect of their innovation. But in two other respects *Pitching Horseshoes* is not typical of them. It is physically larger by far than any of the others. And in contrast to Homer's mature Civil War paintings that are contemporary with it, such as *Veteran in a New Field* of 1865 (fig. 13)—paintings that are compositionally simple, if not simplistic—*Pitching Horseshoes* is considerably more complex. In such respects as these, *Pitching Horseshoes* belongs more comfortably with conventional or academic painting than with Homer's own—with paintings such as Gérôme's, for example (fig. 14).[6] If that is so, then perhaps it is not a coincidence that *Pitching Horseshoes* is the only painting in which drawings made, as I have suggested, for a painting of just such (or even greater) ambition are to be found.

Pitching Horseshoes may not be the only instance of Homer's accommodation with convention. *Prisoners from the Front,*

which Homer painted the following year (fig. 15), is in its conception, in the comparative simplicity of its composition, more characteristic than *Pitching Horseshoes* of Homer's early style. But it differs significantly in subject. It is not a genre painting, as almost all the other Civil War paintings (including *Pitching Horseshoes*) had been, but belongs instead to one of the most traditional modes of art: history painting. Made at the end of the war, it is to

8. Winslow Homer, *Cavalry Soldier,* 1863, black chalk Courtesy Cooper-Hewitt Museum, Smithsonian Institution/Art Resource, New York, Gift of Charles Savage Homer

9. Winslow Homer, *Zouave*,
1864, black and white chalk,
40.3 x 19.2 (15⁹/₁₆ x 7¹³/₁₆)
National Gallery of Art, Washington,
John Davis Hatch Collection, Avalon
Fund

10. Winslow Homer, *Zouave*,
1864, black and white chalk,
40.3 x 19.2 (15⁹/₁₆ x 7¹³/₁₆)
Courtesy Cooper-Hewitt Museum,
Smithsonian Institution/Art
Resource, New York, Gift of
Charles Savage Homer

11. Winslow Homer, *Pitching
Horseshoes*, 1865, oil on
canvas, 67.9 x 136.3 (26¹¹/₁₆ x
53¹¹/₁₆)
Harvard University Art Museums,
Gift of Mr. and Mrs. Frederic H.
Curtiss

some extent, of course, necessarily summary and retrospective. But some of those who have written about the painting in its own time and in ours have located it in traditions of history painting.[7] I am not sure that we need to think that *Prisoners from the Front* had actual sources in earlier historical art, but there is no doubt that the traces of such art, an aroma of its formality, are present in it, perhaps by design. When Homer's friend, the critic Eugene Benson, wrote an article on "Historical Art in the United States" in 1869, *Prisoners from the Front* was the first painting he discussed. "We must all regret," Benson said, "that it is not permanently placed on the walls of the Capitol," with the historical paintings of John Trumbull and others.[8]

The concessions *Pitching Horseshoes* and *Prisoners from the Front* make in their different ways to conventional painting may represent a relaxation or retrenchment on Homer's part following a time of intense, concentrated, and perhaps exhausting innovation. For in a period of two or at most three years he not only began his professional life as a painter, but he almost immediately challenged and renovated traditions of military painting and, with equal rapidity, developed his own,

12. Winslow Homer, *The Briarwood Pipe*, 1864, oil on canvas, 42.9 x 37.5 (16⅞ x 14¾) Cleveland Museum of Art, Mr. and Mrs. William H. Marlatt Fund

13. Winslow Homer, *The Veteran in a New Field*, 1865, oil on canvas, 61.0 x 96.5 (24 x 38) Metropolitan Museum of Art, Bequest of Miss Adelaide Milton de Groot (1876–1967), 1967

14. Jean Léon Gérôme, *The Death of Caesar*, 1867, oil on canvas, 85 x 145 (34 x 57¼) Walters Art Gallery, Baltimore

15. Winslow Homer, *Prisoners from the Front*, 1866, oil on canvas, 61.0 x 96.5 (24 x 38) Metropolitan Museum of Art, Gift of Mrs. Frank B. Porter, 1922

unmistakably individual artistic language.

In any event, these early episodes of conventionalism were passing ones. In 1866, Homer went to France. But able for the first time in his life to experience artistic tradition directly and abundantly, he was unmoved. It had no influence on what little art he produced in France—that was influenced most, and only temporarily, by the recent art of the Barbizon school—and none that I can detect on the art that he produced after he returned. Instead, Homer's art during the approximately ten years after his return from Europe in 1867 was, I think, relentlessly and almost programatically modern, both in its subject—depicting the life of his own time—and in its language of style. One of the classic texts of modernism is Baudelaire's, a passage in "The Painter of Modern Life" (written about 1860) in which he defined modernity as "the ephemeral, the fugitive, the contingent, and the transitory."[9] And it was the flux and change of modern life (including the brilliance and movement of natural light) that Homer's style was designed to describe and express.

This involves the issue of finish. It is a large and complicated issue, of which I can mention just one aspect. Not what Homer's critics called his "coarse," "crude," and "careless" execution (fig. 16), but rather his unfinished or, more exactly, *dis*-finished compositions—not his failure to reach completeness, but his deliberate retreat from it. Artists commonly change their minds and rework their paintings in a variety of ways. But reworkings or reconsiderations seem to have been an important part of Homer's method, particularly in his early paintings. We know, for example, that he greatly altered *The Veteran in a New Field* (fig. 13) after it was first exhibited, changing the scythe and deleting a tree at the right. And we can see with the naked eye changes he made in *Breezing Up*.[10] But the most interesting changes are ones in paintings such as *The Nooning* of 1872 (fig. 17), in which a dog was painted out, and *Boys in a Pasture* of 1874 (fig. 18), in which something—though it is not clear exactly what—seems to have been deleted from its upper right-hand portion.[11] In each, as a result of such deletions or

changes, the remaining figures look at or react to something that is no longer part of the painting. (In other cases, such as *Man with a Scythe* [fig. 19], the vacant space at the left is not the result of deletion, but awaits an element that Homer never managed to add. The painting remained in this state at his death; only in a wood engraving of 1869, *The Last Load* [fig. 20], did he propose, not with complete success, a narrative and compositional conclusion of the image.)

What Homer has done in all of these cases (and also, if less obviously, in *Veteran in a New Field* and *Breezing Up*) is to disrupt or disconnect not the paintings' compositional arrangements so much as

16. Winslow Homer, *Spring*, 1878, watercolor, 28.3 x 22 (11¹/₈ x 8⁵/₈) Collection of Rita and Daniel Fraad

17. Winslow Homer, *The Nooning*, 1872, oil on canvas, 33.8 x 50.2 (13⁵/₁₆ x 19³/₄) Wadsworth Atheneum, Hartford, Ella Gallup Sumner and Mary Catlin Sumner Collection

18. Winslow Homer, *Boys in a Pasture*, 1874, oil on canvas, 38.7 x 57.1 (15¹/₄ x 22¹/₂) Museum of Fine Arts, Boston

19. Winslow Homer, *Man with a Scythe*, c. 1867, oil on canvas, 43.4 x 56 (17¹⁄₈ x 22) Courtesy Cooper-Hewitt Museum, Smithsonian Institution/Art Resource, New York, Gift of Mrs. Charles Savage Homer

20. Winslow Homer, *The Last Load*, 1869, wood engraving *From Appleton's Journal* (7 August 1869), National Gallery of Art, Washington, Avalon Fund

their narrative organization, their legibility, the story they told more easily and obviously before he changed them. Simplification may have improved them visually. But the greater openness and richer ambiguity of meaning that resulted also made them more complex and less conventionally literary by their denial of ordinary narrative expectations. And by disfinishing them, too, he made them, in Baudelaire's terms, more modern, more contingent and transitory by their incompleteness.

There is a different and somewhat contradictory instance of this practice. *Watermelon Boys* (fig. 21) was painted in 1876 but not exhibited until two years later, when it was also reproduced as a wood engraving (fig. 22). The engraving, made evidently from Homer's own sketch several months before the painting was exhibited, included a figure of a farmer at the fence at the right.[12] Apparently the painting did not: "The negro-lad, stealing melons in fulfillment of a predatory law of nature,

21. Winslow Homer, *The Watermelon Boys*, 1876, oil on canvas, 61.3 x 96.8 (24¹/₈ x 38¹/₈) Courtesy Cooper-Hewitt Museum, Smithsonian Institution/Art Resource, New York, Gift of Mrs. Charles Savage Homer

22. Winslow Homer, *Water-Melon Eaters. From a Painting by Winslow Homer*, 1878, wood engraving
Art Journal (New York) 4 (August 1878)

without sin or conviction of sin, but with a side-long eye bent all the while towards the quarter from which the farmer will descend upon him," as a critic described the painting, implies that the farmer was not actually visible in it.[13] This suggests that he was at first present in the engraved image and in the painting on which it was based, but was removed from the painting by the time of its exhibition two years later. Technical examination of the painting however, does not reveal any deletive alteration. This seems, therefore, to be a case not of emendment but of amendment, the correction in the published engraving—perhaps by Homer himself, on his own or under editorial pressure, or by the engraver—of the more ambiguous, less narratively closed painted version.

In each of these cases, Homer's unfinished (or unfinishing) business was directly related to the meaning and purpose of his art.

Beginning at some time in the later 1870s that meaning and purpose began to disintegrate. I cannot consider here the reasons for that disintegration, just its results. One of those results was Homer's increasingly conspicuous and recurrent accommodation with convention and tradition.

There are, for instance, his paintings of shepherdesses. Some clearly derived from actual experience. But others, just as clearly, did not (fig. 23). They were imported from other art, namely, from decorated tiles, Homer's own (fig. 24), and ultimately from traditions of tile decoration. Or there are paintings such as *Autumn* of 1877 (fig. 25) that belong very much to the mode of fashionable contemporary art represented by such artists as Alfred Stevens (fig. 26) or Giovanni Boldini.

And then there are the cases of Homer's murals. If we do not customarily think of Homer as a muralist that is not only because no murals by him survive, but because on the basis of his easel pictures it is difficult to imagine what kind of murals he would have painted. But in the late 1880s Homer, together with such artists as Edwin Austin Abbey, Frederick Bridgman, Kenyon Cox, Francis Millet, and Howard Pyle, was on a list of those proposed to do murals for McKim, Mead, and White's new

23. Winslow Homer, *Fresh Air*, 1878, watercolor, 51.1 x 35.7 (20¹/₈ x 14¹/₁₆)
Brooklyn Museum, Dick S. Ramsay Fund

Boston Public Library, which opened in 1895. He appeared on that list on the strength of murals he evidently made for the business offices in Franklin Square of the publishers Harper and Brothers (for whom Homer worked as a freelance illustrator in the 1860s and early 1870s).[14] William Howe Downes, Homer's first biographer, described the Harper murals quite specifically: one, he reported, depicted Castle Garden, another the Harper building itself and the interior of the pressroom, and a third, "The Genius of the Press" (judging from its title, an allegorical image

24. Winslow Homer, *Shepherdess*, 1878, ceramic tile, 19.7 x 19.7 (7¾ x 7¾) Lyman Allyn Museum, New London, Connecticut

unusual if not unique in Homer's art, which, for that reason, we should very much like to know).[15] The existence of the murals is attested to also by Saint-Gaudens' suggestion that he and McKim go and see them.[16] But the only description of the murals in the Franklin Square building, located in the firm's private offices, mentions ones painted in the late 1870s by Abbey, F. S. Church, C. S. Reinhart, and Alfred Fredericks—all Harper staff artists—but none by Homer.[17] And when Downes tried to see the murals in 1911 they had disappeared.[18] Homer did some tile decorations in the late 1870s (fig. 27), at the same time the Harper murals were evidently executed, and so, while it is a big leap from fireplaces to murals, it is not inconceivable that he might have done even more ambitious mural decorations at about the same time and in the same decorative spirit. But it is hard to imagine what Homer, who was by that time best known as a painter of powerful, heroic seascapes, might have done in the Boston

Public Library in the 1890s, or what his work would have looked like in the company of artists such as Bridgman, Cox, and Millet—or, for that matter, Whistler and La Farge, who were asked to do murals as well—not to mention Abbey, John Singer Sargent, and Puvis de Chavannes, whose murals actually adorn the library.[19]

Or, perhaps, if Homer was invited to do a library mural (all of this, of course, might be pure hearsay), it may not have been only on the strength of the Harper's murals. Homer's work of the 1880s, the time at which he might have been considered for a mural commission, consisted of the most conventionally invented and executed and most openly traditional paintings he ever made, and ones most suited in the monumentality of their conception to public spaces: the series that contained such great heroic paintings as *The Life Line* (1884, Philadelphia Museum of Art), *The Fog Warning* (1885, Museum of Fine Arts, Boston), *The Herring Net* (1885, fig. 28), *Undertow* (1886, fig. 29), and *Eight Bells* (1886, Addison Gallery of American Art).

Homer felt the attraction of convention and artistic tradition most strongly in England beginning in the early 1880s (fig. 30). The suddenly greater physical size of his large English watercolors, their more ambitiously conceived and more carefully studied compositions, graver themes, and weightier figures, all resulted from what clearly seems to have been Homer's determination to give his own art a weight of meaning and a dimension of form that he admired in the art of the past, and perhaps in contemporary official art as well. Homer's English art, as his critics noticed, is consistently more complete and more comprehensive—more realized in execution and resolved in content—than his earlier more fragmentary, allusive, and often ambiguous art had been. "His pictures are not what they used to be, things of shreds and patches," one critic wrote.[20] Another said his English work no longer consisted, as she believed his earlier work had, of "sketches or studies," but of "pictures in the truest sense of the word."[21]

It is precisely in its greater pictorial and narrative completeness that a watercolor such as *The Wreck of the Iron Crown* of

25. Winslow Homer, *Autumn*,
1877, oil on canvas, 97.1 x 58.6
(38¼ x 24³/₁₆)
National Gallery of Art, Washington,
Collection of Mr. and Mrs. Paul Mellon

26. Alfred Stevens, *Fall*, oil on
canvas, 118.3 x 59.2 (46⁹/₁₆ x
23⁵/₁₆)
Sterling and Francine Clark Art
Institute, Williamstown,
Massachusetts

27. Winslow Homer, *Shepherd
and Shepherdess*, 1878, tiled
fireplace, each tile 20.3 x 20.3
(8 x 8)
Collection of Diana and Arthur G.
Altschul

1881 (fig. 31) differs from Homer's earlier work. It achieved that completeness by its more conventionally organized compositional and narrative structure. And it achieved that, in turn, by the more conventional organization of the creative process by which it was made. Homer had always been a prolific and expert draftsman. Earlier, his drawings were notations of experience, not made, so far as we can tell, as studies for specific projects but for possible (though not always for actual) later use. But he studied the subject of *The Wreck of the Iron Crown* in a much more disciplined way, using a series of drawings—in a way that drawings had been traditionally used, but in which he himself had never used them—to develop the idea and its proper pictorial and narrative form (for example, figs. 32, 33). When he showed a group of his English drawings in 1883, a critic wrote that Homer wanted it understood that drawings such as these were "simply one of the steps in the process of making a picture."[22]

His English work was conventional and traditional in its appearance, not merely in its method. Some of his English watercolors imply by their complexity and monumentality (if not by their actual size, although they are significantly larger than any of his earlier watercolors) an ambition to public exhibition pieces—like Sargent's *Oyster Gatherers of Cancale* of 1878 (fig. 34)—and may even have been preparatory explorations for a painting or paintings of that kind (a popular subject in official

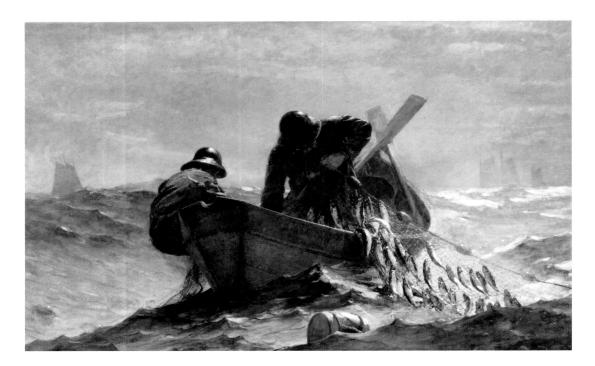

28. Winslow Homer, *The Herring Net*, 1885, oil on canvas, 76.5 x 122.9 (30⅛ x 48⅜)
Art Institute of Chicago, Mr. and Mrs. Martin A. Ryerson Collection

29. Winslow Homer, *Undertow*, 1886, oil on canvas, 75.8 x 121 (29¹³/₁₆ x 47⅝)
Sterling and Francine Clark Art Institute, Williamstown, Massachusetts

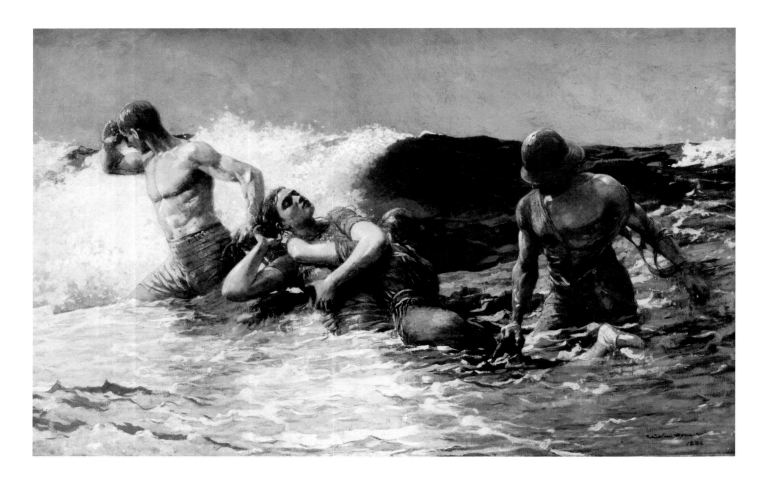

30. Winslow Homer, *Four Fishwives*, 1881, watercolor, 48.3 x 72.4 (19 x 28½)
Scripps College, Claremont, California, Gift of General and Mrs. Edward Clinton Young, 1946

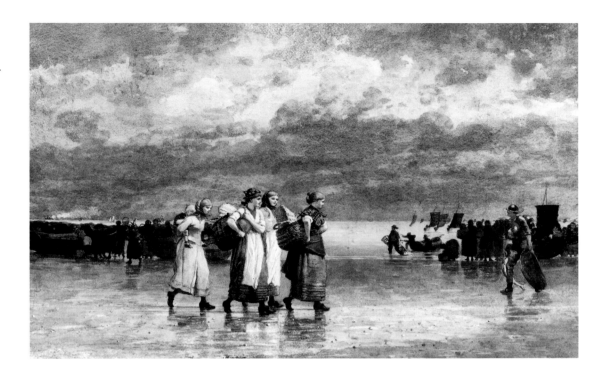

31. Winslow Homer, *The Wreck of the Iron Crown*, 1881, watercolor, 51.4 x 74.7 (20¼ x 29⅜)
Private collection, on indefinite loan to the Baltimore Museum of Art

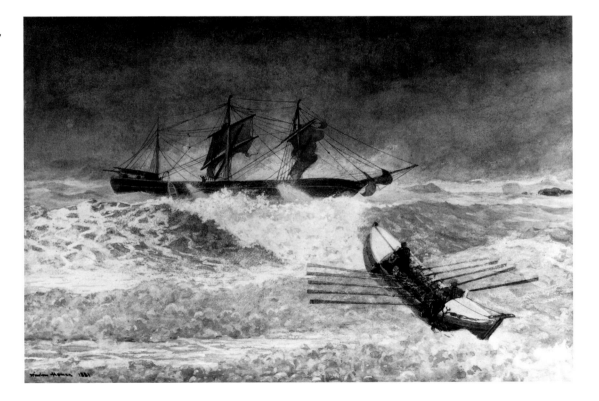

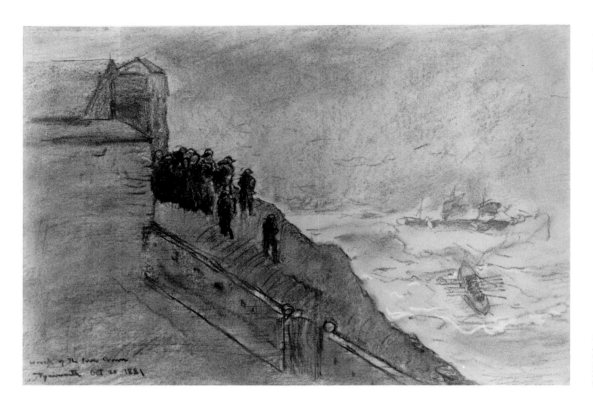

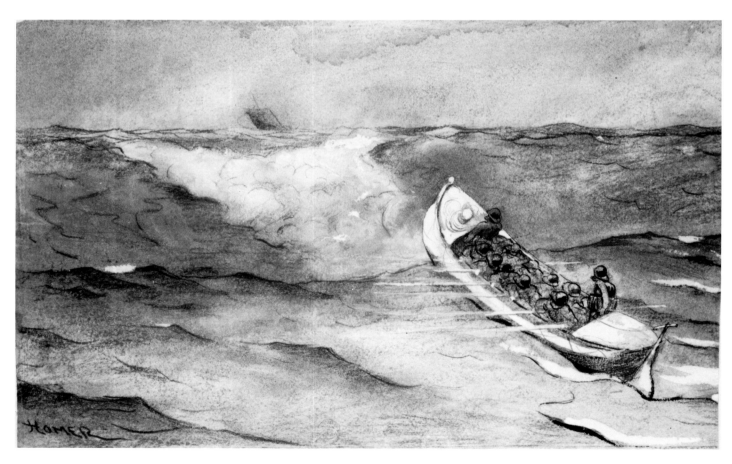

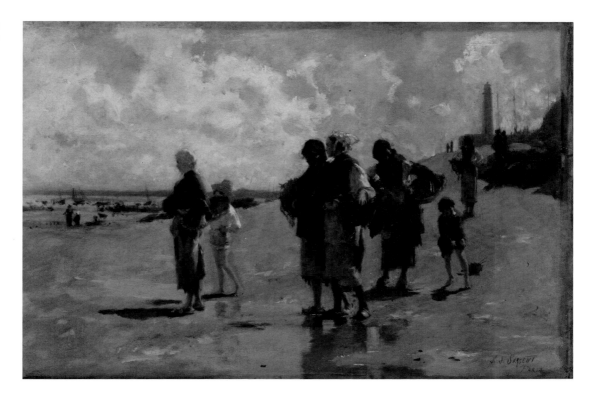

art).[23] Others are overtly traditional, like the large watercolor of 1882 originally titled *Far Away from Billingsgate* (now called *Mending the Nets*), that Homer made purposely to resemble classical relief sculpture (fig. 35).

All of this remained largely exploratory in Homer's English work itself. Only after his return to America in 1883 was it expressed definitively and ambitiously in a series of paintings that were larger and more complete than any he had attempted earlier and more open in their regard for artistic convention. For instance, in *Coming Away of the Gale* of 1883 (fig. 36, now *The Gale*), the first of the series, classical precedents are unmistakable in the figure's resemblance to the famous Winged Victory of Samothrace.[24] They are unmistakable, too, in the resemblance of *Undertow* of 1886 (fig. 29) to the Parthenon sculptures (the Elgin marbles) in the British Museum. (*Undertow* also was studied in a series of compositional drawings.) The pyramidal composition of *The Herring Net* of 1885 (fig. 28) is a virtually standard formal configuration of High Renaissance classicism, which is probably what the critic had in mind who said it "recalls certain old Italian work."[25]

By about 1886 this, the longest episode of conventionalism in Homer's art, had largely passed, leaving behind some of Homer's most ambitious pictures—pictures, perhaps, that were his answer to the relentless chorus of criticism that for so many years complained of the incompleteness and carelessness of his art, proof that he could make conventionally resolved and finished pictures.

After about 1890, having discharged that obligation, the attraction of convention and tradition visibly diminished. His Adirondack paintings, his great seascapes, his late subject pictures—*The Gulf Stream, Searchlight, Kissing the Moon, Cape Trinity, Saquenay River,* and *Right and Left*—no longer invoke or suggest either.[26] It was in the 1890s (and after), in fact, that Homer's critics, and Homer himself, began to claim his singular independence from traditions of the past and conventions of the present. "He does not know what is going on in London, Paris and New York,"

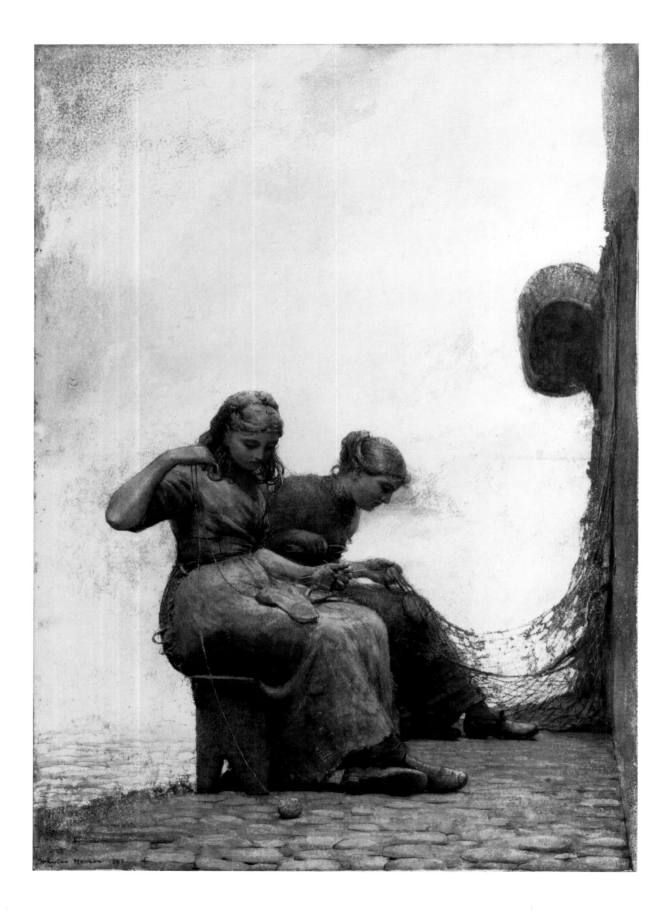

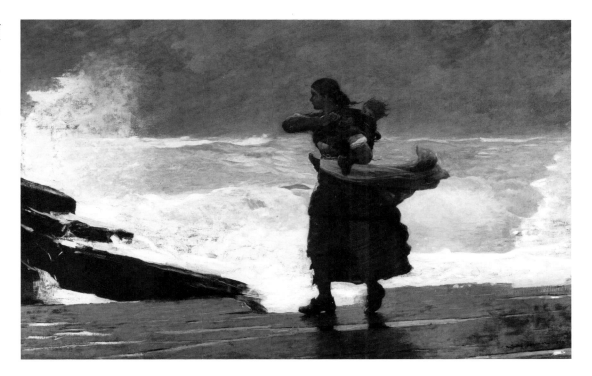

a critic wrote.[27] He is "the most truly and exclusively national painter ever reared in America."[28] And in a statement that Homer endorsed but probably did not write—the official line on the matter—it was said, "He works in utter independence of schools and masters. His method is entirely his own."[29]

Yet even in the artistic authority and financial security of his last years, when he should have felt able to paint entirely as he wished, independently and according to his own method, Homer could not completely release himself from the temptation of convention.

Some drawings that probably date about 1900 suggest that Homer was still thinking of conventional, melodramatic narrative subjects. What makes these drawings particularly interesting is that rather than being discarded pictorial thoughts, they were ideas he kept under active consideration. In 1900, to his dealer in Chicago who asked him to suggest a subject he might paint for a client, Homer wrote this: "I do not care to put out any ideas for pictures. They are too valuable, and can be appropriated by any art student, defrauding me out of a possible picture." But he continued, "I will risk this one, and I assure you that I have some fine subjects to paint."[30] With his letter he enclosed a sketch that he titled variously *Grand Banks*, *Fog*, and *Hard-a-Port*—one that resembled the drawing of a fishing schooner turning sharply to port to avoid an ocean liner suddenly emerging from the fog (fig. 37). From Homer's letter, which described such "ideas" as "valuable" and as "possible pictures" and "fine subjects to paint," it is clear that he seriously considered them to be fruitful pictorial possibilities, not, as they strike us, aberrant thoughts that happily remained unexecuted.

Even at the end of his creative life, when he was widely held up as a model of artistic individuality and independence, Homer was still tempted by convention. If, even then, he kept conventional subjects in reserve, perhaps it was a reflection of an uncertainty and insecurity that, even then, dogged the individuality and independence that Homer claimed in words and displayed in the bulk of his work—an uncertainty and insecurity reflected in his almost morbid sensitivity to criticism, his

37. Winslow Homer, *Hard-a-Port*, 1890–1900, charcoal
Courtesy Cooper-Hewitt Museum, Smithsonian Institution/Art Resource, New York, Gift of Charles Savage Homer

repeated threats to give up painting and his avowals of disinterest in art, and the language of commerce by which, masking his artistic doubts, he described his profession as "business" and his paintings as "goods."

Although episodic—like Homer's art, as a critic said, "a thing of shreds and patches"—this paper addresses, indirectly and from different angles, that relationship of tradition and innovation, convention and invention, whether it took the form of hostility between camps of belief or of a dialogue between competing allegiances within a single artist's work (as in Homer's) that was central to the art of the nineteenth century. Convention was the enemy and often the victim of modernist ambition. But it could also be, for Homer as for many others, a haven from its risks.

NOTES

1. Henrietta Benson Homer to Arthur Patch Homer, 17 December 1861, quoted in Gordon Hendricks, *The Life and Work of Winslow Homer* (New York, 1979), 45. "Win must go to Europe," Homer's father said at about the same time, expressing the urgency of his son's desire. Letter to Arthur Patch Homer, 1 January 1862, quoted in Hendricks, 46.

2. See Christopher Kent Wilson, "Marks of Honor and Death: *Sharpshooter* and the Peninsular Campaign," in *Winslow Homer: Paintings of the Civil War* [exh. cat., Fine Arts Museums of San Francisco] (San Francisco, 1988), 25–45.

3. S. G. W. Benjamin, *Art in America* (New York, 1880), 117.

4. This dismisses without explanation the argument that Homer was decisively influenced by what he experienced in France of advanced painting and Japanese art. But that argument is based largely on circumstance and faith—the coincidence of Homer's presence in France with some of the first occurrences of impressionism and of Japanese art in the West and the faith that this coincidence had some real and significant effect upon him. This argument is most extensively made in Albert Ten Eyck Gardner, *Winslow Homer, American Artist: His World and His Work* (New York, 1961). It can be found as well, somewhat hedged, in John Wilmerding, *Winslow Homer* (New York, 1972).

5. See the entry on *Pitching Quoits* in *Winslow Homer: Paintings of the Civil War*, 212–213.

6. The sculptor Augustus Saint-Gaudens saw Gérôme's *Death of Caesar* (the 1859 version, now lost) at the Goupil gallery in New York early in the Civil War. Introduction, Fanny Field Herring, *The Life and Works of Jean Léon Gérôme* (New York, 1892). Interestingly, a critic said of another of Homer's paintings in the 1865 National Academy of Design exhibition, *The Bright Side* (Fine Arts Museums of San Fran-

cisco), that certain figures were "as true and full of expression as if Mr. Homer could paint like Gé-rôme." "Fine Arts. The Fortieth Exhibition of the National Academy of Design," *Nation* 1 (13 July 1865), 59.

7. Eugene Benson, "Historical Art in the United States," *Appleton's Journal* 1 (10 April 1869), 45–46; Ellwood C. Parry, *The Image of the Indian and the Black Man in American Art 1590–1900* (New York, 1974); Lucretia Giese, "*Prisoners from the Front*: An American History Painting?," *Winslow Homer: Paintings of the Civil War*, 65–81.

8. Benson 1869, 46.

9. Charles Baudelaire, *The Painter of Modern Life and Other Essays*, ed. and trans. Jonathan Mayne (Greenwich, Conn., 1964), 13.

10. For changes made in the Metropolitan Museum version of *Snap the Whip* and in *Prisoners from the Front*, see Natalie Spassky et al., *American Paintings in the Metropolitan Museum of Art*, vol. 3 (New York, 1983), 437, 457–458.

11. Technical examination, however, does not confirm what seems apparent to the naked eye.

12. "Mr. Winslow Homer is drawing on wood sketches of his paintings entitled 'The Song of the Lark' and 'Hooking Watermelons,' which will be engraved for Appleton's *Art Journal*." "Art Notes," *New York Evening Post* (14 February 1878). *Watermelon Boys (Hooking Watermelons)* was exhibited at the National Academy of Design in April 1878.

13. "Fine Arts. The National Academy Exhibition. Final Notice," *Nation* 26 (30 May 1878), 362.

14. The source for this is a letter from the sculptor Augustus Saint-Gaudens to the architect Charles F. McKim: "Aside from [John] La Farge, 'qui va sans dire,' and to whom undoubtedly the big room should be given, the following are the names that you should consider in this matter: Abbey, Bridgman, Cox, Millet, Winslow Homer (who, Abbey tells me, has done some bully decorative things in Harper's office that we can go see together), and Howard Pyle. These are all strong men—every darned one of them." "Saint-Gaudens the Master. The Reminiscences of Homer Saint-Gaudens," *Century* 78 (August 1909), 623. For a discussion of the decoration of the Boston Public Library (in which there is no mention of Homer), see Walter Muir Whitehill, "The Making of an Architectural Masterpiece—The Boston Public Library," *American Art Journal* 2 (Fall 1970), 13–35.

15. John La Farge described a wall decoration that Homer consulted him about as "as learned as if this man had studied all the necessary books," though whether he was referring to its subject or its form is not clear. Gustave Kobbé, "John La Farge and Winslow Homer," *New York Herald* (4 December 1910).

16. Perhaps it was at this time, and even for this project, that Homer considered stained glass decorations. "Many people do not know that he had even thought of stained glass and wall decorations," La Farge reported. "He came to me late to consult me about these questions. The wall decoration I saw the

project for. . . . His glass I had no idea of. I doubt if he himself had any notion, but I regret that such an impossible thing should not have been tried. It is a great honor that he came to me once to ask." Kobbé 1910.

17. *More Than One Hundred Years of Publishing* (New York and London. [1923]), n.p.

18. "When I called at Harper & Brothers' establishment, in February, 1911, and asked about these decorations, nobody knew anything about them, and, although a frieze in the office was shown, it apparently did not include the panels by Homer." Downes 1911, 244.

19. For Whistler's mural, see Whitehill 1970, 22–25.

20. "Art Exhibitions. The Water-Color Society," *New York Sun* (28 January 1883).

21. M. G. Van Rensselaer, "The Water-Color Exhibition, New York," *American Architect and Building News* 13 (24 March 1883), 138.

22. "The Fine Arts. Mr. Homer's Black and Whites," *Boston Advertiser* (29 November 1884).

23. The version of Sargent's painting in the Museum of Fine Arts, Boston (there is a smaller version in the Corcoran Gallery of Art, Washington) was shown in New York in 1878 in the first exhibition of the Society of American Artists. It is likely that Homer saw it there.

24. The painting, now titled *The Gale* (Worcester Art Museum), was extensively reworked in the early 1890s (it is now dated 1893). The Victory of Samothrace was discovered in 1863 and installed in the Louvre in 1867, when Homer was in Paris (it was placed in its present position in 1884). See Francis Haskell and Nicholas Penny, *Taste and the Antique: The Lure of Classical Sculpture, 1500–1900* (New Haven and London, 1981), 333–334.

25. "Art Notes. Winslow Homer at Doll & Richards, Feb. 19–March 3," *Boston Evening Transcript* (25 February 1886).

26. To be sure, *The Gulf Stream* (1899, Metropolitan Museum of Art) recalls Turner's *Slave Ship* (Museum of Fine Arts, Boston) and Delacroix's *Barque of Dante* (Louvre), both paintings that Homer would have known. *Cape Trinity, Saguenay River* (1904–1909, Regis Corporation, Minneapolis) suggests his knowledge of Arnold Boecklin's *Isle of the Dead* (several versions).

27. "Some Living American Painters. Critical Conversations by Howe and Torrey [William Howe Downes and Frank Torrey Robinson]. Second Paper," *Art Interchange* 32 (May 1894), 137.

28. William Howe Downes and Frank Torrey Robinson, "Later American Masters," *New England Magazine* 14 (April 1896), 139.

29. *Catalogue of the Private Art Collection of Thomas B. Clarke of New York*, part 1 (New York, 1899), 63.

30. Homer to O'Brien & Son, September 1900, quoted in Lloyd Goodrich, *Winslow Homer* (New York, 1944), 163.

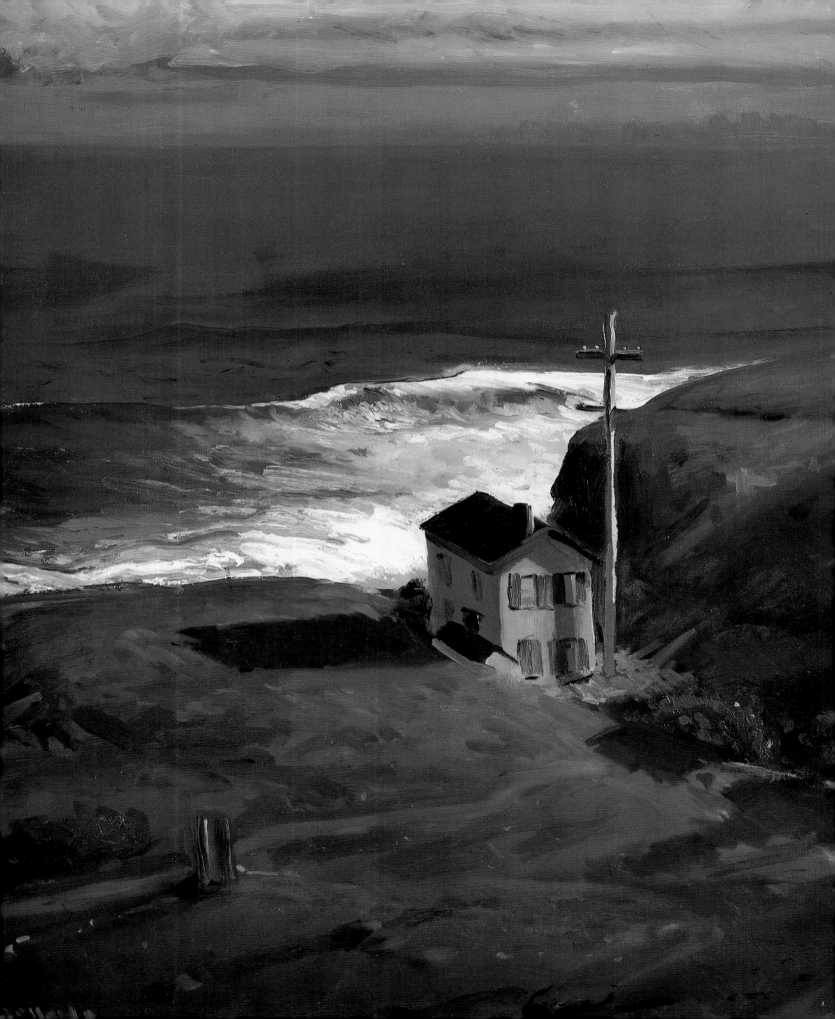

FRANKLIN KELLY
National Gallery of Art

George Bellows' Shore House

Detail fig. 1

Among the many wonderful and moving works in the Fraad Collection, one painting, George Bellows' monumental *Shore House*, surely endures in the memory of anyone who has seen it (fig. 1). Although perhaps not one of the artist's most familiar images, it is nevertheless reasonably well known. Painted in January 1911, it has appeared in more than twenty exhibitions since then.[1] Nor has it eluded those who have written about Bellows, for it receives at least passing mention in virtually every important study of the painter and his art. For Mahonri Sharp Young it is "the best Montauk [Long Island] picture ever painted," and for Linda Ayres it is "modern in its simplicity and in its large masses of color, but timeless in its spirituality and surely must rank as one of George Bellows' crowning achievements."[2] Yet in spite of all this attention, *Shore House* remains one of the most enigmatic, provocative, and suggestive works of an artist who usually seemed to convey his message with straightforward and clearly intelligible enthusiasm. This essay will attempt to define the place *Shore House* holds in Bellows' art in general and to reveal the meaningful information it offers us about Bellows himself.

The hard facts about *Shore House* can be stated quickly. According to a notation in Bellows' record book, it was "Painted from Montauk sketch Jan. 1911." Working backward in the record book we come to an entry for September 1910, which reads: "Honeymoon . . . sketches at Montauk." There are apparently several pages missing from the record book at this point.[3] If Bellows ever wrote a more detailed description of the sketch for *Shore House*—one, for instance, that might have identified the house or offered other useful information—it is lost to us now. We also do not know whether the sketch itself has survived or whether it was in pencil, oil, or some other medium.

Those few facts, along with one or two passing references Bellows made to *Shore House* and a few brief comments in contemporary exhibition reviews, comprise the primary evidence about the painting. Thus, much of what can be said about *Shore House* is, of necessity, speculative. But I am convinced that the only route to understanding *Shore House* and appreciating its full import leads inevitably to the realm of speculation.

Fortunately, we do know a great deal about George Bellows and his art that can be helpful in investigating *Shore House*.[4] Born in Columbus, Ohio, in 1882, Bellows came to New York at the age of twenty, intent on making his way as an artist. He enrolled in the New York School of Art and studied under William Merritt Chase and Robert Henri; among his classmates were two contemporaries: Rockwell Kent and

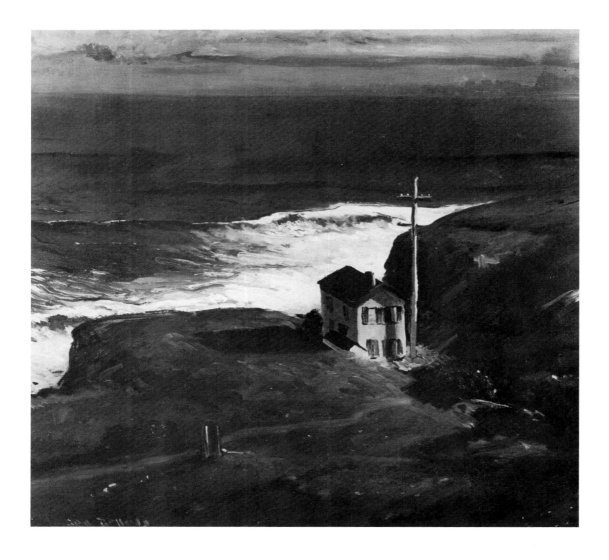

Edward Hopper. Bellows developed rapidly as a painter, absorbing in particular Henri's theories about the validity of choosing subjects from the gritty reality of urban life, and he also quickly learned the slashing brushstroke and dark colors Henri so greatly favored. We can see Bellows' mastery of Henri's style in two important early works, *Kids* of 1906 and *Forty-two Kids* of 1907 (figs. 2, 3). Critics and lovers of art immediately sensed that here was an artist of exceptional promise and talent. As a writer for the *New York Herald* observed of *Forty-two Kids* when it was shown at the National Academy of Design in the spring of 1908: "one of the most original and vivacious canvases in the show. . . .

An artist need never leave Manhattan Island if it yields pictures like this."[5] Indeed, for the next few years Bellows did not, at least in terms of the subjects of his painting, leave New York. The city was in those years expanding rapidly and was alive with the energy of an active and changing population. Mighty bridges were spanning the rivers and new buildings seemed to spring up almost overnight. Compared to Columbus, Ohio, New York was bursting with vitality, and Bellows was greatly inspired. Following Henri's creed that "there is beauty in everything if it looks beautiful to your eyes,"[6] he painted many fine urban landscapes such as *The Bridge, Blackwell's Island* of 1908, which shows a scene under

1. George Bellows, *Shore House*, 1911, oil on canvas, 101.6 x 106.7 (40 x 42) Collection of Rita and Daniel Fraad

2. George Bellows, *Kids*, 1906,
oil on canvas, 81.3 x 106.7
(32 x 42)
Collection of Rita and Daniel Fraad

3. George Bellows, *Forty-two Kids*, 1907, oil on
canvas, 107.6 x 155.6 (42³/₈ x
60¹/₄)
In the collection of the Corcoran
Gallery of Art, Washington,
D.C., Museum Purchase,
William A. Clark Fund

the Queensborough Bridge (fig. 4), and
Blue Morning of 1909, which immortalized
the enormous excavation for Pennsylvania
Station (fig. 5). Such paintings were in Bellows' day, as today, much admired for their
powerful compositions, their directness,
and for their fluid and expressive brushwork. Bellows also explored the more lyrical side of Manhattan's scenery, creating a
number of lovely views, often in winter, of
the rivers that surround the city, such as
North River of 1908 (fig. 6). Ultimately, of
course, Bellows found his greatest contemporary fame for his series of boxing pictures, including *Both Members of This
Club* (fig. 7) and *Stag at Sharkey's* (Cleveland Museum of Art), both of 1909. Even
before he had turned thirty he was generally regarded as one of the leading artists
of the day, and although financial rewards
in the form of sales and commissions were
not abundant, he was able to support himself. In April 1909, before his twenty-seventh birthday, Bellows was elected an associate of the National Academy, one of
the youngest ever accorded the honor by
that august institution.[7]

There were also important developments in Bellows' personal life in these
years. Soon after arriving in New York, he
had met Emma Story, who was briefly a
student at the New York School of Art (see
fig. 8). At first he took no particular notice
of her, and she preferred to keep company
with Rockwell Kent and Edward Hopper.
But suddenly, in the fall of 1905, Bellows
seems to have seen her as if for the first
time, and he fell deeply in love.[8] Although
he made up his mind almost immediately
that he would make her his wife, the
courtship proceeded with agonizing slowness. Emma Story knew how Bellows felt
about her, but she did not reciprocate immediately, and she often ignored his attentions in favor of others.[9] Slowly Bellows
worked his way into her heart. In the
spring of 1910, with a new appointment as
life class instructor at the Art Students
League and the promise of a steady salary
of $1,000 a year, he finally convinced her
to marry him. The wedding, a small affair
to which not even Bellows' own family was
invited, took place on 23 September, almost five years after they had first met.

That night they took a train to Montauk, which brings us back to *Shore House*.
We do not know why they chose Montauk
as the destination for their honeymoon,
but the choice likely was Bellows.' Both of
his parents were from Sag Harbor, Long
Island, and he and his family had often

traveled there from Columbus to visit relatives. Sag Harbor is relatively close to Montauk, and the newlyweds stopped in the town on their way back to New York to visit Bellows' parents, who were staying there at the time. There is no evidence that Bellows had ever been to Montauk before his honeymoon, but he was surely aware of its reputation for dramatic scenery. In 1910 Montauk was still very much an isolated and remote place, with perhaps the most rugged and stirring landscapes and coastal views available anywhere within a day of New York City. Charles Parsons, who had visited in 1870, noted that it was "a region comparatively unknown, except to a few sportsmen, attracted there by its very wildness, and to such tourists as find especial charms in its seclusion, and in the bold and picturesque scenery of its defiant promontory, upon

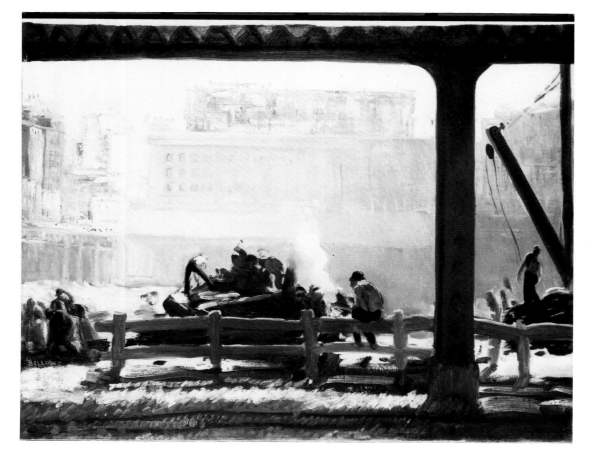

4. George Bellows, *The Bridge, Blackwell's Island*, 1909, oil on canvas, 86.5 x 112 (34¹/₁₆ x 44¹/₁₆)
Toledo Museum of Art, Gift of Edward Drummond Libbey

5. George Bellows, *Blue Morning*, 1909, oil on canvas, 86.4 x 110.2 (34 x 43³/₈)
National Gallery of Art, Washington, Chester Dale Collection

6. George Bellows, *North River*, 1908, oil on canvas, 83.2 x 108.6 (32³/₄ x 42³/₄) Pennsylvania Academy of the Fine Arts, Philadelphia, Joseph E. Temple Fund

which the wild Atlantic incessantly beats, and sometimes with tremendous violence."⁹ Although the area had changed some in the years since Parsons' visit, it had resisted by and large the advance of civilization. Late in the nineteenth cen-

tury a daring entrepreneur named Austin Corbin dreamed of establishing a transatlantic port in Montauk, but he died in an accident before he could realize that dream.¹⁰ In 1895, however, the railroad was extended from Bridgehampton to Montauk, making the region somewhat more accessible.¹¹ Nevertheless, it remained a "wild and desolate country," and tourists who ventured there still had literally "a hard road to travel."¹² According to Bellows' biographer Charles Morgan, "Emma never forgot the drive [from the railroad station] into the darkness surrounded by sand dunes and autumnal red grasses [and] under a sky spilling over with stars."¹³

The couple stayed in a "boarding house," which was customary for visitors as there were no hotels.¹⁴ Much of the undeveloped area around Montauk and the point was used for grazing sheep and cattle.¹⁵ Settlement was relatively sparse. The simple frame dwelling depicted in *Shore House* appears to be a modest, anonymous home, no doubt inhabited by a local family.¹⁶

By 1910, of course, there was a long tradition in American art of landscape paintings that included houses as their central

7. George Bellows, *Both Members of This Club*, 1909, oil on canvas, 114.9 x 160.3 (45¹/₄ x 63¹/₈) National Gallery of Art, Washington, Chester Dale Collection

8. George Bellows, *Emma in a Purple Dress*, 1920–1923, oil on canvas, 160 x 129.5 (63 x 51) Dallas Museum of Art, Dallas Art Association Purchase

subject. In this context there is no need to give a lengthy review of such images, but it is worth considering a few examples. To do so is not to establish that *Shore House* is part of this tradition, but in fact to suggest precisely the opposite, that it is quite different from these earlier works. Compare, for example, a familiar Hudson River School image, Thomas Cole's *The Hun-*

ter's Return of 1845, (fig. 9), with its wilderness family and cozy log cabin. Even by Cole's day the log cabin had become a potent and well-known symbol that summed up the essence of the American pioneer experience. The house in Cole's painting is thus not a specific one, but rather an archetype that embraced a host of meanings beyond individual associations. Later

9. Thomas Cole, *The Hunter's Return*, 1845, oil on canvas, 101.9 x 153.7 (40¹/₈ x 60¹/₂) Amon Carter Museum, Fort Worth

10. Worthington Whittredge, *Old Homestead by the Sea*, 1883, oil on canvas, 55.9 x 81.3 (22 x 32) Bequest of Martha C. Karolik for the Karolik Collection of American Paintings, 1815–1865; Museum of Fine Arts, Boston

in the century Worthington Whittredge often painted the simple houses around Newport, Rhode Island, as in *Old Homestead by the Sea* of 1883, (fig. 10). These were actual buildings Whittredge had seen and sketched and were meant to evoke the everyday life of the New England coast.

Somewhat closer to *Shore House*, at least in terms of geography, are a number of paintings of Long Island scenery that include dwellings. William Sidney Mount's *Long Island Farmhouses* of about 1854, for instance, is a straightforward depiction of

a scene near the artist's hometown of Stony Brook (fig. 11). Long Island was also the site of one of the most famous houses in America, the home of John Howard Payne, who gave us that immortal song, "Home, Sweet Home."[17] It is depicted in a painting by Lemuel Maynard Wiles of 1886 (*Home Sweet Home*, Guïld Hall Museum), as the very embodiment of the words, "Be it ever so humble, there's no place like home." And Long Island's Shinnecock, of course, was for more than ten years home to Bellows' teacher William Merritt Chase, who often included his house and studio in his sparkling, light-filled landscapes of the 1890s.[18]

But when any of the foregoing are compared to *Shore House* (fig. 12), it becomes quite clear that it is in fact very different in its effect on us and in the associations it engenders. This is not a sturdy log cabin in the American wilderness, nor Payne's cozy "Home, Sweet Home," nor Chase's elegantly furnished house and studio. It is a simple frame dwelling of a type common along the East Coast. But there is something oddly provocative in the way it is so isolated and so attenuated in shape. Indeed, *Shore House* seems more comfortable in the company of a work like *House by the Railroad* (Museum of Modern Art), which was painted some fifteen years later by Bellows' friend Edward Hopper. Why is this so? The answer, though far from simple, can nevertheless be summed up in a single word: modernity. *Shore House* is a modern picture in every sense of the word—modern in the formalism of its style and composition, modern in its austerity and in the intensity of its mood and effect, and, perhaps most profoundly, modern in its expression of certain psychological realities about its creator.

Let us start with the easiest to decipher of these qualities of modernity evident in *Shore House*—its style and composition. Although in terms of actual paint handling *Shore House* is not greatly different from many of the New York river scenes that preceded it, the marked centrality of its composition does indicate new directions. Bellows only completed two pictures between his honeymoon and the time he painted *Shore House: Crowd at Polo* (1910,

Mrs. John Hay Whitney Collection) and *Blue Snow, the Battery* (fig. 13). *Crowd at Polo*, based on sketches made in the spring of 1910, is an exuberant and spirited picture, but its energized composition is more closely related to preceding works, such as *Forty-Two Kids* and *Both Members of This Club*, than to *Shore House*. But *Blue Snow, the Battery*, with its elevated vantage point, great simplification of form, solemn mood, and focus on a central structure, does suggest an affinity to *Shore House*. One of the most lyrically beautiful of all Bellows' New York landscapes, *Blue Snow, the Battery* serves as a stylistic bridge between earlier busy urban scenes such as *Blue Morning* and the more restrained, subdued *Shore House*.

It would seem that Bellows in late 1910 and early 1911 was beginning to effect certain changes in his art. We often tend to think of Bellows in this period as a "pure" painter, a man with a superb eye and an extraordinary ability to wield a paintbrush, but not someone much influenced by the art of others. But in some cases he clearly drew inspiration from others' works. As Bellows once observed: "There is no new thing proposed, relating to my art as a painter of easel pictures, that I will not consider."[19] He also prided himself on his willingness to experiment and on his resistance to formulating artistic dogma; "rules and regulations," he once said with characteristic directness, "are made by sapheads for the use of other sapheads!"[20] Clearly not a "saphead" himself, Bellows was quick to notice when another artist's work offered inspiration. One likely influence was Bellows' former classmate Rockwell Kent, whose powerful series of Monhegan landscapes and seascapes—such as the well-known *Toilers of the Sea* (1907, New Britain Museum of American Art)— had been shown in New York in 1907.[21] One of these—*Winter, Monhegan* (fig. 14)— bears more than passing resemblance to Bellows' *Blue Snow, the Battery*. Bellows certainly saw Kent's works, and according to Morgan he "feasted his eyes long and enviously on these pictures, vowing that someday he would go to Monhegan himself and do better ones."[22] Although Bellows would not reach Monhegan until the

11. William Sidney Mount, *Long Island Farmhouses*, c. 1854, oil on canvas, 55.6 x 75.9 (21⁷⁄₈ x 29⁷⁄₈) Metropolitan Museum of Art, Gift of Louise F. Wickham in memory of her father, William H. Wickham, 1928

12. Detail of house in George Bellows, *Shore House*, 1911

13. George Bellows, *Blue Snow, the Battery*, 1910, oil on canvas, 86.4 x 111.8 (34 x 44) Columbus Museum of Art, Museum Purchase, Howald Fund

14. Rockwell Kent, *Winter, Monhegan*, 1907, oil on canvas, 86.0 x 111.8 (33⁷⁄₈ x 44) Metropolitan Museum of Art, New York, George A. Hearn Fund, 1917

summer of 1911, *Blue Snow, the Battery* and *Shore House* are evidence that he clearly learned something from Kent's starkly simplified pictures.[23]

For Bellows' contemporaries, however, another artist seemed to stand behind much of his work at this point, and, most especially, behind *Shore House*. That was Winslow Homer, who had died on 29 September 1910, just six days after Bellows was married. As a critic for the *New York Times* wrote, Bellows "arrives at mastery by simple means in the 'Shore House,' a square house . . . with a massive blue sea beyond as gaunt and dignified in arrangement as a Winslow Homer."[24] Bellows greatly admired Homer and his work, and on one level *Shore House* might be seen as a memorial to him.[25] Homer was, of course, famous not only for his powerful marines, but also for his solitary and reclu-

sive lifestyle at Prout's Neck, Maine, where his studio overlooked the ocean. In Bellows' painting, then, the image of a solitary house in an austere landscape with a surging ocean beyond may be read as a testament to the memory of this great American painter of the sea.

Shore House also reflects the actual influence of Homer's art, in particular the great late seascapes such as *On a Lee Shore* of 1900 (fig. 15). In these works Homer reduced the elements of his compositions to a minimum, concentrating the effect powerfully; to paint the sea, he advised, "do it with one wave, not more than two."[26] Although in *Shore House* the breaking waves

are not thrust to the very front of the picture plane, as they generally are in Homer's late works, they nevertheless are possessed of sufficient force to lead one critic to declare them even "more stirringly real than most of the seas in Homer's oils."[27] That Bellows did learn much from Homer is evident in the small oils of breaking waves he painted on Monhegan Island in the summer of 1911 (e.g., fig. 16). Some of these, such as *The Grey Sea*, come close to virtual abstraction in their energized portrayal of the surging waves (fig. 17).

In *Shore House* Bellows also used a nearly square format, as had Homer on occasion (for example, *On a Lee Shore*). As

William Gerdts has discussed, the choice of the square format in American art of the late nineteenth and early twentieth centuries was, in itself, an expression of aesthetic modernism, for its compositional dynamics tend to work against illusionism and draw the viewer's attention to the flatness of the picture plane.[28] Unlike traditional horizontal-format landscapes, which emphasize lateral expansion of space, or vertical ones, which emphasize up and down, the square format tends to contain visual movement, forcing the viewer's eye over and over again to the center of the picture. Often, as in Albert Pinkham Ryder's *Siegfried and the Rhine Maidens* (fig. 18), the composition is arranged around diagonal elements. Bellows was clearly aware of such issues. We may note, for instance, the way the electric pole and the crosstree line up along one diagonal and the way the lines of the roof similarly

16. George Bellows, *Churn and Break*, 1913, oil on panel, 45.1 x 55.9 (17³/₄ x 22) Columbus Museum of Art, Gift of Mrs. Edward Powell

17. George Bellows, *The Grey Sea*, 1913, oil on panel, 32.7 x 49.2 (12⁷/₈ x 19³/₈) Columbus Museum of Art, Gift of Jessie March Powell in memory of Edward Thomson Powell

follow the diagonals, focusing our attention repeatedly on the center of the painting. The house itself is placed slightly off center, so as our eye shifts from the center to it, a visual movement begins that leads us again through the picture. Yet there is no escape, no visual path that leads us out of the picture's space. By making the horizon high on the canvas, and by making the sky similar in color to the sea, Bellows effectively denied movement into an infinite distance. In these ways, *Shore House* works against traditional illusionism. Although it is not, to be sure, especially radical in terms of European vanguard painting of the same period, it nevertheless represents a sophisticated understanding on Bellows' part of the relationship between painting as a window into the world and painting as flat object.

But in the end, this kind of formal analysis, although it can help us see how the picture works visually, does not help much with the inevitable question of meaning. It may be a truism to say that anything an artist creates is in some measure autobiographical. But *Shore House*, perhaps more than any other single painting of Bellow's career, does seem to demand an autobiographical reading. Bellows himself recognized—and these are his words—that "a picture is a human document of the artist."[29] Furthermore, he felt that learning to draw or paint was "an easy matter," but "to say anything you must have ideas." "Drawing and painting," he observed, "is a language. You can be great or small, glad or sad, in its use according to what you have to say."[30]

What did Bellows have to say in *Shore House*? Was it great or small, glad or sad, or something else entirely? We cannot, of course, reconstruct the innermost workings of his mind, nor can we be certain that he was conscious of every meaning *Shore House* offers. But after all autobiography, whether written or painted, is often most revealing not for what it actually says, but for the deeper truths that frequently underlie the literal. The true challenge, then, of a work such as *Shore House*, and perhaps the greatest evidence of its modernity, is the way it engages for its subject the life of the artist himself.

As we have seen, *Shore House* grew from an important experience in Bellows' life—his honeymoon. After five years of patient and persistent courtship, he had finally won Emma Story, and he knew he had reached the turning point that comes to young men when they marry. With a wife he faced the prospect of beginning a family of his own. Gradually he would face the inevitable process of separation from his other family, in particular from his adored and adoring mother. Bellows had not lived with his parents for almost a decade, and his bachelor artist existence had not been marked by anything resembling domesticity. Now, however, he and Emma had purchased a house in New York, and he had spent much of the time before the wedding working to ready it. The house in *Shore House*, though remote in place and spirit from the New York townhouse, is nonetheless a house, albeit a rather simple one. We know that Bellows admired and even identified with this kind of straightforward vernacular architecture. As he observed: "I

18. Albert Pinkham Ryder, *Siegfried and the Rhine Maidens*, 1888–1891, oil on canvas, 50.5 x 52.1 (19⅞ x 20½) National Gallery of Art, Washington, Andrew W. Mellon Collection

am sick of American buildings like Greek temples and of rich men building Italian homes. It is tiresome and shows a lack of invention. . . . All living art is of its own time."[31] For Bellows this house possessed an honesty and genuineness that set it apart from the ostentatious houses of the very rich that were already dominating Manhattan. Perhaps Bellows could imagine living in just this kind of house; indeed, in 1922, when he realized a lifelong dream and built his own house in the country at Woodstock, New York, it was in a similar simple style.[32] More to the point, Bellows may well have seen this house as a place where people lived together as a family; that is, after all, the function of a house. And because there is nothing in the painting that identifies the house with a specific family and no people are present, the image is open to personal associations. For Bellows, such associations would have included memories of his own life with his family, who traced their origins to a humble house on Long Island, and also the prospects of a future life with a family and house of his own. Ronald Pisano has interpreted Shore House as "an image of strength and endurance, an appropriate and hopeful symbol for a marriage."[33] Perhaps this is so; in fact, Bellows, while on Monhegan in the summer of 1911, wrote to Emma that he imagined the two of them sitting by the sea: "We two and the great sea and the mighty rocks greater than the sea, and we two greater than the rocks and the sea. Four eternities."[34] His earlier experience of seeing the house in Montauk with his new bride might well have occasioned similar thoughts of eternity.

In suggesting this kind of meaning for Shore House, in proposing that it might be read as representing the artist's thoughts about home and family, past, present, and future, I cannot deny that there remains an underlying current of mystery, uncertainty, and, most especially loneliness that does not necessarily complement such associations. There is something undeniably somber and alienated about this solitary house perched at the edge of the great blue sea. Bellows was not unacquainted with loneliness; he had endured periods of profound loneliness as a child and as a college student.[35] He had also painted in 1909 The Lone Tenement (fig. 19), a moving image of urban dispossession and isolation that stands as a compelling precedent to Shore House.[36] And just after completing Shore House, he painted the powerful New York, in which most of the figures seem absorbed in their own worlds, each, as it were, alone in a crowd (fig. 20). Still, Shore House is so charged with mystery as to be puzzling and enigmatic. We do not usually think of Bellows as a painter of mysterious images—as Mahonri Young has observed, "There never was much mystery about Bellows"[37]—but he did create a few deeply evocative and moving works. The one that comes closest in mood and feeling to Shore House is called An Island in the Sea, which Bellows painted at Monhegan in the summer of 1911 (fig. 21). Bellows himself saw the two works as related; as he wrote to Emma, "Well dear sweetheart I painted a sure enough masterpiece today which walks up to the 'Shore House' and says 'Hello, Kid, I'm with you.' It's 'An Island in the Sea.'"[38] To be sure, An Island in the Sea intensifies the mood of isolation and mystery, but seeing it helps us appreciate those qualities in Shore House all the more. The two works are pictorial cousins, both broadly simplified and powerful images of land, sea, and air in which human creations seem not so much coequal eternities, but small and tenuous presences in the natural world.

And that brings us to the deepest, most profound meaning of Shore House. If we agree with Bellows that a work such as Shore House can be read as "a human document of the artist," how do we account for its mood of mystery, loneliness, and alienation? One way to do so is to see it as a document of a man who has come to a crossroads in his life, fully aware of the ultimate uncertainty of life itself. It is an image painted by someone who was assessing his past and speculating about the future. Professionally, with his early successes behind him, Bellows was ready for new artistic challenges. The dramatic landscape he found at Montauk pointed him in a new direction, one he would follow to great success that summer in Monhegan.

19. George Bellows, *The Lone Tenement*, 1909, oil on canvas, 91.8 x 122.2 (36⅛ x 48⅛) National Gallery of Art, Washington, Chester Dale Collection

20. George Bellows, *New York*, 1911, oil on canvas, 106.7 x 152.4 (42 x 60) National Gallery of Art, Washington, Collection of Mr. and Mrs. Paul Mellon

21. George Bellows, *An Island in the Sea*, 1911, oil on canvas, 87 x 112.7 (34¼ x 44⅜)
Columbus Museum of Art, Gift of Howard B. Monett

Emotionally, he was embarking on a journey through the rest of his life with a woman he deeply loved. He was approaching his thirtieth birthday and imagining life as a father and provider. It was a moment to examine his own life, to come to grips with fears and uncertainties and face the future; it was a moment to reckon with his own mortality and know that there is only one living soul that each of us can ever truly know, and that is ourselves. For Bellows the sea was an image of power and beauty, and even though he was a strong swimmer, it also evoked for him fears about death. He admitted to being afraid of "the waves [that] reach for us . . . [with] those crystal green hands which are so

clean and cold"[39] (fig. 22). And although not a regular churchgoer, Bellows, according to Morgan, found "something basic in the Christian theme of redemption through suffering that he could not dismiss."[40] His own middle name was Wesley, after John Wesley, founder of the Methodist Church, and it had been bestowed on him by his deeply religious mother, who had hoped he would become a minister. We cannot doubt that Bellows was perfectly aware of the fact that the tall electrical pole in *Shore House*, although nominally a reminder of civilization's long reach, was also powerfully suggestive of a cross. Although perhaps not drawn to religious imagery, he was not altogether averse to it, either; in 1923, for

instance, following the death of his mother, he would paint his own monumental version of the Crucifixion (Lutheran Brotherhood, Minneapolis). Might he have intended for his picture of a lonely house to evoke speculation about the fundamental mysteries of life and death? There can be no certain answers, but we may be certain that Bellows was capable of expressing far more profound meaning and sentiment in his art than he traditionally is given credit for. He was, to be sure, often a painter who painted what he saw, but on occasion he also painted what he felt. *Shore House* was one of those occasions. Beautiful and deeply moving, it challenges us in the end to make of it what we will.

For Walt Whitman, whom the painter greatly admired, seeing the dramatic scenery of Montauk led to deeper musings about the restlessness of life and the eternal quest of the human soul to find understanding. There is no way of knowing, but perhaps Whitman's words about Montauk were in Bellows' mind when he painted *Shore House*:

I stand as on some mighty eagle's beak,
Eastward the sea absorbing, viewing (nothing but
 sea and sky,)
The tossing waves, the foam, the ships in the
 distance,
The wild unrest, the snowy, curling caps—that
 inbound urge and urge of waves,
Seeking the shores forever.[41]

NOTES

1. See the list in Linda Ayres, *American Paintings, Watercolors, and Drawings from the Collection of Rita and Daniel Fraad* [exh. cat., Amon Carter Museum] (Fort Worth, 1985), 94–95. My thanks to Rita Fraad for her kindness and support, and for her hospitality, during the time I was investigating *Shore House*.

2. Mahonri Sharp Young, *The Paintings of George Bellows* (New York, 1973), 58; Ayres 1985, 96.

3. Information and quotations kindly provided by Glen Peck of H. V. Allison Galleries, New York,

which has responsibility for Bellows' record book and the Bellows estate.

4. The standard source on Bellows' art and the most complete account of his life is Charles H. Morgan, *George Bellows: Painter of America* (New York, 1965).

5. Quoted in Morgan 1965, 83.

6. Quoted in Morgan 1965, 40.

7. Morgan 1965, 93–94. Morgan states that "before his twenty-seventh birthday Bellows had become the

youngest associate member the Academy had ever elected." That honor, however, belongs to the landscape painter Frederic Edwin Church (1826–1900), who achieved the same status in 1848 and who was elected a full member the following year.

8. Morgan 1965, 48.

9. Charles Parsons, "Montauk Point, Long Island," *Harper's New Monthly Magazine* 43 (September 1871), 481.

10. Bernie Bookbinder, *Long Island: People and Places, Past and Present* (New York, 1983), 106.

11. Bookbinder 1983, 110; E. B. Hinsdale, *History of the Long Island Railroad Company, 1834–1898* (New York, 1898), 33.

12. Parsons 1871, 481.

13. Morgan 1965, 120.

14. Morgan 1965, 120.

15. William Oliver Stevens, *Discovering Long Island* (1939; repr. ed., Port Washington, N.Y., 1969), 177. For additional information on the history of Long Island, see Benjamin F. Thompson, *History of Long Island, From Its Discovery and Settlement to the Present Time*, 3d ed., rev. Charles J. Werner (New York, 1918). For an excellent overview of Long Island as a subject in American art, see Ronald G. Pisano, *Long Island Landscape Painting, 1820–1920* (New York, 1985).

16. Stevens 1969, 177. According to Stevens, three substantial houses, named First House, Second House, and Third House, had been set up on the point for the men who tended the flocks. Third House "served as a sort of guesthouse for the people who used to come to Montauk for hunting, fishing, and adventures"; among its distinguished visitors were the Tile Club, a group of artists who ventured there in 1881, and Theodore Roosevelt and some of the Rough Riders, who stopped in 1898 on their way back from Cuba. Perhaps Bellows and Emma stayed there as well, but we cannot be certain of that.

17. Pisano 1985, 94.

18. See Nicolai Cikovsky, Jr. and D. Scott Atkinson, *William Merritt Chase: Summers at Shinnecock, 1891–1902* [exh. cat., National Gallery of Art and Terra Museum of American Art] (Washington, D.C., 1987).

19. Quoted in "The Relation of Painting to Architecture: An Interview with George Bellows, N. A., in Which Certain Characteristics of the Truly Original Artist are Shown to Have a Vital Relation to the Architect and His Profession," *American Architect* 118 (29 December 1920), 848.

20. "Relation of Painting to Architecture," 850.

21. Bruce Robertson of the Cleveland Museum of Art, who is preparing an exhibition on Winslow Homer and American realism, kindly suggested to me the likely importance Kent's work held for Bellows.

22. Morgan 1965, 68.

23. Kent, it would seem, also learned something from Bellows. In 1915 he would paint his own picture of a house high on a bluff overlooking the sea, which he gave the ominous title *The House of Dread* (State University of New York, Plattsburgh, Permanent Art Collection, Myers/Rockwell Kent Galleries). This almost certainly must have been in part inspired by *Shore House*. For Kent's painting, see Richard V. West, *"An Enkindled Eye": The Paintings of Rockwell Kent* [exh. cat., Santa Barbara Museum of Art] (Santa Barbara, Calif. 1985), 19, 57.

24. "News and Notes of the Art World," *New York Times*, 29 January 1911, sec. 5, 15.

25. According to Morgan 1965, 272, Bellows admired Thomas Eakins and James A. M. Whistler, but considered Homer his "particular pet."

26. Quoted in Morgan 1965, 171.

27. Edward Alden Jewell, untitled review of a Bellows exhibition at H. V. Allison Galleries, *New York Times*, 25 October 1942, sec. 8, 9.

28. William H. Gerdts, "The Square Format and Proto-Modernism in American Painting," *Arts Magazine* 50 (June 1976), 70–75.

29. "Relation of Painting to Architecture," 849.

30. From an interview in the *New York Herald*, quoted in Morgan 1965, 158.

31. "Relation of Painting to Architecture," 847.

32. See Morgan 1965, chapter 9, "The House that George Built," 251–285.

33. Pisano 1985, 158.

34. Quoted in Morgan 1965, 137.

35. Morgan 1965, 21, 27.

36. See Donald Braider, *George Bellows and the Ashcan School of Painting*, (Garden City, N.Y., 1971), 67: "*Shore House*, a recollection of Montauk that is a kind of country cousin to *Lone Tenement* in its treatment of space and architecture."

37. Young 1973, 60.

38. Quoted in Morgan 1965, 137.

39. Quoted in Morgan 1965, 137.

40. Morgan 1965, 264.

41. Walt Whitman, "From Montauk Point," in *The Complete Writings of Walt Whitman* (New York, 1902), 293–294. See also Joan D. Berbrich, *Sounds and Sweet Airs: The Poetry of Long Island* (Port Washington, N.Y., 1970), 51.

Contributors

Doreen Bolger, curator of paintings and sculpture at the Amon Carter Museum, was formerly curator of American paintings and sculpture and manager of the Henry R. Luce Center for the Study of American Art at the Metropolitan Museum of Art. She is the author of *American Paintings in the Metropolitan Museum of Art, Volume III: A Catalogue of Works by Artists Born between 1846 and 1864* (1980) and *J. Alden Weir: An American Impressionist* (1983). She has written numerous catalogue essays, including "Painters and Sculptors in a Decorative Age," for *In Pursuit of Beauty: Americans and the Aesthetic Movement* (1986).

Nicolai Cikovsky, Jr. became curator of American art at the National Gallery of Art in 1983 after a long career of college teaching (most recently as chairman of the art department at the University of New Mexico). As curator of American art he has been responsible for exhibitions of George Inness, Ansel Adams, William Merritt Chase, Raphaelle Peale, Childe Hassam, John Twachtman, and the Manoogian Collection. Among his publications are books, exhibition catalogues, and articles on Inness, Chase, Peale, Sanford Gifford, Samuel F. B. Morse, Winslow Homer, Thomas Eakins, and aspects of nineteenth-century American landscape painting.

Trevor Fairbrother is associate curator of contemporary art at the Museum of Fine Arts, Boston. He recently wrote three essays on Andy Warhol, and is organizing a retrospective of objects, drawings, and video by Robert Wilson for 1991.

Linda S. Ferber is chief curator and curator of American paintings and sculpture at the Brooklyn Museum. Among her recent publications is "The Clearest Lens: William J. Stillman and American Landscape Painting," in *Poetic Localities: Photographs of Adirondacks, Cambridge, Crete, Italy, Athens: William J. Stillman* (New York, 1988). She is currently at work, with Nancy K. Anderson of the National Gallery of Art, on the exhibition and publication *Albert Bierstadt: Art & Enterprise* for 1991.

Kathleen A. Foster is curator of nineteenth and twentieth century art at the Indiana University Art Museum. She also serves as adjunct curator at the Pennsylvania Academy of the Fine Arts and is preparing an exhibition and catalogue of Charles Bregler's Thomas Eakins Collection for the fall of 1991.

Franklin Kelly, research curator of American art at the National Gallery of Art, has held curatorial positions at the Corcoran Gallery of Art, the Minneapolis Institute of Arts, and the Virginia Museum. He holds degrees in art history from the University of North Carolina at Chapel Hill, Williams College, and the University of Delaware. A specialist on nineteenth-century American painting, Kelly is the author of *Frederic Edwin Church and the National Landscape* and was the curator of the *Frederic Edwin Church* exhibition held at the National Gallery in 1989–1990.